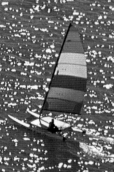

· JOURNEY THROUGH ·
SEYCHELLES

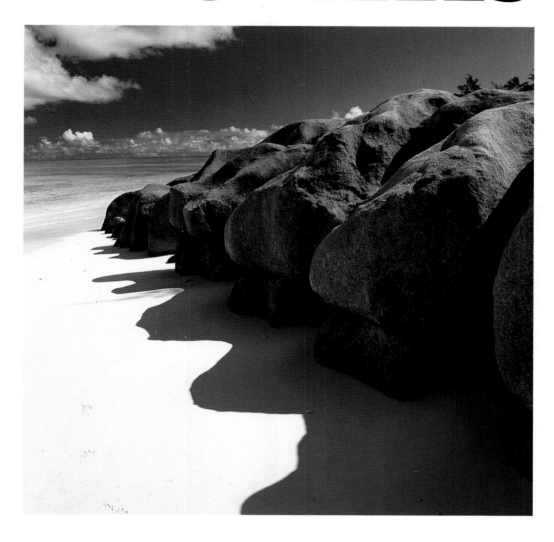

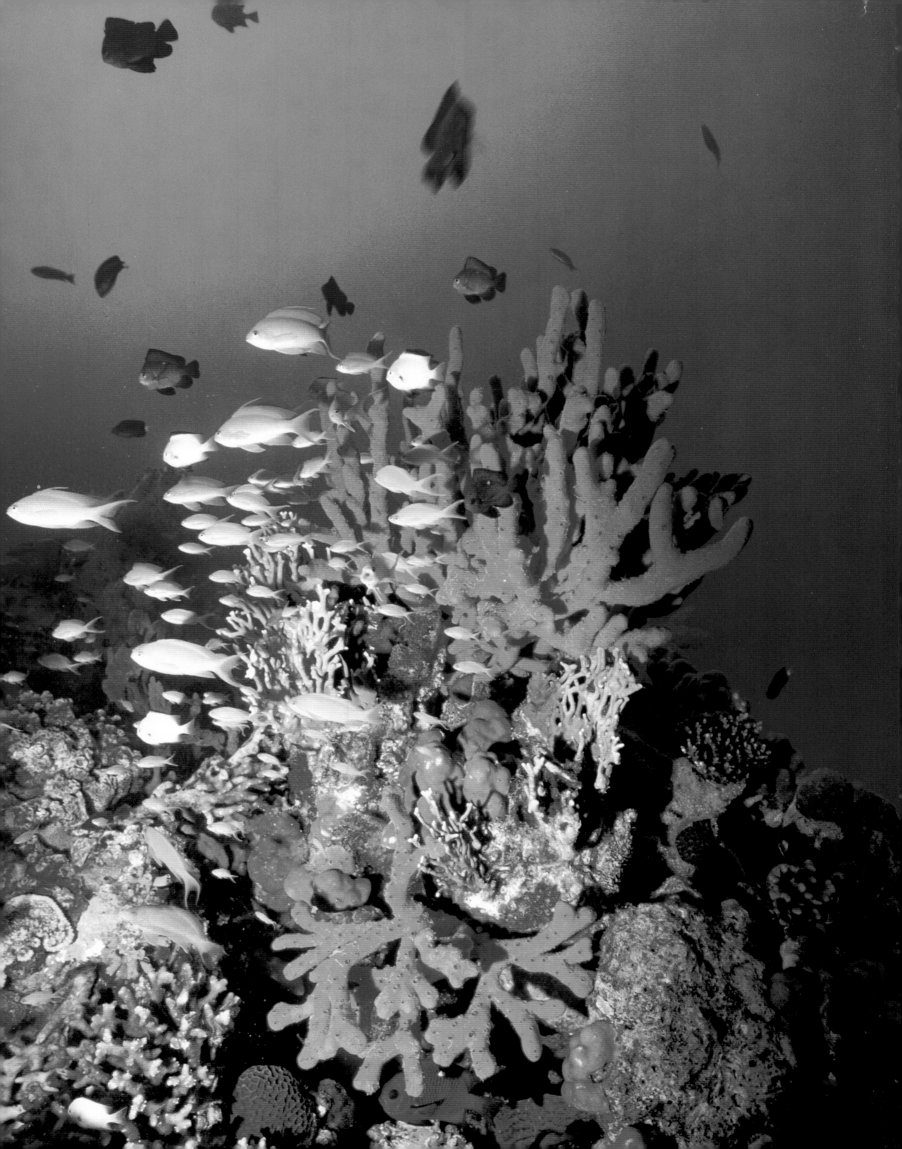

JOURNEY THROUGH
SEYCHELLES

■ MOHAMED AMIN ■ DUNCAN WILLETTS ■
■ TEXT BY ADRIAN AND JUDITH SKERRETT ■

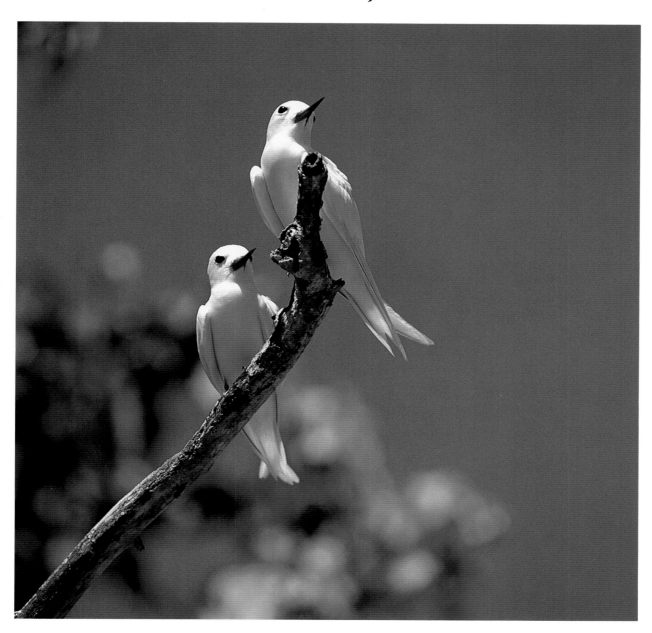

Camerapix Publishers International
NAIROBI

■ 4

Acknowledgements
We would like to thank the many organizations and people throughout Seychelles who gave us help and advice in the production of this book, in particular Vic Davies of Helicopter Seychelles for his assistance with the aerial photography. We must also thank all the people of Seychelles who made us so welcome.

All photographs by Duncan Willetts and Mohamed Amin except for John and Eliza Forder pages 22, 23, 127, 145 and Debbie Gaiger pages 8-9, 68, 69, 92, 95, 110, 112, 124, 125, 128-9.

First published in 1994 by
Camerapix Publishers International,
P.O. Box 45048,
Nairobi, Kenya

© 1994 Camerapix

ISBN 1-874041-90-3

This book was designed and produced by
Camerapix Publishers International,
P.O. Box 45048,
Nairobi, Kenya

Edited by Bob Smith and Brian Tetley
Production Director and Design: Debbie Gaiger

Printed in Hong Kong by South China Printing (1988) Limited.

End papers: Watersports at Mahé. Half-title: Pink-hued granite casts its shadows over a pristine beach on La Digue Island. Page 2: Brilliant colours of red finger sponges, fire corals, and other marine growths in the calm waters of the Indian Ocean. Title page: Fairy terns on the island of Desnoeufs in the Amirantes. Contents page: Water lilies burst into glorious flower in an ornamental pond at Mahé's Plantation Club.

·CONTENTS·

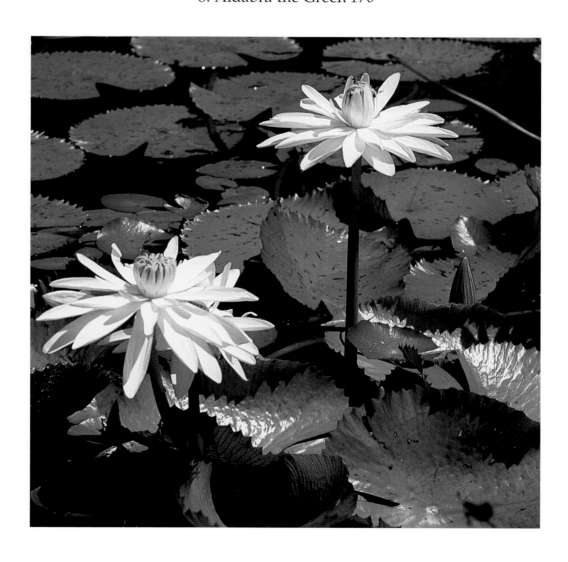

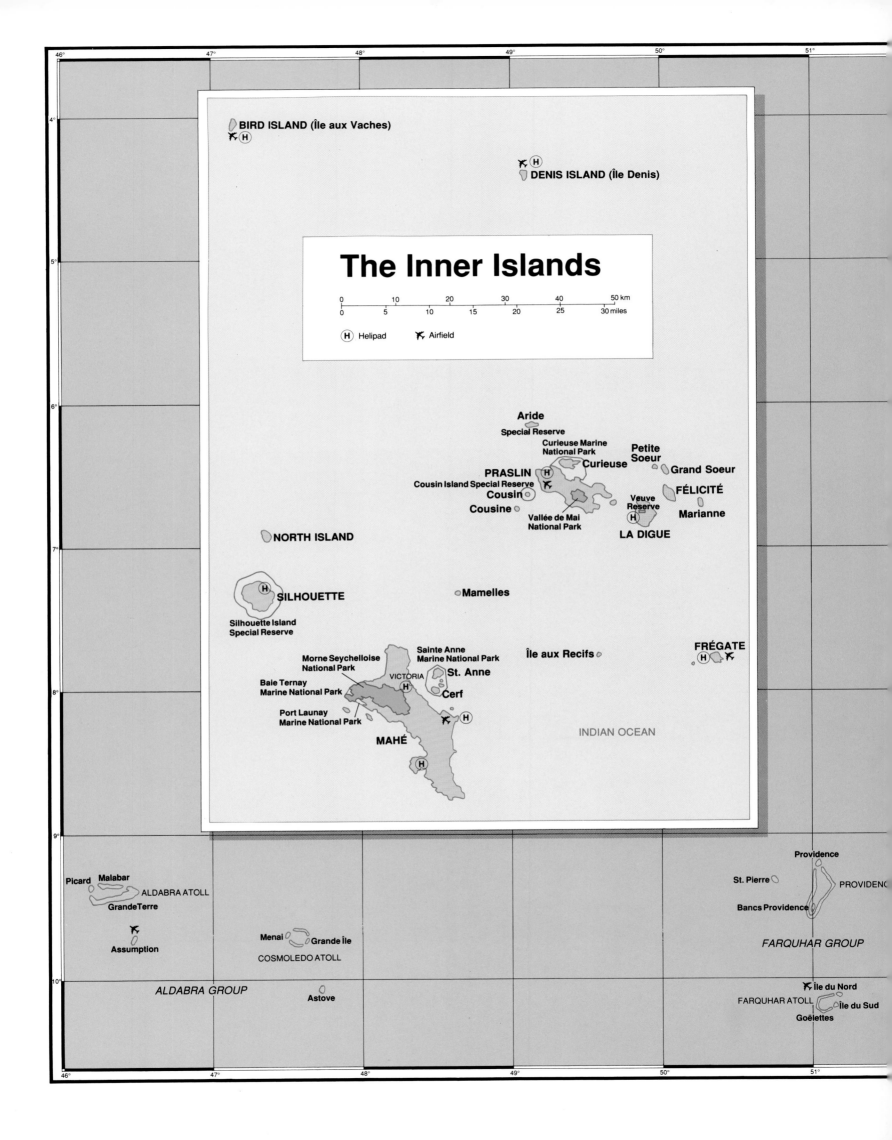

The Inner Islands

0 — 10 — 20 — 30 — 40 — 50 km
0 — 5 — 10 — 15 — 20 — 25 — 30 miles

(H) Helipad ✈ Airfield

BIRD ISLAND (Île aux Vaches)

DENIS ISLAND (Île Denis)

Aride
Special Reserve

Curieuse Marine
National Park

Curieuse

Petite
Soeur

Grand Soeur

PRASLIN

Cousin Island Special Reserve

Cousin

FÉLICITÉ

Veuve
Reserve

Cousine

Vallée de Mai
National Park

Marianne

LA DIGUE

NORTH ISLAND

Mamelles

SILHOUETTE

Silhouette Island
Special Reserve

Sainte Anne
Marine National Park

Île aux Recifs

FRÉGATE

Morne Seychelloise
National Park

VICTORIA

St. Anne

Baie Ternay
Marine National Park

Cerf

Port Launay
Marine National Park

MAHÉ

INDIAN OCEAN

Providence

Picard Malabar

St. Pierre

PROVIDENC

ALDABRA ATOLL

GrandeTerre

Bancs Providence

✈

Assumption

Menai Grande Île

FARQUHAR GROUP

COSMOLEDO ATOLL

ALDABRA GROUP

Astove

✈ Île du Nord

FARQUHAR ATOLL Île du Sud

Goëlettes

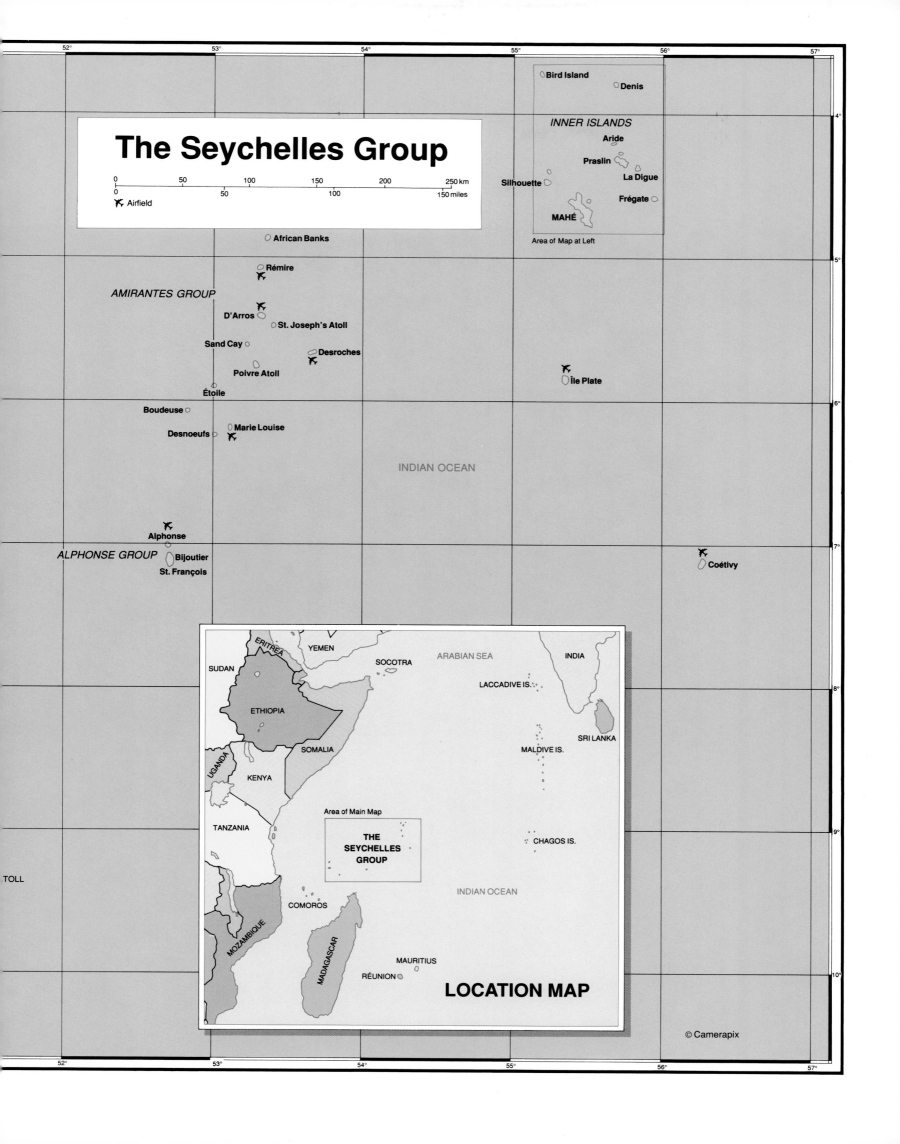

The Seychelles Group

| 0 | 50 | 100 | 150 | 200 | 250 km |
| 0 | | 50 | | 100 | 150 miles |

✈ Airfield

INNER ISLANDS

○ Bird Island ○ Denis

Aride
Praslin
Silhouette ○ La Digue
MAHÉ Frégate ○

Area of Map at Left

○ African Banks

○ Rémire
✈

AMIRANTES GROUP

✈
D'Arros ○
○ St. Joseph's Atoll

Sand Cay ○
○ Desroches
✈

Poivre Atoll ○

Étoile ○

Boudeuse ○

Desnoeufs ○ ○ Marie Louise
✈

✈ Île Plate

INDIAN OCEAN

✈
Alphonse ○

ALPHONSE GROUP ○ Bijoutier
St. François

✈
○ Coétivy

LOCATION MAP

ERITREA YEMEN ARABIAN SEA INDIA
SUDAN SOCOTRA
LACCADIVE IS.
ETHIOPIA
UGANDA SOMALIA MALDIVE IS. SRI LANKA
KENYA
Area of Main Map
TANZANIA **THE SEYCHELLES GROUP**
CHAGOS IS.
INDIAN OCEAN
MOZAMBIQUE COMOROS
MADAGASCAR
MAURITIUS
RÉUNION

TOLL

THROUGH SEYCHELLES

A thousand miles from anywhere — a thousand years outside time — a scattering of islands dreamed in the Indian Ocean; so isolated, they were forgotten long before man had evolved to forget. The Seychelles archipelago, born in the turmoil of massive geological upheaval, was left alone to develop into the unique microcosm it remains today.

The beauty of Seychelles is awesome. No one who gazes upon the granite cliffs where tropicbirds soar can fail to sense the timeless lineage. No one who explores the hidden mist forest could not appreciate this splendid isolation.

And yet time was when these 115 islands formed a greater landmass, making up a piece of the supercontinent Pangaea which was torn apart 200 million years ago by the unstoppable forces of nature.

Later the landmass split into continents and smaller sections fragmented eventually being separated by encroaching seas. These monumental upheavals formed the basis of Continental Drift, a theory considered radical and ludicrous when first proposed by German scientist Alfred Wegener in 1912. This hapless visionary died in 1930, a disillusioned man, and it was not until thirty years later that a Doctor Dietz of California was able to confirm his beliefs.

Today, after walking in the silence of the islands' ancient forests, or sunsoaking in empty coves touched only by the kiss of tide and rustle of palms, visitors return to air-conditioned comfort. But when man originally found these islands which lie a thousand miles off the Kenya coast, four degrees south of the Equator, he had no such refuge. We cannot share the thoughts of the Arab traders who perhaps first trod these shores or those of their coralline counterparts. Not until 1609 do voices from the past reach us, ringing with that same sense of awe when in quiet commune with the beauty of Seychelles. These voices do not sound with the bravado of conquerers, but are the whispers of supplicants.

The islands' whereabouts were charted by chance on the Fourth Voyage of the English East India Company, under the command of Alexander Sharpeigh, which had set its sights on the riches of Arabia and India. The first three Company voyages, funded by private subscription, had been successful, and when the ships left Woolwich, South London, in March 1608 and the wind billowed the great sails of the *Ascension* and *Union*, there was every prospect of further profit. They sailed comfortably to the Cape, where the vessel *Good Hope*, was built to join them. Then Sharpeigh sailed for the Indian Ocean and their luck changed.

They were hit by a storm, became separated, and the *Ascension* was left to explore the Mozambique Channel, calling in at Grande Comore and Pemba where a shore party was attacked by Arabs and the bosun's servant, John Harrington, murdered. Thirsting for revenge, they encountered a fleet of Arab dhows, invited the crew aboard, provoked a fight, "and beganne to kill as faste

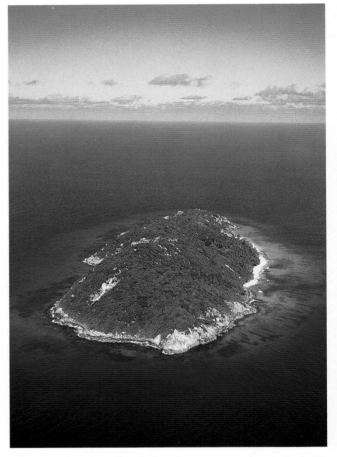

Above: Gleaming jewel in the sun — forested Aride Island, off the north-west coast of Praslin, is a world-renowned bird sanctuary.

Opposite: Lush palm trees lean eagerly to the sun across the dappled waters of the Indian Ocean.

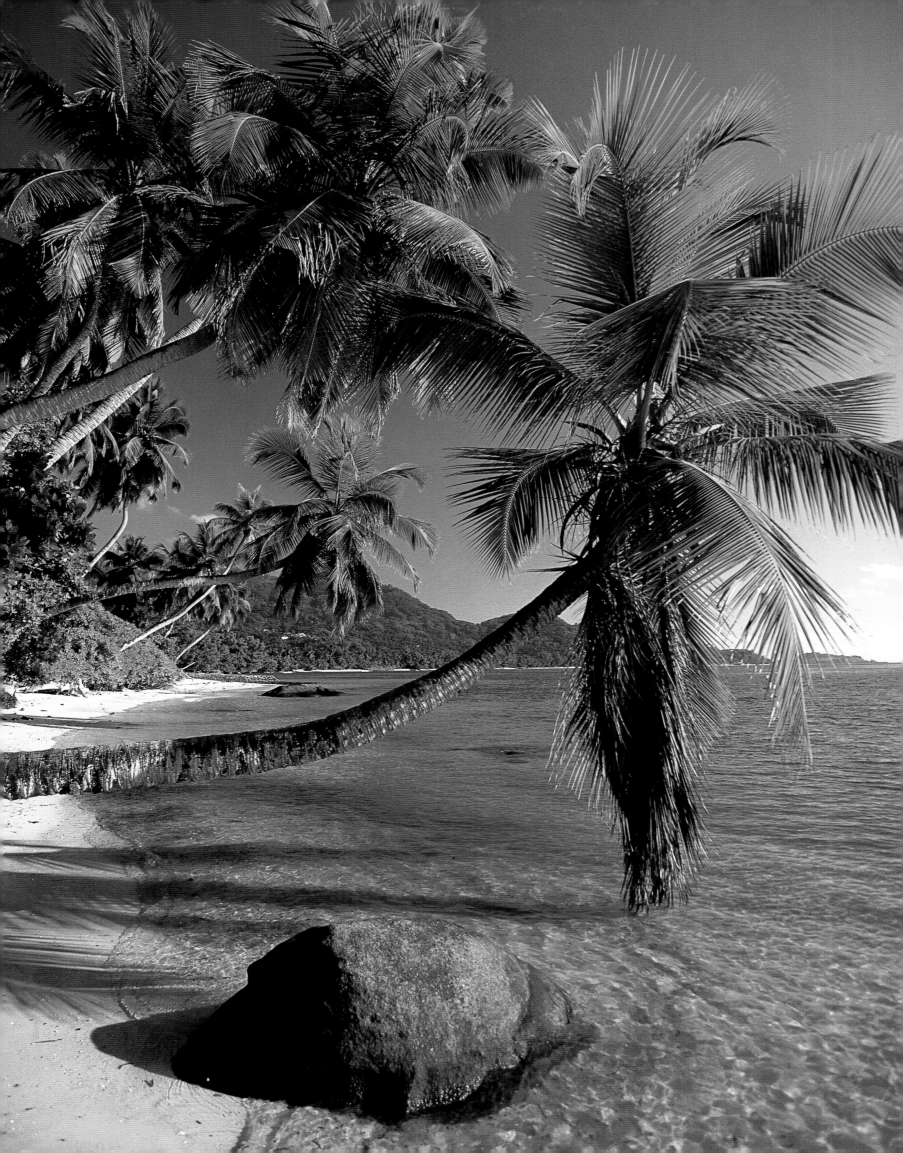

as they could", as the company factor, John Jourdain noted, blaming the *Ascension*'s captain, Grove, for the massacre. The dhows were ransacked, but Grove, afraid of possible retaliation from the Arabs' Portuguese allies, set a hasty course for the island of Socotra. Battling against the north-east monsoon proved impossible, so he headed south-east.

Instead of Socotra he discovered Seychelles. First they were no more than "high land" on the horizon. Edging closer, other islands emerged and the English decided they must be in the Amirantes, already charted by the Portuguese. By 19 January 1609 they were five leagues off the main island and, as night approached, cautiously slackened sail. By morning light, they moved into the safe haven of Mahé and the inner islands. There they anchored, "in a manner land locked", and studied their refuge. They were surrounded by three islands, about three leagues distant from their anchorage, with a channel leading to open sea to the east-north-east. Cautiously, on 21 January, they despatched landing parties to search for water and supplies.

To the bosun it was an earthly paradise. "Water is there in great abundance, also great store of coco-nuts, great store of fresh fish, and likewise store of turtle doves, which are so tame that one man may take with his hand twenty dozen in a day", he wrote, but went on to name them "the desolate islands" because they could find no trace of men.

Jourdain noted the "many coker nutts, both ripe and greene, of all sorts, and much fishe and fowle and tortells . . . it is a very good refreshing place . . . without any feare or danger except the allagartes, for you cannot discerne that ever any people had bene before us."

There was nothing for them to fear except the "allagartes" — Nile crocodiles — which roamed in great numbers, until they were hunted to extinction. Yet there was an unease in their accounts which hinted at a presence felt.

They gathered coconuts, hunted Seychelles turtle doves, fished for "scates" and used staves to kill the "lande turtles of so huge a bidgnes which men will thinke incredible". The latter were not a popular diet with the men, who found they had "small luste to eate" of the meat because the tortoises were "such huge defourmed creatures". They also noted the excellent forests which covered the island, with "as good tymber" as John Jourdain had ever seen, with "many trees of 60 and 70 feete without sprigge except at the topp, very bigge and straight as an arrowe." All in all, it was a sailor's dream "for those which are forced and stand in neede of water and such things . . . it is an excellent place and comfortabell Thus much I thought good to wryte touchinge these ilandes", summed up William Revett, one of the sailors aboard.

Nonetheless, they sailed on 1 February with scarcely a look back, leaving no flag or possession stone to pin these enigmatic scraps of land to a nation. The islands were left alone once more.

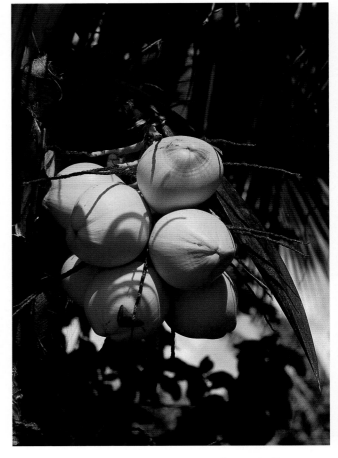

Above: Coconuts ripen in one of Seychelles many abandoned plantations.

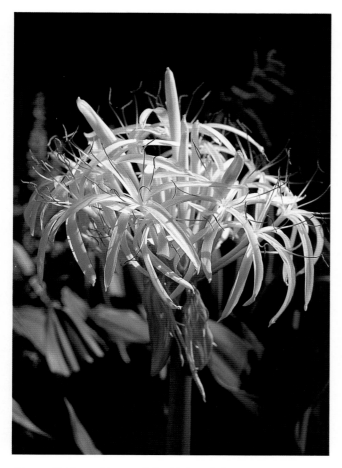

Above: Delicate bloom of the Poison Lily.

It is doubtful these English sailors were first to set foot on Seychelles. Arabs had long been trading across the Indian Ocean and the Portuguese had been active in the region since the late fifteenth century. Jean de Nove, sailing eastwards for India, discovered the Seychelles island, Farquhar, south west of the main group and, shortly afterwards, Vasco da Gama on his second voyage to India, sighted some islands he named Almirante, or "Islands seen . . . by the admiral Dom Vasco". Changed to Amirante, this name became associated with the coralline islands, part of Seychelles group, which lie to the south-west of the larger, granite islands of central Seychelles.

It has been suggested that Vasco da Gama may have sighted the granitic islands as well as the atolls of the Amirantes. An unknown sailor in his expedition reported sighting two islands in March 1503, describing bonfires lit ashore and people around them, waving frantically to attract attention. If true, their efforts were in vain. The Portuguese sailed serenely by. The incident and the islands did not even get an entry in the official log.

Seychelles, under various names, began to appear on charts from the early sixteenth century. A planisphere, an early version of a globe, created by the Spaniard Alberto Cantino, has an obscure reference to Seychelles. It disappeared for many years, but was rediscovered in 1806 in a butcher's shop in Italy, being opened out for use as a screen.

In the wake of Vasco da Gama's 1503 voyage, Fernão Soares, another Portuguese navigator, noted some islands to the north east of Madagascar and named them As Irmas (The Sisters). The first chart to use the title is attributed to Jorge Reinel. In his later charts, the islands become As Sete Irmas, the Seven Sisters. Then they changed sex and became the Seven Brothers, and by the eighteenth century, they were down to three.

In a 1512 chart by Francisco Rodrigues, the Seychelles are shown fairly accurately and the Indian Ocean was now peppered with grand-sounding Portuguese names: Cosmoledo, Diego Garcia, Agaléga, Chagos and Rodrigues. Most Seychelles islands have been renamed, apart from Cosmoledo and the Amirantes.

Pirates were probably next to visit Seychelles towards the end of the seventeenth century. They had been driven from the Caribbean and were searching for new hunting grounds. They turned to the Red Sea and Indian Ocean, where the ships of the grand Mughals of India and the trading dhows of Arab merchants promised rich pickings.

Many chose Ile Ste. Marie, off Madagascar, for their base, but perhaps some also used Seychelles for fresh water and to repair their ships. By the 1720s the pirates' heyday had passed, leaving their legends of coins, cutlasses and treasure. The only trace of the islands was that tantalising name Seven Sisters (or Three Brothers) on the charts.

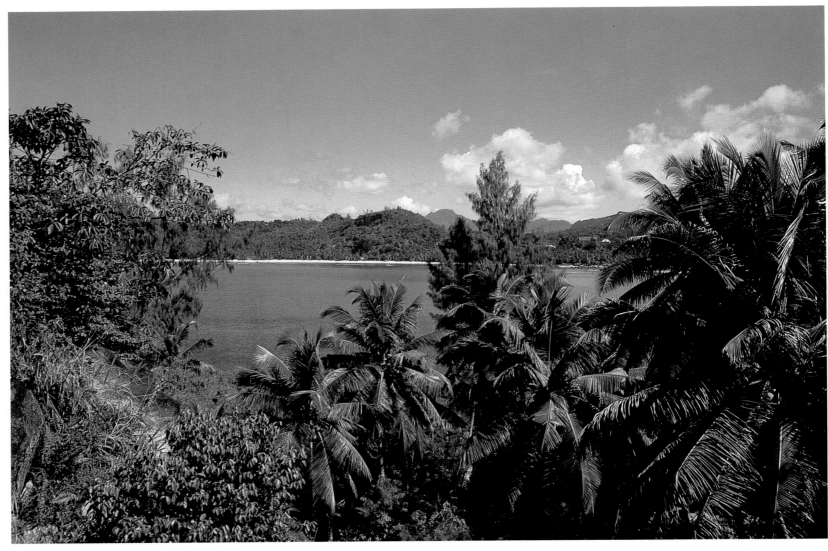

Above: Lush foliage frames view of Baie Lazare, on Mahé's south-west coast, one of the most beautiful of the island's sixty-eight bays and beaches.

Now a Frenchman steps into the Seychelles story. Bertrand François de Labourdonnais was born in St. Malo in 1699 with adventure in his blood. Off to sea at the age of ten, he became a lieutenant in the French East India Company in 1718. He took part in the French capture of Mayyazhi (renamed Mahé) on the Malabar coast, and adopted the name Mahé de Labourdonnais. After some years as a private trader, he took service with the Portuguese Viceroy of Goa. For eleven years from 1735, he was governor of Ile de France (Mauritius) and Bourbon (Reunion).

The islands to the north-west of the Ile de France, intrigued Labourdonnais. They seemed too small to be colonised but were large enough for a British base from which to harry French shipping. And with fresh water, coconuts, fish, timber, tortoise and turtle meat, they would make an excellent stop-over for French vessels plying between his colonies and India. This was an age of intense rivalry between England and France. If only to keep the English out,

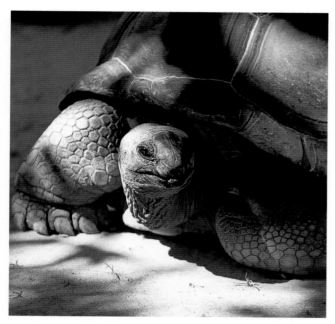

Above: Sage face of an ancient race — giant land tortoises roamed the world long before mankind.

Labourdonnais felt he must claim the islands. He despatched Captain Lazare Picault to explore them. Lazare sailed for Seychelles in August 1742, master of a tartane, the *Elisabeth*, with responsibility also for the fifty-ton *Le Charle*, captained by Jean Grossin, with a crew of sixteen.

The expedition took ten weeks to find Seven Sisters (or Three Brothers). At last, on 19 November 1742, "a very high island" was spotted. After a night of rainy squalls, and a current running so loudly they feared they were on a reef, dawn showed one island had become two, the second "high, round and rugged". Picault was still confused about his position. Instinct told him this was Three Brothers, his charts insisted he was in the Amirantes. Wherever he was, the islands warranted investigation and he needed water urgently. The long boat was lowered and landing parties headed for shore.

This first "official" landing on what was to become Mahé, largest of the islands, was made along the west coast, at Anse Boileau, and not at the bay which now bears Picault's name, Baie Lazare. They discovered steep land, densely forested and, most importantly, a stream. Further investigation brought reports of good timber and many giant land tortoises in the forests, along with several strange types of bird. Along the beaches were an abundance of coconut palms, and evidence of many turtles.

To Picault it was a land of plenty, so he named it the Ile d'Abondance. Four days later, his holds crammed with filled water butts and coconuts, he departed on 26 November convinced that the uninhabited islands had potential as a base.

Gentle northerly winds carried them clear of "Port St. Lazare" and, as they passed the southern tip of the island, they sighted three more to the north-east. Picault's report made interesting reading but Labourdonnais wanted to know more and required better maps. So, a year later in December 1743, Picault was back aboard the *Elisabeth*, bound for the Three Brothers. This time he had no sister ship, but he did have a good cartographer.

By 28 May 1744, he was anchored off Frégate, part of Seychelles' central granitic group. From there he could see "the former three brothers" and twelve other islands on the horizon from south-west to west. Next morning, Picault sailed to Mahé, spending two weeks exploring. He reported "springs and ravines" of fresh water, tortoises in good numbers, and fertile red soil, which supported trees seventy feet tall and fifteen feet around. Parties investigating neighbouring islands found them all suitable for settlement. Picault thought the land would support 300 good farms, with rice growing well in some of the marshes. Although there was a reasonable number of tortoises, he thought them too difficult to hunt in their thick forest home, and suggested that early colonists should rely on fish.

On 10 June Picault sailed for the Isle de Palme (Praslin), naming the island for its large numbers of palms, including "lataniers bearing cotton". What he

probably saw was the strange flowering stalk of one of Seychelles' endemic lataniers. Nearby Ile Rouge (Curieuse) was named for its noticeable patches of bare red earth on the mountainside, suggesting forest fires. Even today they still leave Curieuse hillsides bare and red. Picault thought the Isle de Palme would make a better settlement than Mahé — which he had renamed in honour of his patron — because the terrain was less mountainous.

He arrived back in July, and two months later the Ile de France found itself on the front line of war. Labourdonnais had to put aside plans for Seychelles. The next governor of the Ile de France, René Magon de la Villebague, was in the same quandary. Worried that the English would use Seychelles as a base, he decided he should take formal possession and on 16 July 1756, Corneille Nicolas Morphey was duly despatched to do so. He was in command of the frigate *Cerf*, and a "gaulette", the *Saint Benôit*.

Morphey was born in 1724 at Saint-Servan, the son of an Irishman, Cornelius O'Murphy of Waterford, and his French wife, Jacqueline. In 1753, as captain of the frigate *La Colombe*, he had sailed to Madagascar to take possession of Ile Ste. Marie and, when a reliable man was needed to make a similar voyage to Seychelles, he was an obvious choice.

Morphey dropped anchor at Port Royal (now Victoria) on 9 September, the feast of Saint Anne. Thus did the first of the inner islands which guard Victoria's lovely bay, get its name. Later, the second largest of these island acolytes was named Cerf, after his ship.

Morphey sent a reconaissance party inland which reported "fine trees everywhere and beyond the peak, which is in the middle of the pass, quite a spacious plain", which stretched as far as the sea. There the soil was "black, rich and suitable for cultivation".

Morphey sent another party to explore the coastline and the interior. They were to keep "an exact journal of the nature and quality of the land and of the produce". They had also to "examine the rivers, the fish and in general all the animals, reptiles, birds and insects". Their report made disappointing reading: the soil was mostly poor, "yellowish and sandy, gravelly and little suitable for cultivation" although the forest trees thrived on it. There were several rivers with "carp" and "trout", but they suspected that crocodiles took a heavy toll of them. These reptiles they had found "as far as the summits of the steepest mountains where they likewise destroy the land tortoises".

Investigation of the heart of the island also proved disappointing for there was no flat land for farming.

Morphey reported: "One could hardly flatter oneself that any useful habitation could be made on this island. The only advantage was the beauty of its port in which you could put more than 200 vessels securely . . . the wood is at the same time an object of consideration."

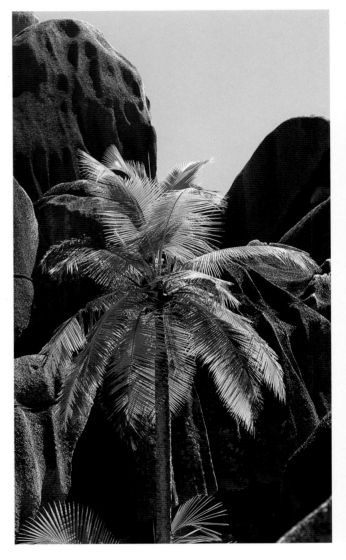

Above: Verdant palm tree contrasts with granite face of Mahé.

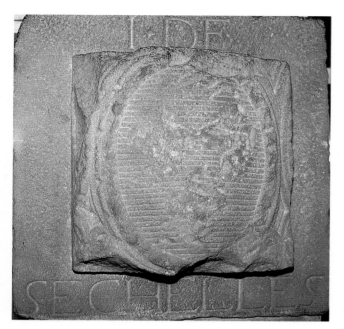

Above: Stone of Possession in Victoria's National Museum was laid nearby in November 1756 by Corneille Nicholas Morphey claiming Seychelles for France.

Nonetheless, on 1 November 1756, the royal standard was raised and a stone, engraved with the arms of France, was laid on "a big rock facing the entry to the port". Morphey formerly took "possession of the Island and of its port in the name of the King and of the Compagnie des Indes under the name of Isle de Séchelles". He then sailed away, his report was forgotten, the flag rotted, and rain and lichens ate into the Stone of Possession.

Twelve years later, Pierre Poivre, new administrator of the Ile de France, used the excuse of timber gathering to send another mission to the islands. He contracted Nicolas Thomas Marion Dufresne, who was loaned two ships "constructed and rigged out at the expense of his Majesty", in order to ascertain "the usefulness which the Seychelles could have if the state took possession". Dufresne reminded his sponsors that "the article of the Woods suitable for masts alone is of an infinite importance to the port of the Ile de France", and the taking of "Woods of other qualities will delay the devastation of those of the Ile de France". In short, it was deemed more expedient to destroy those of Seychelles. The two ships were the *Curieuse* and the *Digue*. In overall command was Jean Duchemin. His number two, captaining the *Digue,* was Lampériaire.

From the moment the expedition arrived on 9 October 1768, it rained, delaying the cutting of the timber. To Duchemin's exasperation, the slaves loaned to the expedition were continually escaping, and crocodiles became a menace by wandering into the camps at night.

Despite the setbacks, they were ready to load the *Digue* with timber by 1 November, and the *Curieuse* sailed on another mission, to explore the Ile Moras, the latest name for what would become Praslin. Duchemin remained off Mahé, loading timber and surveying. On Christmas Day 1768 he renewed the declaration of sovereignty over Isle Séchelles, extending it to cover "all the islands that are adjacent, within sight and out of sight . . . generally all that exists on this bank". Once again the royal flag flew above the Possession Stone, and there was a salute of seven cannon shots.

Poivre's name remains very much a part of Seychelles history. Given his name he was surely destined to be associated with spices, and it was his determination to break the Dutch monopoly over this trade which led to the introduction of spices to Seychelles.

During this period, spices were expensive, and the Dutch, with their possession of the Spice Islands, virtually cornered the market. Poivre, determined that France should have a share, planned to steal spice plants from the Dutch then grow them on a tropical French possession. His mind turned to Seychelles as a suitable location.

Born in Lyon in 1719, the son of a merchant, Poivre was a brilliant student who spent some time in Batavia, where he watched the Dutch cultivation of spices with great interest. He noted that one small island "with a circumference

of two leagues, grows all the nutmeg which the world consumes". At the heart of the trade were just a few islands, and Dutch sea patrols were slack. It needed someone "daring enough to share with them this never-failing source of wealth". No mean feat when the penalty for stealing such plants was death.

Poivre planned to trade with natives for the plants, then smuggle them out via a trading post at Cochin. He was not alone in his ambition. In India, Dupleix the French Commander, had announced an award of 200,000 piastres for anyone who could get twenty-five plants of each spice — cinnamon, nutmeg, clove and pepper — to his agent. In April 1753, Monsieur Aubry of Bengal succeeded in carrying a nutmeg plant to the Ile de France and promised to bring more for a reward of 60,000 piastres and the Order of St. Michael.

Since 1751 Poivre had been based on Manila and, soon after his arrival, obtained nutmeg plants from a Chinese merchant. These he planted and, within a year, he had thirty-two healthy specimens. He asked the governor of the Ile de France to prepare a spice garden there. He arrived in December 1753 with just five seedlings left. The governor was sympathetic and gave him a ship to search for more. At Timor, Poivre obtained twenty cloves and twenty nutmegs. By June 1755 he was back on the Ile de France, with the seeds, powdered sugar, white rice and slaves. The latter trade goods made him a handsome profit of over 30,000 livres. But there was also bad news.

The first five nutmeg plants had died under suspicious circumstances. Jean Baptiste Aublet, who had been entrusted with their care, was chief suspect. Poivre scented sabotage and, in disgust, left the colony, eventually returning to France. But in July 1767, Poivre arrived back on the Ile de France, this time as a governor. Soon he sent agents to find spices. It took three years before he had enough to send to Seychelles and so fulfil his dream.

By this time there was a settlement on St. Anne, but Poivre had lost faith in its proprietor and entrusted the project to Antoine Gillot, a militia captain from the Ile de France. It was he who sailed for Seychelles with the fruits of all Poivre's labours; the nutmeg, cloves, peppercorn and cinnamon, and two copies of Poivre's careful notes on their cultivation.

The St. Anne settlement was in a marshy area in the south of the island and consisted of one woman and twenty-seven men, both black and white. Under their manager, Charles Delaunay, they had been sent to cut wood, fish, and provision ships by Henri François Charles Brayer du Barré, one of the most colourful characters in Seychelles' history. Considered a rogue: a "spiv in a periwig" as Ommanney called him, du Barré emerges from his correspondence with his "patron", the Duc du Praslin, and the government at Versailles as a tragi-comic figure destined for failure and scandal.

He was not so much dishonest as weak. He pursued wild ideas through the coconut mills and coffee plantations of his fertile imagination. He was a poor

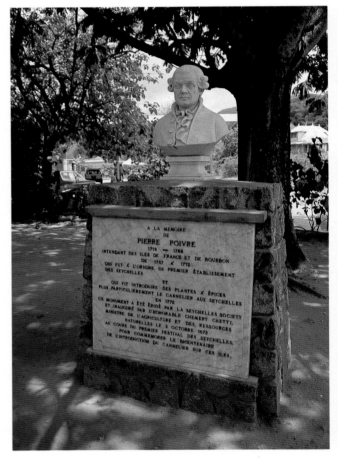

Above: Bust and plaque honour Pierre Poivre, eighteenth-century French governor of Mauritius, who founded Seychelles' spice industry.

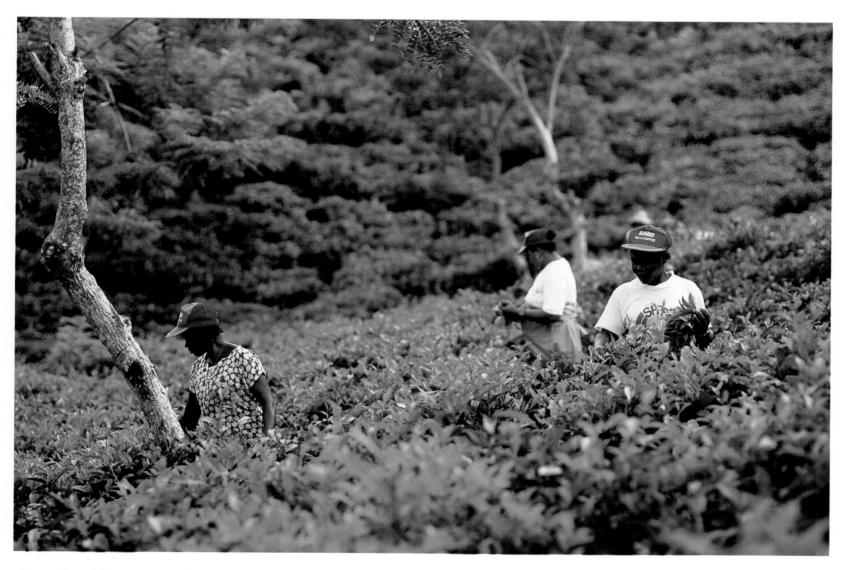

Above: Tea pickers work a plantation on the verdant hillsides of Mahé.

money manager and, as pressure increased, he panicked, and when he panicked, he told lies. The greater the pressure, the bigger the lie.

But his biggest fault was that he was penniless. As a minister dryly commented on a later would-be Seychelles settlement, "a project undertaken by a man who has nothing usually ends up with nothing".

Du Barré was running a lottery in Rouen when he decided to seek his fortune in Versailles. At court, the Duc de Praslin, Minister of Marine, loaned him three ships to carry troops and supplies to the Ile de France. Once there, he could use the vessels to trade on his own account. This should have been lucrative. But problems beset him from the beginning. He was paid well below the usual rate for transporting troops and, when the ships arrived at Port Louis, he was already in debt. But when he was offered the chance of creating a settlement on St. Anne, even though he was expected to pay for provisions, tools, arms and ammunition, he accepted.

Seychelles had become important to the French in 1769, when Jacques Grenier proved that ships en route for India could save time during both monsoons by sailing via the islands. Given Poivre's existing interest, a settlement became a priority. But neither he, nor his government, wanted to pay. Du Barré's timing was fortuitous.

The fifteen whites, seven slaves, five Indians, and Marie, a female slave had much to do. Ultimately du Barré intended colonising Mahé, but in the meantime there were tortoises, turtles and fish to catch and coconuts to be harvested and processed for ships' stores; maize, rice, cocoa, sweet potato, cotton, coffee and fruit trees to be planted.

He wanted a company of artillerymen to help build forts and ships to explore other islands. He needed more settlers, and had written to France to obtain "foundlings . . . used to field work" and "workers of all types . . . from the hospitals of sea towns". The islands were to become an êntrepôt for the slave trade so there would be no shortage of labour. Du Barré's problem was that he had barely a sous to his name.

Above: Mildewed headstones in an old overgrown graveyard on the island of La Digue.

At first the new settlement flourished. The harvest was good, with crops of maize, rice, tobacco, coffee and cotton. But when du Barré, based on Ile de France, heard of this success it went to his head. His ideas, fuelled by Poivre's promise of spice plants, grew outlandish. On the Ile de France there was growing resentment of his being handed a colony, and a campaign began against him.

Du Barré's hopes of government financial assistance dwindled and Poivre further disappointed him by entrusting Gillot with the spice plants for Seychelles. The two settlements did not see eye to eye and du Barré saw what little funding there was going to Gillot's development, undermining the status of his "official" project.

The second harvest failed and Delauney was losing control of his settlers. Finally the colony was abandoned leaving just a small group of people who took refuge on Mahé and were half-starved when finally evacuated.

With no force to prevent them, passing ships plundered the forests, tortoises and turtles. Deserters and runaway slaves only contributed to the anarchy. Pierre Hangard, whom Poivre had allowed to go out to the colony, appropriated du Barré's buildings and tools, in payment, he claimed, of debts. Du Barré was powerless, in debt, and banned from leaving the Ile de France until his dues were paid.

Now he retreated further into fantasy, telling the new Minister of Marine to expect pearls and amber from the islands, and promising him a good crop of indigo and dates. He claimed that by 1778, the profits from cowrie shells, cordage, rum, tanned sea cow hides, sugar, goatskins, plus the amber and pearls, would amount to 1.5 million livres.

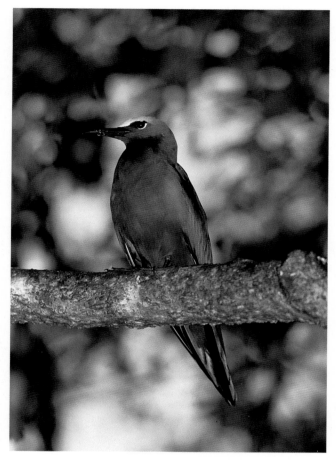

Above: Noddy terns breed in large numbers between April and September throughout the islands of Seychelles.

The minister was unimpressed and decided to end du Barré's tenure in the islands. He asked the Ile de France authorities to find "some private individual who would undertake to exploit them at his own cost". But there were few takers, and all schemes came to nothing. When the bankrupt du Barré heard of this attempt to oust him, he decided on one last desperate ploy. He claimed silver had been discovered on St. Anne in a bid to raise cash. The ruse failed and du Barré was destroyed.

In 1776 he was allowed to go to Seychelles, where he was later reported to have recruited marine deserters into a mercenary army to exert authority over settlers and visiting ships. Now an acute embarrassment to the government, he was removed, finally dying in obscurity in Pondicherry, India. But at least his example ended the French government's penny-pinching approach to colonising the islands. They now decided to turn the islands into a royal colony.

Praslin had also become of interest, and not only to the French. In 1768, Lampériaire had explored this second-largest island in the group. It became French, and was given a change of name in tribute to the Duc de Praslin, Minister of Marine.

The landing party noticed nothing remarkable about the island, except "some sort of palmiste which covered the mountains; not a single tree suitable for anything but firewood". They had hoped to see masts and spars. Yet the "palmiste" was worthy of far more attention.

At least the anchorage met with Lampériaire's approval. It was a "most beautiful place". There his enthusiasm ended. Praslin was too steep and littered with huge rocks. The good timber seemed to have been burnt out in regular fires. Rocks also showed signs of having been burnt. There were too many crocodiles and the soil looked poor. The only interest was a palm tree with a double coconut, and they were extremely common. "There are many here", Lampériaire notes. "The sandy bays, as elsewhere, are covered with them". He might have been complaining about a plague of mosquitoes.

Although Praslin had no apparent use, on Sunday 20 November 1768, a detachment of men performed the simple ceremony, unfurling a flag at the bay which is still called Anse Possession and is still "a most beautiful place". After shouts of "Long Live The King!", and a salute of cannon, a lead plaque was positioned on a stone base, proclaiming Praslin French territory. Lampériaire sailed back to Mahé to report to Duchemin, who in turn reported that Praslin did not live up to "the agreeable aspect that it offers from afar".

Somewhere in the hold of the *Curieuse* were thirty of the double coconuts. They had been collected by a member of the expedition, a surveyor called Barré. When he stepped ashore, and spotted the first nut lying on the beach, his heart missed a beat. Surely this was the fabled coco de mer — the mysterious nut said to grow beneath the sea? He knew such curiosities fetched enormous prices. He

hid it, thinking his fortune was made, but as he moved on into the forest, his heart sank. They were everywhere. The coco de mer was supposed to be a rarity. The thing he had found was commonplace and could not be the stuff of legend. With thoughts of fortune fading he collected a handful just to show the people at home.

When Poivre saw them, back on the Ile de France, he knew at once that Barré's first reaction had been correct. These were coco de mer and he knew he was looking at a fortune. Until the Portuguese began to explore the Indian Ocean, the coco de mer was unknown in Europe. On the shores of India, Sri Lanka, Indonesia and the Maldives, where they occasionally washed up, they already had great value. A maze of superstition grew up around them. The flesh of the nut was considered an aphrodisiac, and rulers who had cause to fear poison asked for drinking cups fashioned from the shell because it was thought to neutralize noxious substances.

Above: Four-foot catkin of the male coco de mer spurred legends that the Valleé de Mai was the biblical Garden of Eden.

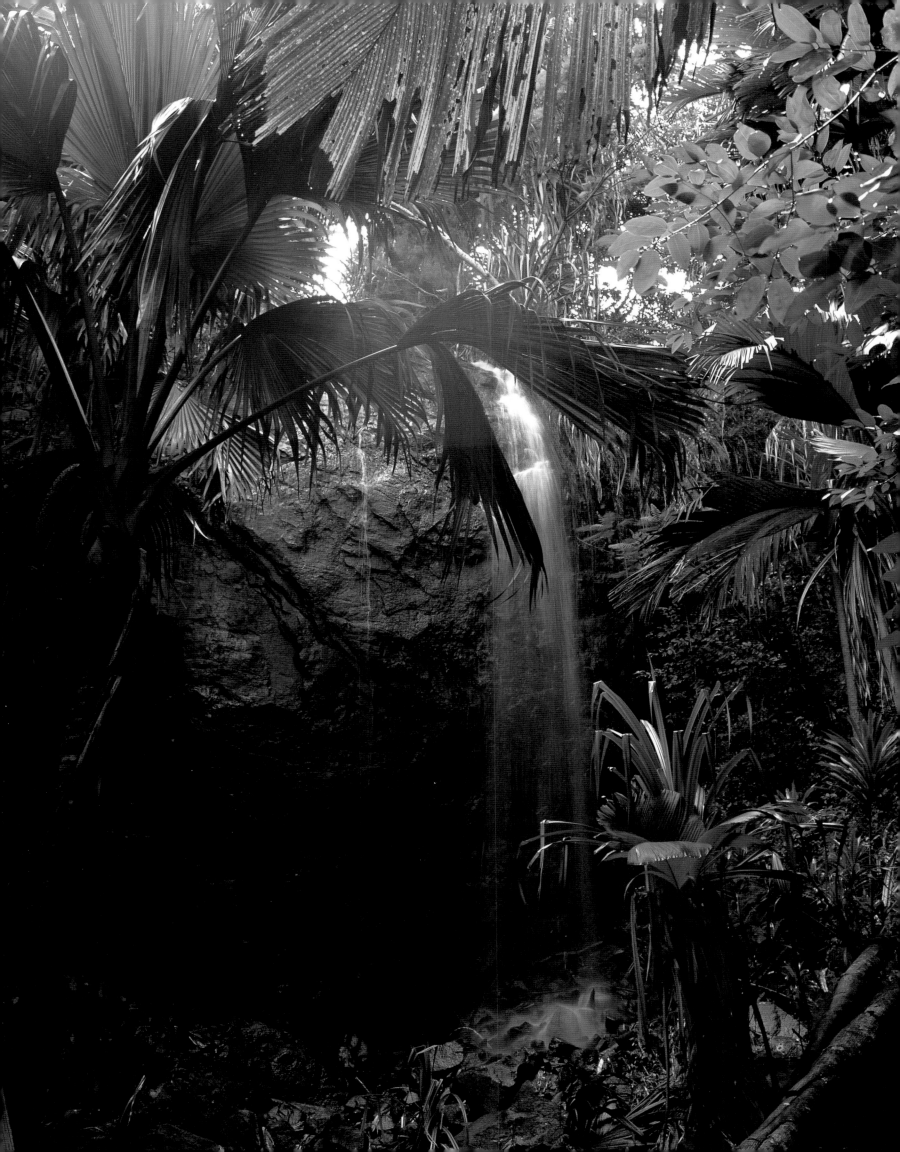

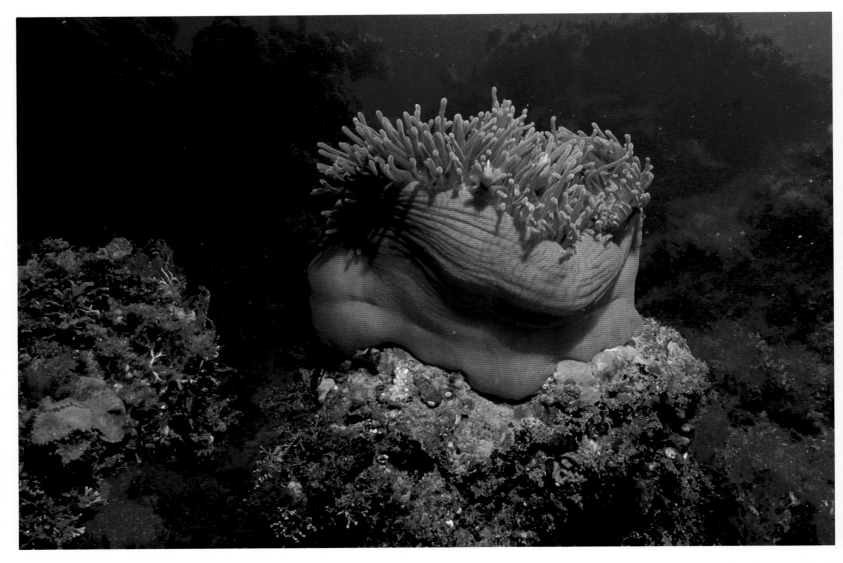

Above: Nose stripe clown fish hover within the tentacles of their host anemone.

Once Europeans heard about the coco de mer, they wanted them too. No price was too high. The Holy Roman Emperor, Rudolf II offered 4,000 gold florins for one. Once in royal possession, they were carved, gilded, decorated, mounted and embellished with silver and gold. Examples can still be seen in the British Museum, the Kremlin and other collections.

Everyone agreed the mysterious nut must grow in the sea. Antonio Pigafetta, in his account of Magellan's first world voyage, confidently confirmed this to his readers. Somewhere below Java, he wrote, there grew enormous trees in the middle of the ocean and huge birds called Garuda (similar to Marco Polo's Roc) lived in their branches. Battered by constant storms, the area was impossible to approach, but once a boat was wrecked there. The crew perished but for a boy who struggled towards the trees and climbed one. He sheltered under the wing of a perching Garuda, and when it flew off next day, he managed to cling on, nimbly jumping down when the giant bird landed to feed. In this way he was

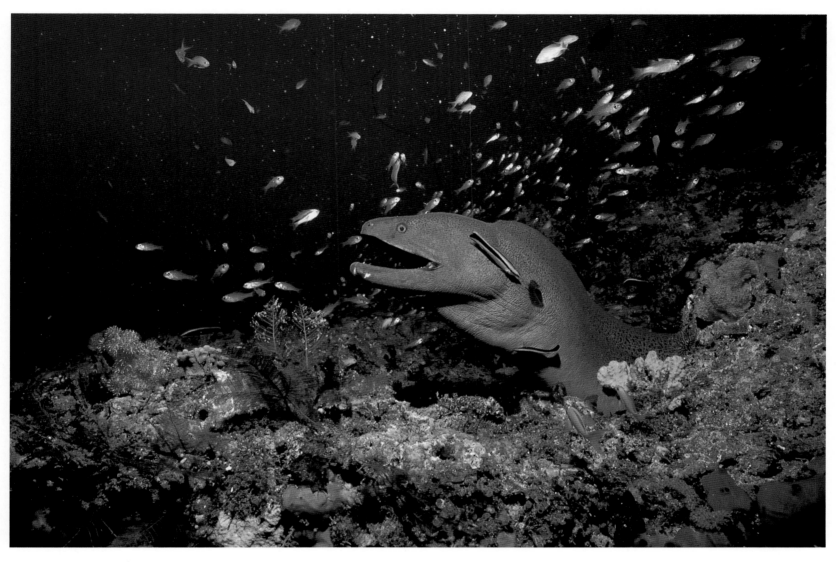

Above: Yellow edged moray eels can reach up to a metre-and-a-half in length.

able to tell the world that "the fruits which they found on the sea" in fact grew on these marvellous trees.

By 1553, the idea of a tree which grew in the sea was firmly fixed in European minds. Joao de Barros, a Portuguese writer, added to the folklore by reporting that its medicinal properties were superior to bezoar, a stony mass found in the stomach of ruminants, which was thought to be an antidote to all poisons. The reputation of the nut grew. Within ten years, it had become a panacea for epilepsy, colic, paralysis, bowel disease and nervous complaints.

Better still, it could *prevent* illness. If you seeped some water in a shell which had a little kernel attached, you obtained a liquor which would protect you from all ills. Poets eulogised the coco de mer. Botanists pondered upon it, and kings in the Maldives kept small stocks which they gave as gifts to other kings and potentates. In the Maldives, if you found one and failed to hand it to the king, you had your hand cut off.

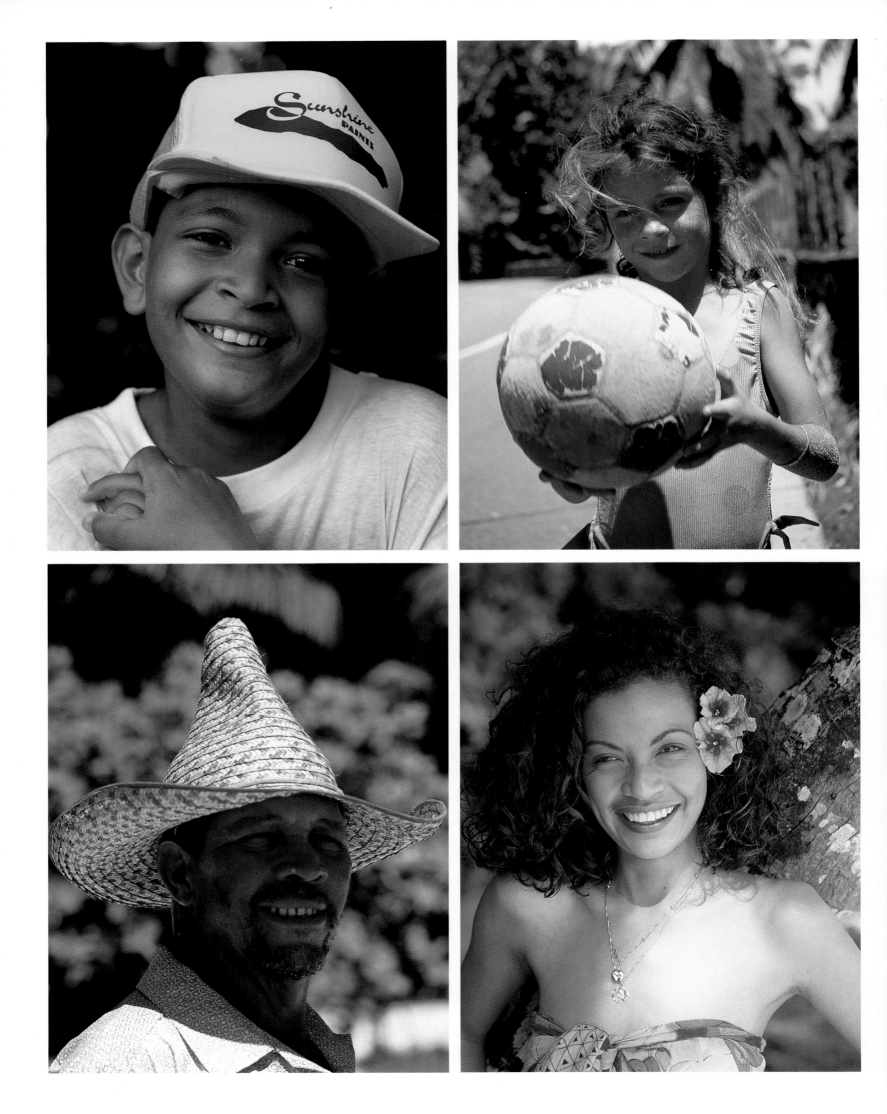

Smiling faces of the sunshine islanders of Seychelles. Opposite left: Schoolboy in baseball cap. Opposite: Young girl with soccer ball.

What Poivre had was a heavy — twenty kilos — two-lobed, brown nut, with an outer green husk. The nut itself looks like the buttocks and thighs of a woman, a fact which troubled early writers. The Abbé Rochon would only admit to it being a "strange" shape. Some found it too indecent to describe. Author Bernadin de Saint Pierre was less fastidious. It was like "the anterior and posterior parts of the body of a negress at its bifurcation". General Charles Gordon, of Khartoum fame, summed it up for everyone. The nut represented "the thighs and belly . . . which I consider as the true seat of carnal desires", which is why there was such a fuss about the shape in the first place.

Poivre asked the navigators, Grenier and Rochon, to confirm the discovery of the true source of the coco de mer during their voyage to Seychelles in 1769. Rochon returned home with more nuts and several live specimens of the tree which bore it. Poivre realised that the secret of marketing the coco de mer was to keep supplies scarce, its location secret and its price high. However Duchemin was not so forward thinking. As soon as he realised these were coco de mer nuts, he sailed back to Praslin and gathered a boat load. He tried to sell them in India, but he not only swamped his market, he also let the coco de mer's location out of the bag. English merchants heard where the nuts could be found and sent their ships on a collecting mission.

The English succeeded where Duchemin failed. They profited from the coco de mer, and made "a new branch of commerce out of this find" for some time.

This brief flurry of trade was short-lived and marked the end of the nut's mystique. Soon its only commercial value was as a souvenir or hollowed out to make boat bailers and sugar scoops. On Praslin they used it for kitchen utensils, known as Praslin crockery.

To early French visitors Praslin was "nothing but mountains, ravines piled high with rocks and practically impassable". The English thought more of it, and they considered a settlement there. Hearing this, Brayer du Barré immediately suggested setting up a sugar cane mill to establish a French presence. Like so many of his ideas, it came to nothing. Eventually a detachment of soldiers was sent to fly the flag and keep English noses out. The island also attracted its first settler. Monsieur Lambert, "retired captain, merchant", took thirty arpents of land, and thirteen slaves to tend it. A bay near Anse Possession was named after him, and somewhere between the two was Seychelles' first recorded building. Lampériaire had put a small guard house on a point between the two bays, where five men were stationed during the expedition's visit, busily cutting what timber they could find.

Until Emancipation, the slaves in Seychelles outnumbered white planters. In 1788 there were thirteen settlers and 221 slaves. In 1827 there were 471 whites and 6,638 slaves, but history records little of their lives, unless one of their masters was complaining about them running away. Gillot was plagued by his

Opposite left: Seychellois fisherman. Opposite: Typical Seychellois beauty.

Above: Brilliant flowers of a flamboyant tree (Delonix regia) *brighten the capital of Victoria.*

"black rascals", in particular Domingue Machabée who escaped to Silhouette in a small boat with another slave and a woman. Gillot sent soldiers to hunt them down, but they only caught the woman. Furious, Gillot said he would send the soldiers "to bring back the head of this Domingue, who is a rascal, an arsonist". He intended to have the head displayed as a warning.

This is a rare example of a slave stepping into the spotlight, yet the "silent majority" were one of the main agents which shaped Seychelles. Settlers could have achieved little without them. It was considered essential to have ten to twelve for every 108 arpents of land.

In return for their labour, they were beaten, overworked and poorly housed by some masters. The Code Noir, which laid down rules for the treatment of slaves, and outlawed torture and mutilation, was considered an enlightened document in its day. However, the same document also stipulated a penalty of death if a slave ran away from his master three times. It was a risk some, like

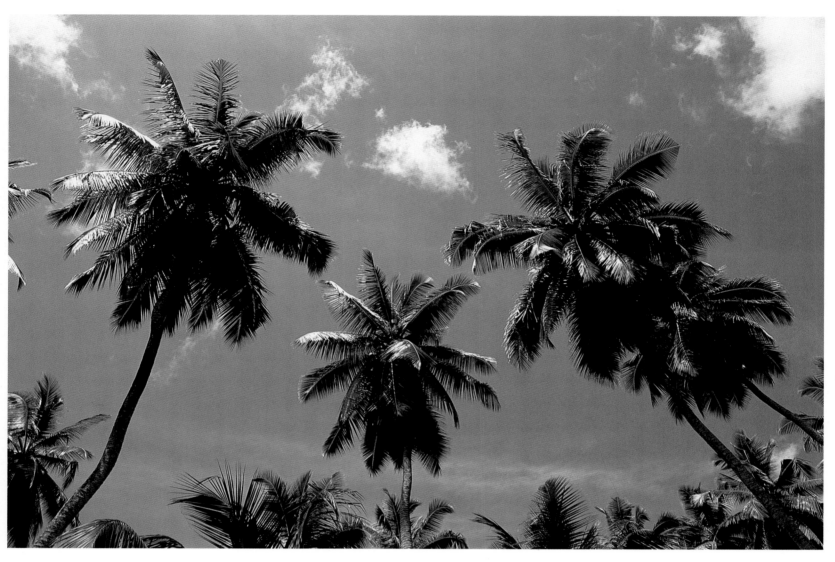

Above: Tall crowns of coconut palms reach for the sun from their plantation roots.

Machabée, were willing to take. At least the Code provided some humanitarian protection. Slaves did not have to work on Sundays or holy days, nor could they be forced to marry. And owners were bound to educate them in the Christian faith, and feed and clothe them adequately. If an owner killed a slave through ill-treatment, he could be sentenced to death.

Most slaves in Seychelles came originally from East Africa or Madagascar, but in the early days many had already been in service on the Ile de France. During the Seven Years and Napoleonic Wars, when the British blockaded the mother colony but Seychelles enjoyed a right of free passage, enterprising local ship owners carried slaves from the African coast to sell on the Ile de France. For several years, du Barré's vision of Seychelles as a slaving port was a reality, and the white population did very nicely. A year before the war ended, the slave population rose to more than 3,000, an average of ten a settler. By this time slaves born in Seychelles were known as Creoles, and were considered superior

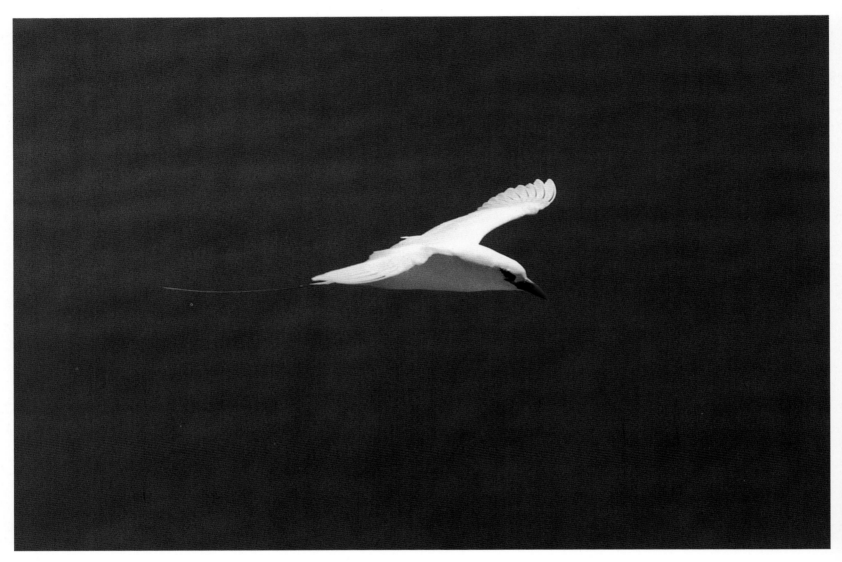

workers. Many were made foremen on the plantations where they worked.

The French National Assembly abolished slavery in all French possessions during the Revolution, but the decree was ignored in Seychelles. When commissioners were sent to enforce it on Mauritius, there was an uprising and they had to retreat. In Seychelles they were treated with more respect, but after their departure slavery resumed as it had before.

Britain abolished slavery in its colonies in 1807, so when Seychelles was ceded to it after the French surrender of Mauritius in 1810, one of the priorities was to ensure the slave trade did not continue there illicitly. Planters were initially allowed to keep the slaves they had, but trade was forbidden. The first British Civil Agent, Bartholemew Sullivan, did his best to stop the transit of slaves through Seychelles.

Settlers played every trick in the book to keep to their old way of life. Against their united front, Sullivan had only one real success. Hearing that a cargo of

Above: Red-tailed tropicbird in flight over Aride Island. These birds only breed on Aride, located in the central islands, and on Aldabra where they are much more common.

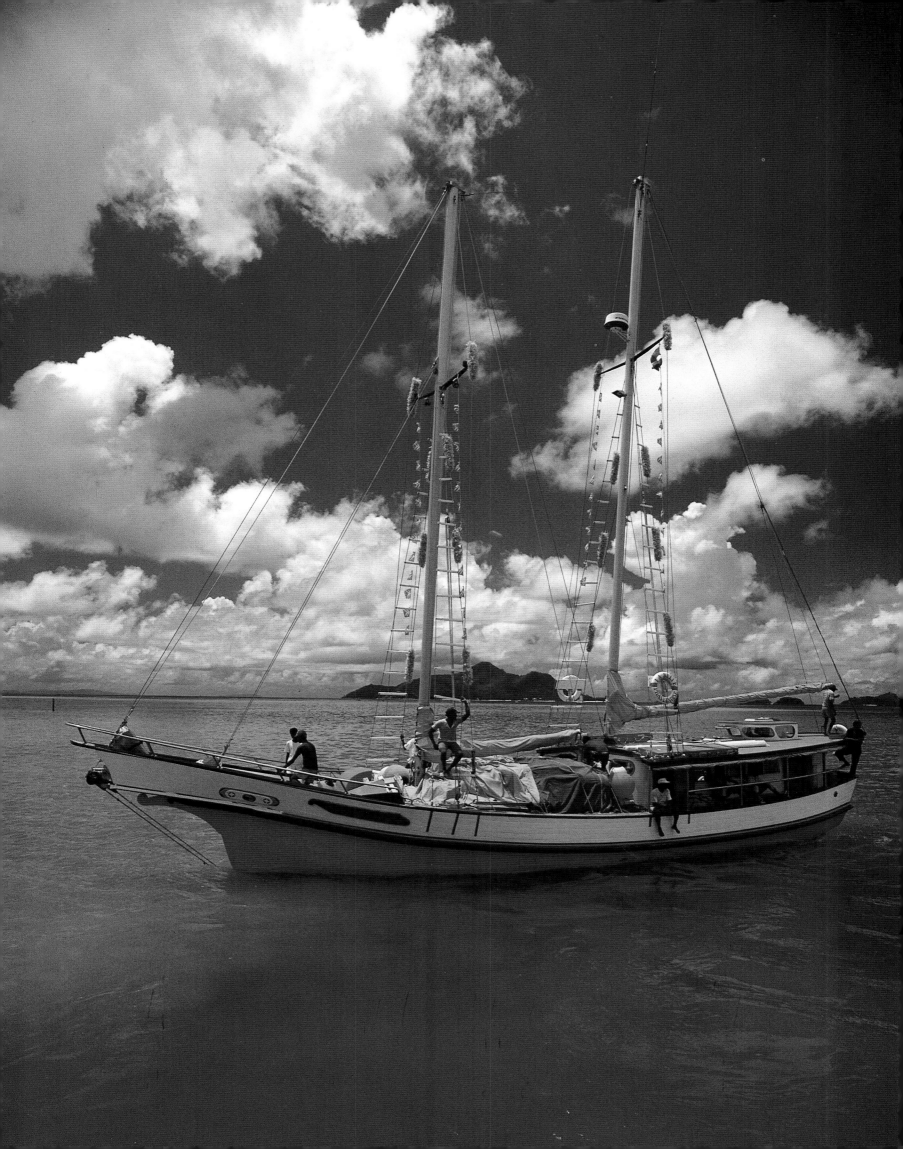

slaves had just been landed on Praslin, he rowed there through the night, and with a small armed band launched a dawn raid. He confiscated forty-one slaves who were "nearly starved" after their voyage. One of his successors, Edward Madge, also made some attempts to stop the trade, though his efforts were half-hearted. On one occasion he seized a slave ship with forty-eight slaves aboard, but the owner escaped on another ship with eleven of the slaves. Madge claimed that the local justice of the peace (and former commandant), de Quincy, had aided the escape. Madge sent him for trial in Mauritius, but no case was found for de Quincy to answer.

Despite these token efforts, the slave population doubled during these years. However, the world was changing. In 1835 the Emancipation Act gave freedom to all slaves. Some attempt was made to phase in this radical new measure by converting all slaves over six years old into apprentice labourers, who were supposed to spend six years learning how to be independent and feed themselves, whilst the planters adjusted to having paid workers rather than slaves to man their estates. The idea failed, and was abandoned by 1838. The usual practice then was for former slaves to be given small areas of land on which to produce their own food, in return for labouring on the plantations.

The effects were devastating. Formerly the colony had produced labour intensive crops such as sugar cane, rice, and coffee, and was able to export cotton; 150,000 dollars worth in 1818. By 1850 it was a very different story. "Scarcely any of the numerous 'habitations'. . . can be said to be under cultivation, or to furnish anything either for exportation or for home consumption", one commentator summed up. Most of the liberated slaves refused to enter into regular employment. They could live reasonably well without working. As one writer put it, "they had already contracted habits of idleness, which they soon began to look upon as identical with freedom, and had made the fatal discovery that in these islands life was sustainable almost without the necessity of exertion".

The planters, meanwhile, failed to realise that other factors had contributed to the depression, such as poor husbandry, exhausted soil and the collapse of the world market for cotton. They blamed emancipation entirely and as "long as the money received for indemnity lasted, the proprietors lived on in idleness, making no exertions to discover new sources of industry or profit".

This stalemate continued until 1861, when 250 slaves liberated by the British from Arab traders on the East African coast, were landed in Seychelles. They were the first of many liberated during regular anti-slaver patrols in the region. In all, between 1861 and 1874 over 2,500 freed slaves were brought to Seychelles, and of those about 2,400 stayed. This was the supply of cheap labour the planters had dreamed of. Men and women over eighteen were apprenticed by the landowners for three years on their arrival, and provided with rations

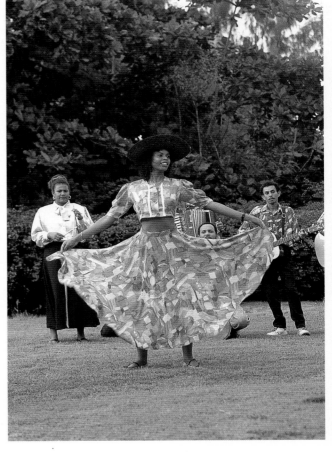

Above: Traditional dancer performs the sega *dance at Victoria's Botanical Gardens.*

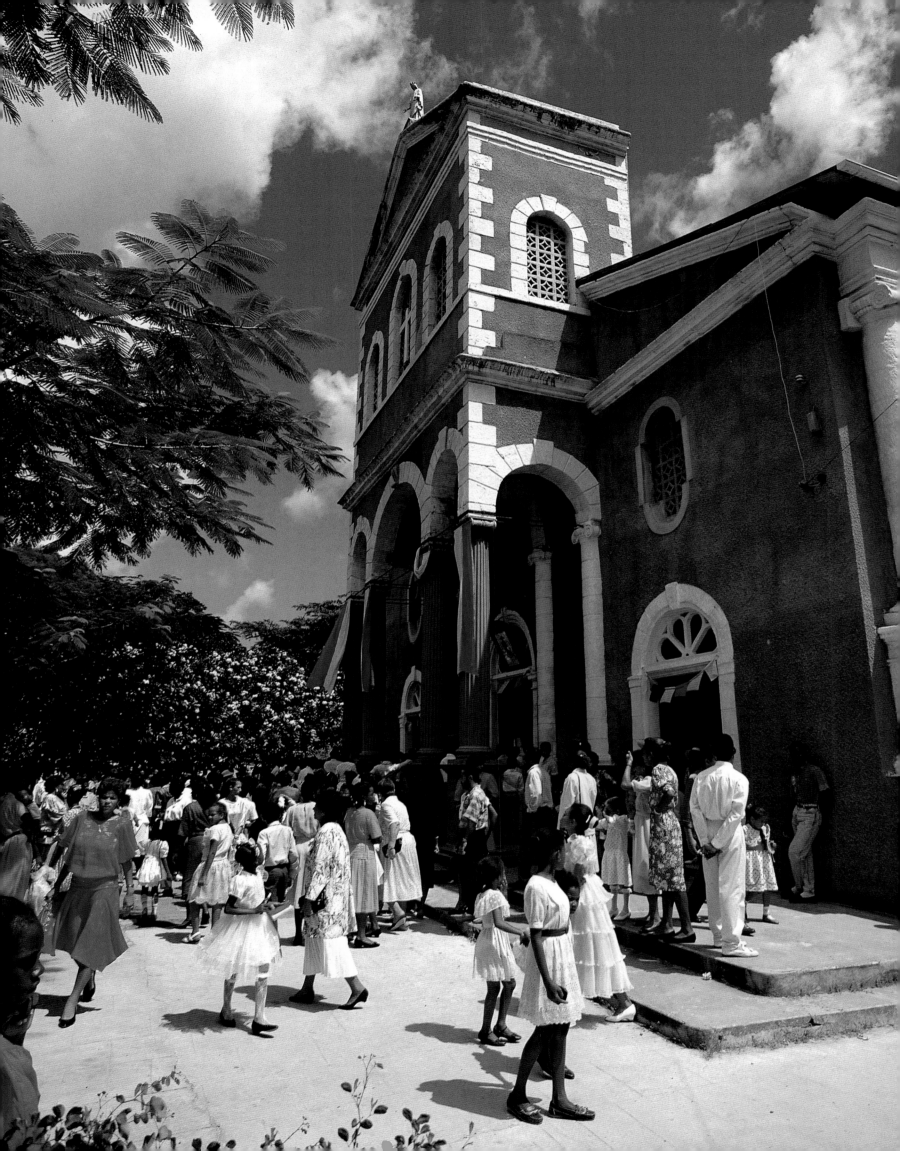

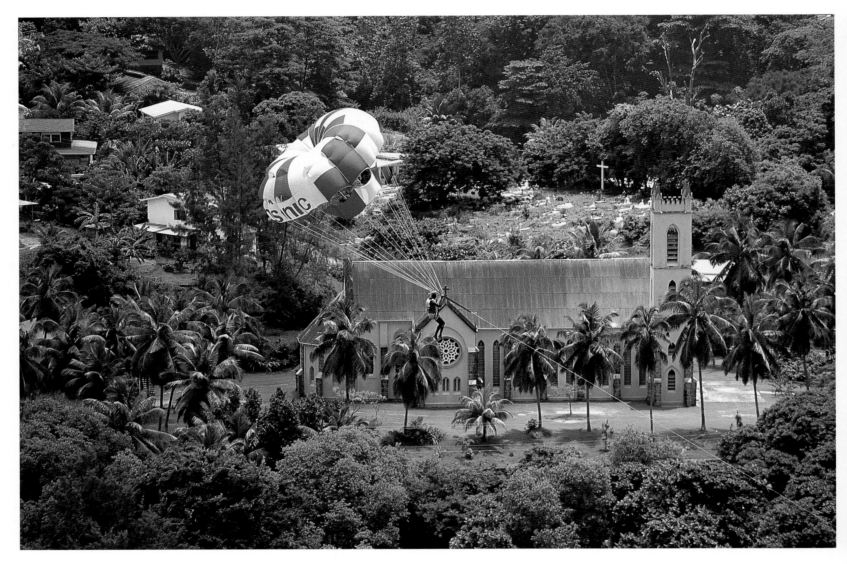

Above: Seychelles parasailer drifts gracefully past the Catholic church at Bel Ombre.

and a low wage in return for their labour. Soon they were put to work laying out vast plantations for a new cash crop, the coconut, and the estates began to produce coffee, tobacco, and sugar cane once more. The coconut was an ideal crop because it required less labour, and the plantation owners were still refusing "to swallow the bitter pill of paying those to whose services they still maintain they are entitled."

At least the French, when the crown took over the colony in 1778, did not have this problem to worry about. Their major concern was the threat of war with England, and in 1792 the French revolutionary wars began.

This was an extraordinary period in Seychelles' history. Whilst what amounted to a world war raged around the colony, and the administration on the Ile de France was cut off by an English naval blockade, the commandant de Quincy played shrewdly what few cards he had. For the defence of Seychelles, he had about forty white male settlers, only half of whom could be counted on

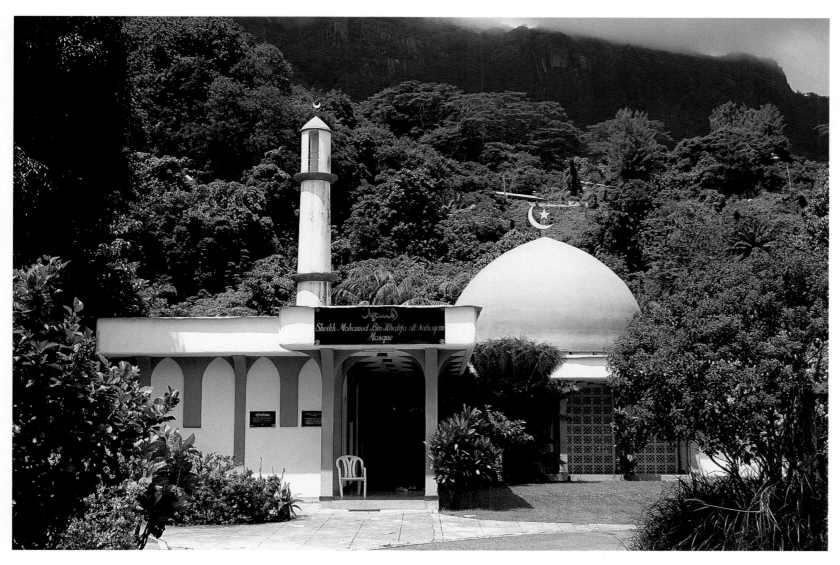

Above: Mahé's Muslim population offers prayers at Victoria's Sheikh Mohamed Bin-Khalifa Mosque.

for active duty. It was thought the 500 slaves might prove unreliable in a fight. For arms and ammunition there were eight small cannons and sixty assorted muskets and pistols. De Quincy knew they had no hope against an English squadron, or even a lone frigate.

The inevitable happened in May 1794 when five English ships appeared off St. Anne. De Quincy consulted hurriedly with his little band of defenders, among them Jean François Hodoul, a corsair and one of Seychelles' most famous figures. Hodoul was a "legalized pirate", one of a band of seafaring men used by both the English and French in the region during the Napoleonic Wars as a means of harrying enemy shipping. Unlike pirates, corsairs operated within the law, and declared their prizes to the authorities in return for immunity from prosecution under piracy laws.

Hodoul "ravaged the Red Sea, Gulf of Persia, Malabar and Coromandel Coasts, Sumatra and Java", according to the Seychelles Almanac of 1819, but he

often appeared in Seychelles waters. He had just sailed into port with his brig, the *Olivette.*

Hodoul would have rather run the *Olivette* onto the reef than see her taken, but did not get the opportunity. The English squadron seized the brig before heading to *L'Etablissement,* as the settlement which is now Victoria was called, where Lieutenant Goate of the frigate *Orpheus* explained that the squadron commodore, Captain Henry Newcombe, required water and supplies.

De Quincy had little choice but to comply. To his eight cannon, the *Orpheus* had thirty-two. Rather than surrender de Quincy "capitulated", or surrendered "temporarily". The English accepted this — and the commandant's stipulation that the rights and properties of settlers must be respected. The French flag was lowered. The British insisted that the *Olivette* was now theirs. They put her to work bringing in tortoises from Praslin for their provisions.

On 1 June, the English sailed away. No attempt was made to enforce the capitulation. Newcombe did not think the place "of sufficient consequence". The settlers thought it unwise to replace the French flag. They decided to remain neutral. The French authorities were less than happy with Seychelles' surrender, but although de Quincy was ordered to restore the tricolour, he was not dismissed. Back in Seychelles, the settlers ignored the orders to fly the French flag again. Until they were sent a garrison to defend it, they said, it could stay in its box.

On the second capitulation, in 1804, de Quincy secured a privilege for Seychelles' shipping: a Flag of Capitulation which gave local ships trading in the Indian Ocean immunity from interference by the British navy.

Hodoul, meanwhile, had taken command of the sixteen-gun *Apollon,* and soon established his reputation as a privateer. After considerable success off the Malabar coast, he was able to buy the *Uni,* and in 1800 was back in Seychelles. Here he found an English privateer, the *Henriette* which he chased and, knowing the waters well, was able to "drive it to destruction on a treacherous coral reef". According to legend he took a great treasure off the *Henriette.* There were rumours of Hodoul's mysterious night-time activities, of large holes being dug and trails being found which suggested a heavily laden boat had been dragged up the shore. Other stories concerned Chateau Mamelles on Mahé and a ghost with a bag full of treasure, and a tunnel to St. Anne — an island where Hodoul is supposed to have buried treasure, though others said it was on Silhouette.

Hodoul retired to Seychelles and became a Justice of the Peace and ran an estate at Ma Constance. When he died in January 1835, at the age of sixty-nine, he was "one of the oldest and most wealthy, as well as one of the most respectable inhabitants of the place". His grave, inscribed "Il fut juste", may still be seen in Bel Air cemetery.

Hodoul was the inheritor of a tradition of piracy in Seychelles, and the region

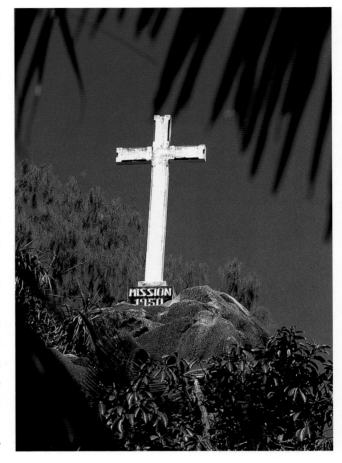

Above: Mission cross raised on a natural rock pedestal on Mahé in 1950.

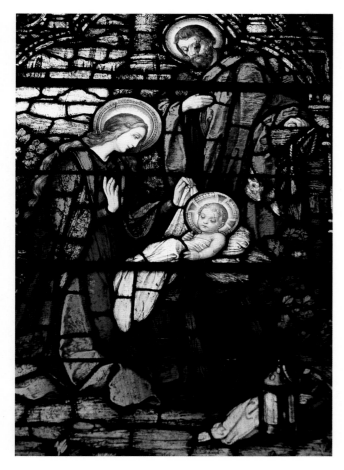

Above: Stained-glass depiction of the Nativity in Victoria's Cathedral of the Immaculate Conception.

in general. By the 1670s, the English East India Company had regular shipping passing through the area, and on the tail of possible spoils, plunderers had soon appeared. There were the fearsome Sanganian pirates from Gujarat, who gave no quarter to prisoners, Omani Arab pirates, and the English and French adventurers who drifted there when loot dried up in the West Indies after navy patrols in the Caribbean made life uncomfortable. Between 1690 and 1720, these European pirates made Madagascar their base. Sometimes as many as seventeen pirate ships anchored in the harbour of St. Mary's Island, off Madagascar's north-east coast, and a floating population of over a thousand men went there to relax, repair their ships and sell their ill-gotten gains. To some of them, perhaps Seychelles was also well known.

The fabled hauls of treasure were not common, and merchants had the upper hand in their bargaining. Pirates needed basic necessities, which merchants sold at high prices, or bartered for precious stones and coin. Occasionally a pirate did strike it very rich. In 1691, a merchant on Ile Ste. Marie reported the arrival of George Raynor, who had just taken a great prize in the Red Sea. At the division of the spoils, each man in the crew got £1,100 apiece. Le Vasseur, along with two English pirates, seized a Portuguese treasure ship, the *Vierge du Cap* off the island of Bourbon, in April 1721. This yielded gold and silver bars, gold coins by the chestful, diamonds, pearls and silks, not to mention the jewel-encrusted regalia of the Archbishop of Goa, which included a massive gold cross studded with rubies. Every man took away 5,000 golden guineas and forty-two diamonds, whilst Le Vasseur decided to keep the archbishop's regalia. It is this treasure which is being sought at Bel Ombre, on Mahé, today.

Le Vasseur was captured by the French and hanged on Bourbon in 1730. From the scaffold he tossed a scrap of paper into the crowd (supposedly a map or cryptogram) with the taunt: "My treasure to he who can understand." De Quincy had other things to worry about than pirate ghosts, however.

In Paris, on Christmas Eve 1800, a bomb exploded in the Rue St. Nicaise, killing several people. Only seconds earlier, the carriages of Napoleon Bonaparte, First Consul of France, and his wife Josephine, had passed the spot.

Napoleon launched a hunt for the assassins, as well as a round up of known opposition members, in particular the Republicans. He was also presented with a list of 132 "despised demagogues and anarchists of the capital", considered potential dangers to him, who were sentenced to deportation. Many had earned fearsome reputations for their zeal during the Revolution.

Napoleon banished them, leaving his Minister of Marine to choose a place of exile. The colony selected was Seychelles. The *Flêche*, with some of the deportees aboard, set sail from St. Nazaire in February 1801, and the *Chiffone*, carrying the remainder, left that March, heading towards a far from warm reception in the Indian Ocean. De Quincy, already struggling to guide his colony safely through

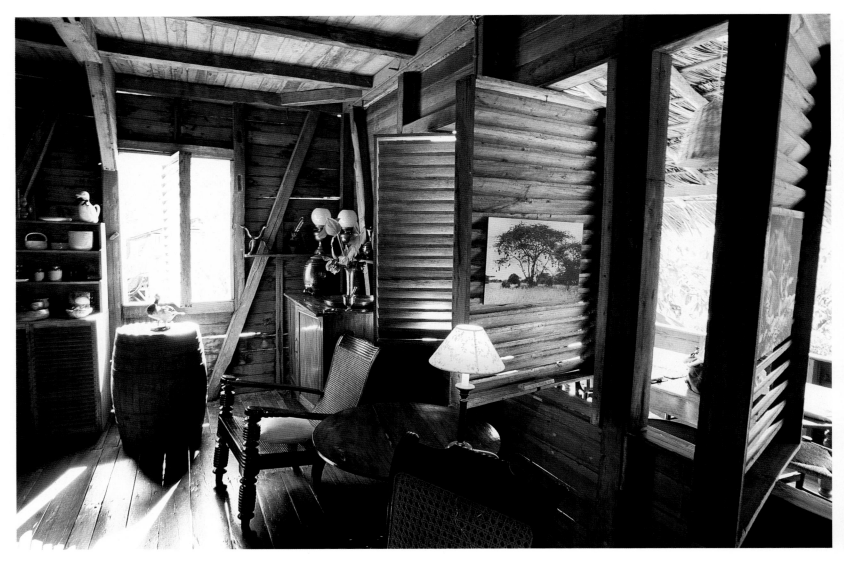

Above: Creole-style house at Anse Takamaka records the passage of past generations.

a war, must have been dismayed when he learned who was aboard the *Chiffone*. Besides other problems, the deportees meant a great many extra mouths to feed. The settlers were furious. Rumours spread that these Republicans intended to start a revolution in Seychelles, leading the slaves in revolt against their masters. Settlers panicked, making plans to leave, but de Quincy calmed their fears, and even persuaded some to take deportees into their homes.

Amongst those who offered was Volamaëffa, a freed slave from Madagascar who had inherited everything when her lover, Quienet, died. She became a wealthy woman and slave owner herself. Deportee Laurent Derville, a former cavalry officer, went to live at her home, and was visited by a friend, who returned home to *L'Etablissement* with stories of revelry and dancing among the slaves at Volamaëffa's place. This aroused the curiosity of Louis Serpholet, who set out the next Sunday to see the fun. Serpholet had a high time of it, dancing and drinking with the slaves — to the horror and scandal of the settlers. The

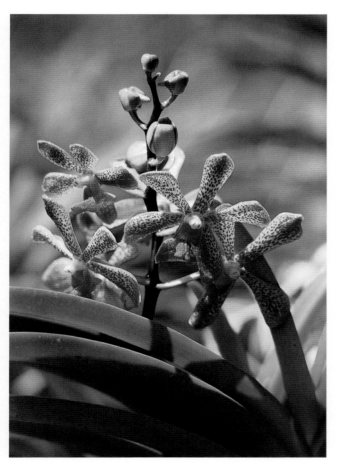

Above: Mokara Madame Pannes orchid, one of the many rare and colourful species to be cultivated in Seychelles.

affair was seen as a deliberate attempt to stir up the slaves and get them to take over the island. The nervous settlers decided that Serpholet, and four of the slaves involved — Moutons, Jolicoeur, Fernando and Etienne — should be deported to Frégate.

Settlers on the nearby Ile de France had been almost as unhappy about the arrival of the deportees as those in Seychelles. When they heard exaggerated tales of this "slave uprising", they sent a ship to Seychelles to collect the deportees, who were to be taken to Anjouan in the Comoros. An armed party quickly made arrests, and the *Bélier* set sail with its prisoners aboard, calling in at Frégate en route to collect Serpholet and the four slaves. They reached Anjouan in April and, before many months, all but eleven were dead of cholera.

It was one less worry for the beleaguered colonists of Seychelles, who were finding it hard enough to survive from day to day.

Life on island plantations was never easy, despite seeming idyllic to an outsider. In 1940, one writer declared island workers had a happy time, a free and easy life; no schools, no religion, no worries about outside affairs, cut off from the world, except for two or three visits each year by schooners.

In fact life was uncomfortable, dangerous, and lonely. Some islands had a death toll of two or three men a year. Even in quite recent times islands had few medical supplies, and infrequent visits by a doctor. The schooner's arrival was unpredictable and a sick or injured person might wait weeks for a boat to Mahé. Then they had to survive the voyage, which could take days. Often basic foods ran out, and some islands provided little in the way of fresh fruit or vegetables.

Once slavery was abolished, if a planter needed labourers, he would spread the word in Victoria through his clerks. There would be no shortage of volunteers, despite the low pay. The inducement was two to four months pay in advance, and with nothing to spend their money on, men returned to Mahé with a respectable sum in their pockets.

After passing a medical, the recruit went before a magistrate who explained terms and conditions. Contracts were for between twelve months and two years. To most of the "regulars" it was a way of life; a year or two of arduous toil and physical deprivation followed by a few months of uninhibited pleasure and idleness back on Mahé. Once the money was gone, they waited under the Clock Tower in Victoria for fresh work.

But it was not all hard times and when a schooner arrived, and the stores were filled, the men might get together around a camp fire to dance and sing and, if the manager allowed it, share a drink. There would be toddy or *kalou*, tapped from the living shoot of a palm tree. Innocuous when first collected, it ferments rapidly into a potent brew, up to eight per cent proof. *Lapire* was even stronger, and could be made out of any vegetable matter which would ferment with the addition of sugar. Since few of the outer islands grew sugar cane, *baka*,

Opposite: *Colourful painting by Mahé artist Michael Adams. His work also dominates a man-made waterfall in Mahé's plush Plantation Club.*

41 ■

Above: Expressive sculpture by Mahé-based Tom Bowers whose strong but delicate modelling has won him a place among the world's masters.

or cane wine, which was made from this, was more commonly drunk on the granite islands.

After a few sips of toddy, someone might sing one of the sentimental *romans*, traditional at weddings, and usually of French origin, or else a roundsong, rarely heard today. These men, for whom the sea was all important, knew the chants of the *pirogye*, who had to row great distances, singing to keep their strokes in time. Some were musicians playing improvised instruments. The *bob* or *bonm* is like an archer's bow, with a calabash or gourd fixed to a wooden shaft as a resonance chamber. It is played by plucking the string, varying the sound by pressing the calabash close to the stomach or moving it away. The *makalapo* is similar but the wooden bow is attached to a piece of corrugated tin, partially buried in the sand. It is held on one side by a large piece of coral, and on the other by a section of palm trunk. Sitting astride the tin, the player can produce sounds by hitting the string. The *makalapo* was supposed to summon spirits to join in the dancing.

The *zez* and *mouloumpa* have their origins in Madagascar. The *zez* has one string, attached to a baton notched at one end. Again a calabash is used as a resonance chamber. The *mouloumpa* is made from a section of bamboo, and the strings, made from bamboo bark, are strung around the outside. The player sang into this megaphone, whilst scraping the strings with a stick. There were special chants used with the *mouloumpa* which were delivered very rapidly and interspersed with gasps and grunts.

As the night wore on, and the bonfires flickered in *lakour* at the heart of the settlement, thoughts would turn to the supernatural world. *Grigri*, or local magic, practised by a sorcerer or *bonnonm* or *bonnfanm dibwa*, existed alongside the Catholic faith for many years, and there have been conflicts between the two. A *bonnonm* provides spells or potions to secure the favours of a lover, change someone's luck, ensure revenge, or influence those in authority.

Ceremonies involve unlikely ingredients, including bottles of mysterious blue water, old playing cards and coins, rusty tins filled with face powder or dried coconut, powdered herbs or pebbles. Black magic once had followers here. Two volumes entitled the *Secrets of Grand Albert* and the *Secrets of Petit Albert*, which were supposed to contain the secrets of Albert Magnus, a twelfth-century magician, were popular in France around 1800, and copies of the books found their way to Seychelles.

The best sorcerers had fearsome reputations. It was believed they could change shape and form and could kill anyone who defied them. On a less sinister note, many were custodians of herbal medicinal lore, which could mean the difference between life and death on the islands. Madagascar periwinkle was a great local cure-all. *Sitronel* was taken to settle the stomach, and *tokmarya*, in a tisane, was good for the chest and throat. *Yapana*, mixed with honey, was

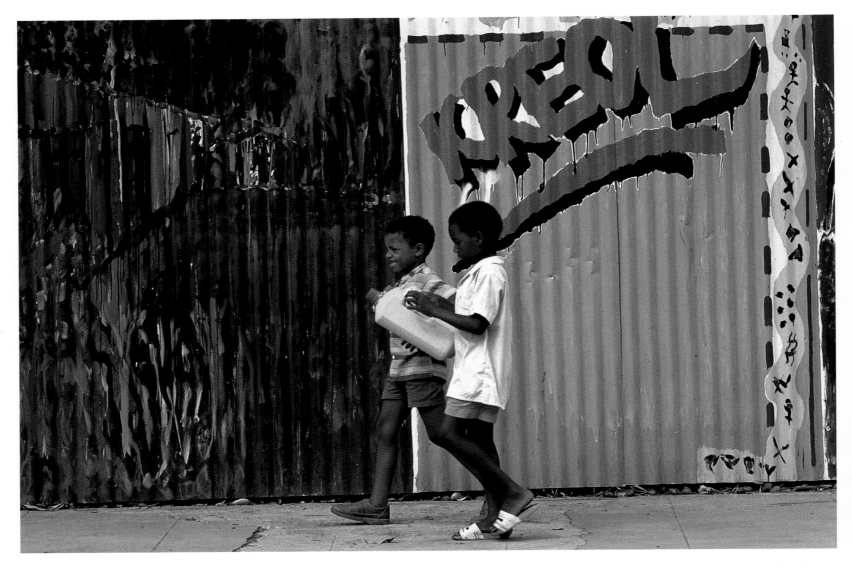

taken for coughs and chills, and for indigestion. *Papiyon* was used to treat diseases of the heart, and the bark of *bonnen kare* (barringtonia) was an antidote for the sting of the stone fish.

Other common wild plants provided eyewash, and treatments for urethritis, cystitis, and hepatitis. The flowers of datura made a treatment for asthma, and smoking the leaves had an hallucinogenic effect.

Despite their disparate lives, scattered among the 115 islands of the archipelago, the 70,000 Seychellois are today united by a unique culture. Theirs is a rich mixture of peoples drawn from around the world.

No one lived in Seychelles until the seventeenth century and development was slow for the next 200 years, then the population substantially increased as thousands of Africans, freed from slave ships, were set down on the islands by the British Navy. Joining them were a trickle of settlers, many from France and others from south-west India and the Canton region of China. The result is the

Above: Murals on corrugated-iron hoardings brighten a busy street in downtown Victoria.

Above: Tiny statue of Queen Victoria to be found in the centre of Victoria.

colourful people and Creole language which thrives today. Most Seychellois now live on the larger cultivated granitic islands, with Mahé having the most inhabitants. Together with Praslin and La Digue it accounts for ninety-nine per cent of the total population.

Seychelles is a young nation, borne out by the fact that more than half the people are under twenty-five. In Victoria, daily life is business-like with commerce continuing much as you might expect for a capital town, although the pace is never very hurried. The Seychellois are a relaxed people comfortable with their traditional lifestyle, despite modern influences.

Creole was the first great binding agent for the Seychellois. In this lively *lingua franca*, Madagascan slave could speak with French master, or to his fellow slave dragged to Seychelles from the heart of Africa. Loosely based on French, it is now also absorbing American English at a great rate.

The second bonding agent was the Roman Catholic Church. It was the faith of the planters, and although slaves arrived there with tribal religions and beliefs, they soon saw the benefits of conversion. They then took a solace in the church for its own sake. Today, some ninety per cent of Seychellois are at least nominal Roman Catholics, and the church plays an active role in both state affairs and daily doings.

Superstition is another matter. Their polyglot heritage has landed them with not one, but three or four sets of superstitions to worry about. So, they have to avoid ladders, never sweep the house after dark, encourage the lucky black cat and shoo away the turtle dove circling the eaves — a sure sign of great sorrow to come. The kestrel brings death to its roost, and dogs barking at night beneath the moon have scented the *dondosias* or *zombie*, and it is best to stay at home on Friday the thirteenth.

Almost everyone is afraid of death, but the Seychellois have a particular respect for the dead, perhaps inherited from their Madagascan forbears, who still carry out elaborate funeral rites and ceremonies. The aim is to keep evil spirits away from the dead, preventing the creation of *zombies* or *nam* (ghosts).

Traditionally, the deceased is displayed to family and friends by the light of candles, with his feet towards the sea. Those closest to him will sit up through the night around the coffin, playing cards or dominoes, and above all making as much din as possible to keep undesirable spirits away.

Like many of the old ways, these *vielles mortuairs* are rapidly being abandoned. Ten years ago you would see funeral processions winding their way towards the town, the coffin wheeled on a hand cart and followed by a long chain of mourners. Later the "pick-up" truck, bedecked with flowers, took over from the cart. Today there are the shiny black hearses found at funerals anywhere in the world.

Turning to happier times, weddings are more carefree affairs, all the more so

■ 44

Opposite: Traditional plantation house on the island of La Digue. Fourth-largest of the central islands of Seychelles, La Digue lies across the channel from Praslin.

since many Seychellois do not consider getting married until they have enough money to have a really spectacular wedding. Couples who have been together for thirty or forty years may suddenly decide that it is time for a truly memorable knees-up, and no expense is spared. The fun of dressing up, the solemnity of the church service is one thing, but the food and drink and the tipsy aftermath are equally important.

The traditional centrepiece of the wedding breakfast is the meat of a giant tortoise, which would have been given to the bride when she was a little girl as a hatchling, and lived its life with this potential doom hanging over it. This dish, in a more conservation-minded age, is not now so favoured. Another traditional dish, also forbidden fruit today, is turtle meat, once considered a great treat.

Wine and beer flow freely, so that when the entertainment begins, everyone is in the right mood; which is just as well, because the guests *are* the entertainment. Jollied along by a confident maitre d', aged aunts stand up to

Above: One of Seychelles many cherished national monuments — the Cappucin Seminary, built in Portuguese-style in 1933, next to the Cathedral of the Immaculate Conception.

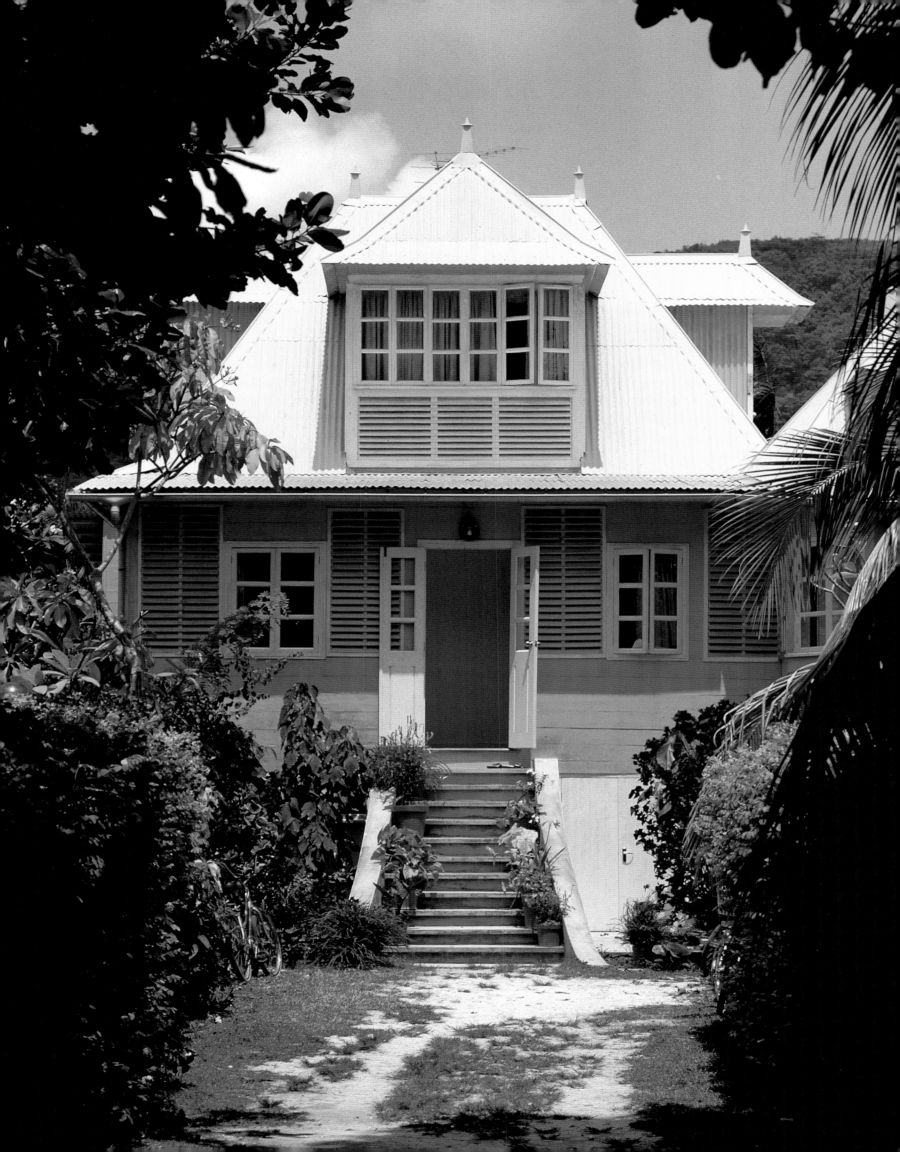

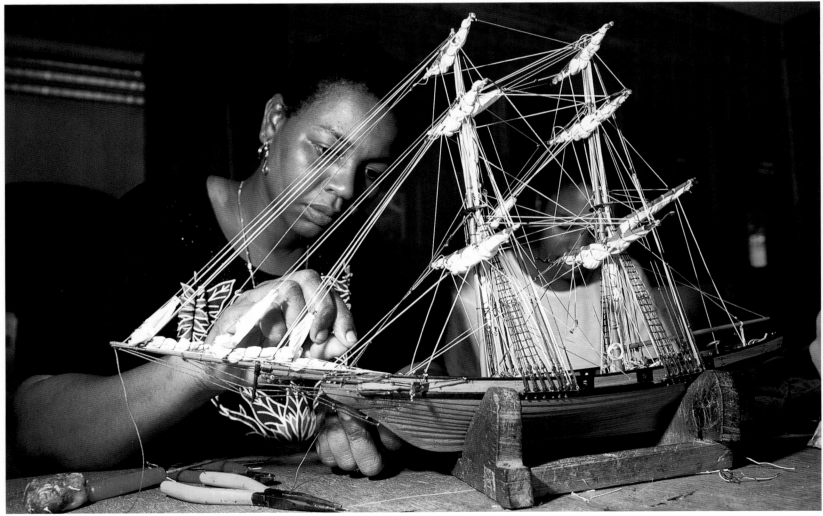

Opposite: Traditional settler furniture reflects solid values of the plantation elite which commissioned them.

47 ■

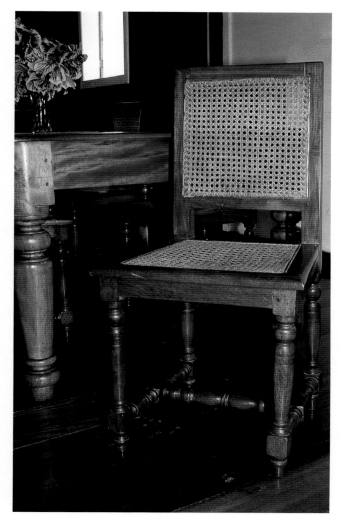

Above: Antique chair survives the centuries in an old settler house on Mahé.

Opposite: Hours of painstaking work go into the production of these beautifully handcrafted model schooners.

warble *Ave Maria* (there are always three or four renditions of this), young men make cheeky speeches, old men sing the sad *romans*, and make everyone cry a little. There may even be one outburst of *My Way*. Few escape the eagle eye of the compere, and avoid performing a speech, a song, an anecdote or even a dance before a well-disposed audience. Then the band, be it two guitars and a drum kit, or fiddles, accordion, and triangles, strike up the old favourite *Serenade* and bride and groom lead their laughing guests through the *Sale Vert*, an archway made of palm leaves and decorated with bougainvillea and frangipani.

Not all customs are a sad loss. Newly-weds in Seychelles cannot mourn the passing of the *levers de chambre*, a visit from the rest of the family early next day to check that all went well the night before. Even worse, in past times the whole wedding party reconvened eight days later, expecting to carry on the frolics and feasting where they left off.

No wedding would be complete without dancing. These days, the music will probably come from electric guitars and keyboards, but most of the tunes will have the lilting beat of the *sega*, the dance you will see performed in hotel floor shows, which found its way here in relatively recent times from Mauritius. The dance step itself looks very easy — a sort of sideways shuffle on the ball of the foot, as if one were crushing a cockroach, but it is strangely difficult to do properly. Once you have the knack, however, and can combine it with a suitably sexy sway and jerk to the hips, all you have to do is put your arms in the air, circle your partner and smile.

The collection of dances known as the *kamtole* are a different matter. Some are complicated enough to warrant the services of a *komander*, who barks out instructions to you in a monotone above the cheery din of the band with its violins, banjos, triangles, drums and accordions. These are robust country dances, home-grown versions of more elegant posturings seen in Europe and brought home. There are polkas, waltzes, Scottish jigs and other formation dances. A good time will be had by all, but it is hot work in the tropics.

The *moutya*, oldest of all the traditional dances, does not have this uncomplicated sense of fun. The dance has dark undertones and, even when performed today on a public stage or hotel lounge, it seems to speak eloquently of past times, when slaves would gather around bonfires in secluded clearings in the forest, and enjoy this secret, illicit pleasure. For decades, church and government tried to suppress the *moutya*; British colonial officers having, as might be expected, a particular horror of its so-called licentiousness. Even today, real *moutyas* have a secretive mood about them, as though they are not quite the place for outsiders.

Today, many Seychellois awake in comfortable bungalows, commute to air-conditioned offices, and lunch on a takeaway and a bottle of Coke. Chances are

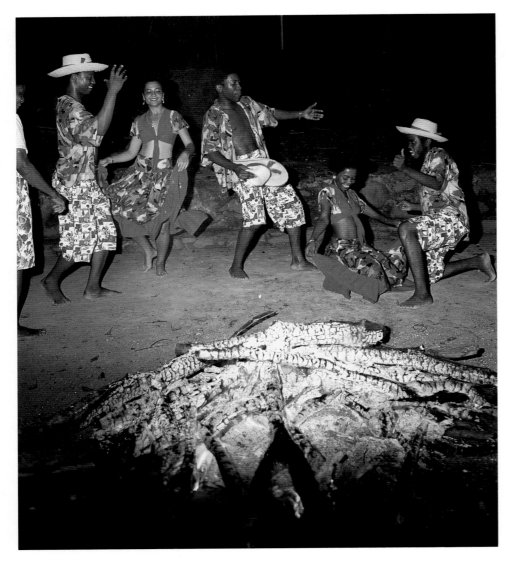

Opposite: Dancers wearing vibrantly coloured traditional costumes perform the moutya *around a bonfire on Round Island.*

that they will be going home to a dinner of fish, however. This remains the local staple, and as you would expect, the sea and its produce still plays a large part in the lives of many. The shop and office workers usually rely on Victoria's fish market, but you can still see huddles of locals gathered around piles of fish still wet from the sea, lying on a beach just feet from the *pirogs* from which they were caught.

Many homes are still surrounded by small gardens in which chickens scratch around the breadfruit, mango and pawpaw trees or look for pickings beneath the cassava and banana plants. In another corner there will be a sharpened stick rammed firmly into the ground, on which the husk can be peeled off coconuts, and on the shady porch, grandmother might sit astride the coconut stool, patiently grating out the coconut flesh using the blade on the end of it, to make coconut milk, or coconut nougat.

Extended families are still the norm in Seychelles, and are very much the

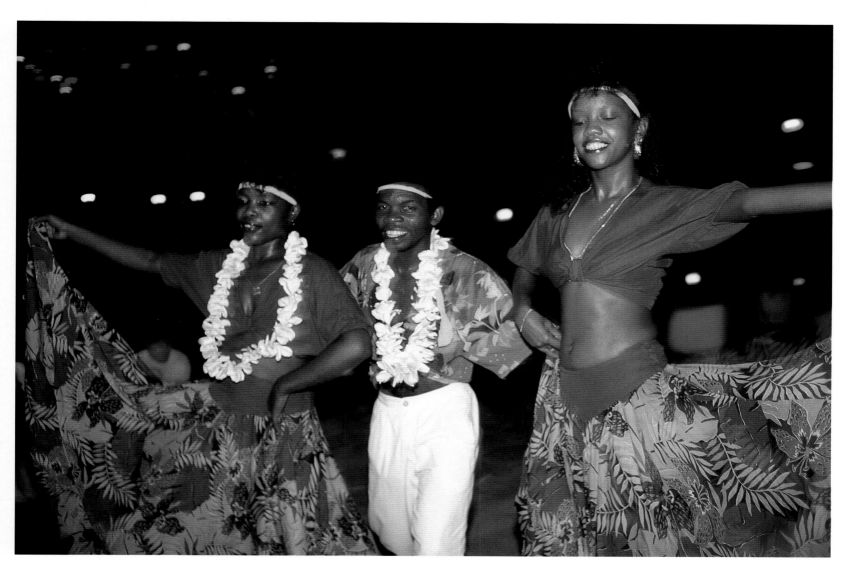

Above: Smiling trio demonstrate the tricky steps of the Seychelles traditional sega *dance.*

responsibility of the womenfolk. Relationships being casual in many cases, the men wander. The women keep the children, often going out to work leaving grandmother to care for them. Sometimes, when a man reaches a stage of life when he is tired, lonely and ready to settle, he returns to a former love and ends his days in comfort and companionship, past wrongs being forgotten with time.

At weekends he may do a little fishing with his friends, laying wickerwork fish traps on the sea bed, or bobbing for hours in a small boat with a handline, drinking beers and telling tall tales. In the mackerel season, they may team up with other boats to lay the long seine nets into which the fish are herded. Younger men wade over the reefs with sharpened sticks, on the look out for octopus, or go scrambling over rocks at night, looking for crabs by torchlight.

For the womenfolk, the highlight of the week is Sunday morning mass. The words and ritual are reassuring and much-loved, but the occasion is also an opportunity to dress up in best clothes, often home made with great care and

skill, and to wear their charming broad-brimmed straw hats with trimmings of ribbon and flowers. The children go too, the boys smartly dressed in long sleeved white shirts and dickie bow ties and the girls in frothy, lacy party dresses bedecked in lace, bows and ribbons.

On gala days there may be a trip to the beach to dig for *tectecs* to put in the soup for tea, or for a picnic involving all the neighbours, everyone piling into the back of an open truck for the hazardous but hilarious drive over the hills to Grand Anse or Anse à la Mouche. When the sun goes down, the islands are redolent with the smell of frying garlic and grilling fish. Through the open shutters of the ramshackle tin house, or the louvres of the new bungalow, you can see the glimmer of the television or hear the blare of the radio. Just as in homes all over the world, the people of Seychelles prepare for another week.

Lively and colourful, this emergent nation is still evolving, learning to live with its legacy of African, Asian and European influences and embracing a high-tech future. The phlegmatic nature of the people is certain to be a key factor in the development of Seychelles' self-determination.

Before the international airport was built, reaching Seychelles was an adventure in itself. Most people came by steamboat via Bombay or Mombasa, but from 1944, a BOAC four-engine flying boat, the *Golden Hind*, flew regularly from Durban refuelling en route to Sri Lanka.

When the war ended, the service was withdrawn and an attempt by East African Airways to replace it in 1953 was abandoned after just one trial run. Pan Am were next with a Grumman Albatross amphibian which, for seven years from 1963, made a weekly flight to service the American satellite tracking station on Mahé.

In the run-up to independence, the British commissioned the Costain-Blankevoort group to build an international airport at Pointe Larue. They began work in January 1969, reclaiming land from the sea using rocks blasted from South-East Island. By May 1970, the runway was partially completed and twice-weekly flights from Mombasa began.

On the first flight there were just five fare-paying passengers aboard a Piper Navajo. They had flown the two-day trip via the Comoros and Madagascar. With good winds, the overnight stop at Diego Suarez could be omitted, reducing the trip to a single day. But the pilot had to be certain he could make it. It was Mahé or bust and each plane was required to have two pilots and a very large life raft.

This was not the only problem. The Navajos had no toilet. It was not unusual for passengers, on arrival, to dash for the nearest bush after the six-hour flight. One VIP was so desperate he ignored the governor's welcoming delegation and ran straight for the trees. It must have been a relief, in more ways than one, when large airliners finally took over the route.

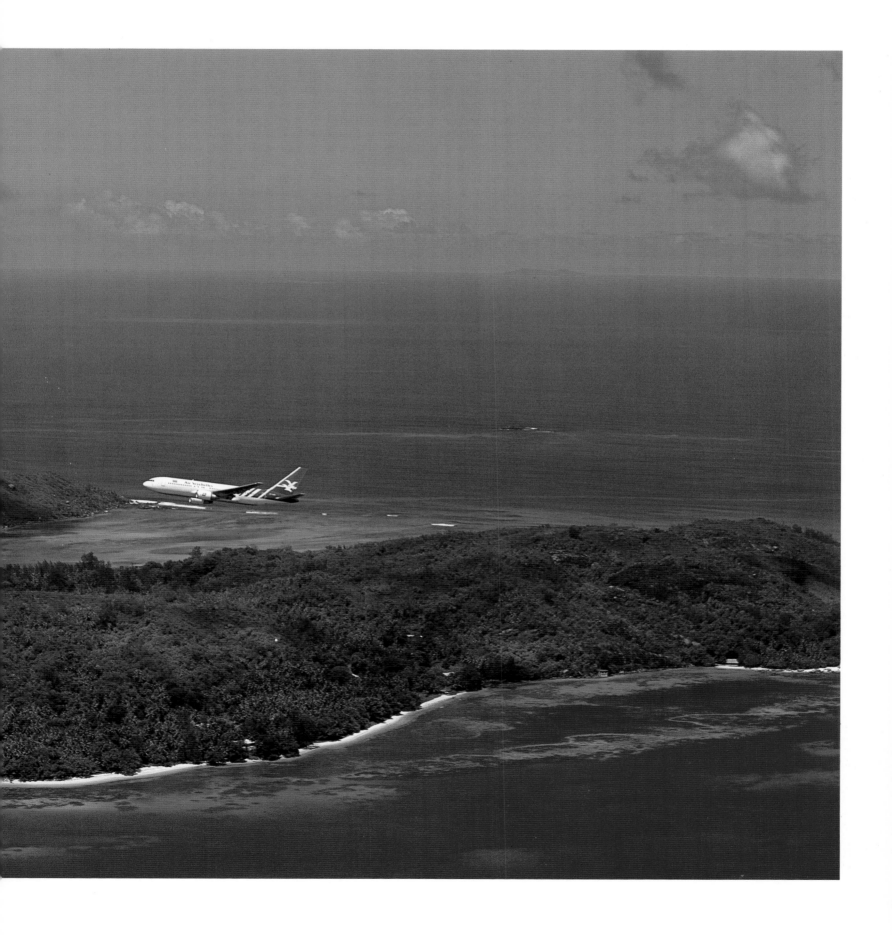

LOST WORLD OF LEMURIA

As you sail towards Seychelles, the rim of islands may often be seen from some way off where a tidal race creates a white line of choppy waves as the great ocean depths rise up to greet this subterranean microcontinent. The granite islands and the two volcanic syenite islands of Silhouette and North were united as one landmass as recently as 10,000 years ago, at the end of the last ice age. Since then, sea levels have risen and the land between Mahé, Praslin and their satellites has become submerged.

Before this, Seychelles was part of the legendary land of Lemuria, the lost continent. Where dolphin now leap and dive, where shoals of reef fish swim among forests of fan corals, once ancient palm forests grew down the hillside to the beach; a beach that never bore the imprint of human footsteps.

An English zoologist, Philip Sclater, suggested that Lemuria broke off as one fragment from Pangaea. The land took its name from the lemur, a small mammal now native only to Madagascar but which was also found in Africa, India and Malaya. Sclater proved that the only way to explain this distribution was the existence of a land bridge which once linked these far-flung lands.

The Lemurian theory gained popular acceptance and was even described as "man's primeval home", but if this was so, then mankind had long deserted the region that was to become Seychelles. For when the first explorers touched on these Lemurian shores they found them empty, desolate and forgotten.

In 1893, botanical artist Marianne North wrote: "I landed in Mahé at daybreak. The lovely bay is surrounded by islands, Mahé encircling two sides of it, the mountains rising nearly 3,000 feet above it. The coca-nuts mounted higher than I ever saw them do before On the top of all are fine granite cliffs . . . broken up and scattered amongst the green."

Seventy years later, biologist Tony Beamish recalled: "The morning sun now lit up the steep green slopes tumbling to the sea. Coconut palms lined the rocky shore and above them, breaking the canopy of green, giant granite boulders hung precariously . . . We were now entering the harbour of Victoria . . . I thought then and believe still that it is the most beautiful in the world."

As Tony Beamish and Marianne North suggest, the most breathtaking way to discover Mahé, is to sail slowly towards it out of the dawn, having made the long journey across a thousand miles of ocean. Only then is this jewel truly established in its setting. The grey-brown granite juts proudly skyward in dramatic 3,000-foot cliffs. Ravines plunge into emerald forest, a hard nape of rock glimpsed occasionally through the verdant mantle. The summit, Morne Seychellois, is usually lost in heavy clouds.

There are the ancient mist forests. Trees found nowhere else grow in this secret place where clouds brush the hills and all is still save the drip of rainwater from the leaves and mosses. It is dark among the trees with their twisted limbs. Stately tree ferns, in turn festooned with smaller ferns, grow side

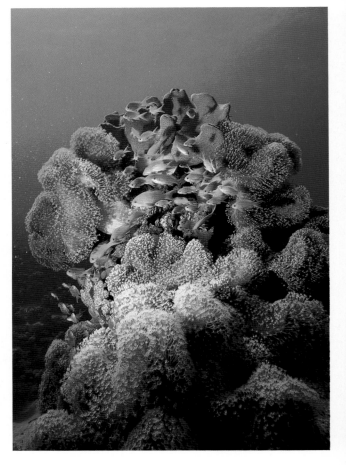

Above: Colourful fish dart through a leather coral garden.

Opposite: Pleasure craft anchored in St. Anne Marine National Park off Moyenne Island, home of former newspaper man and latter-day Robinson Crusoe, Brendon Grimshaw.

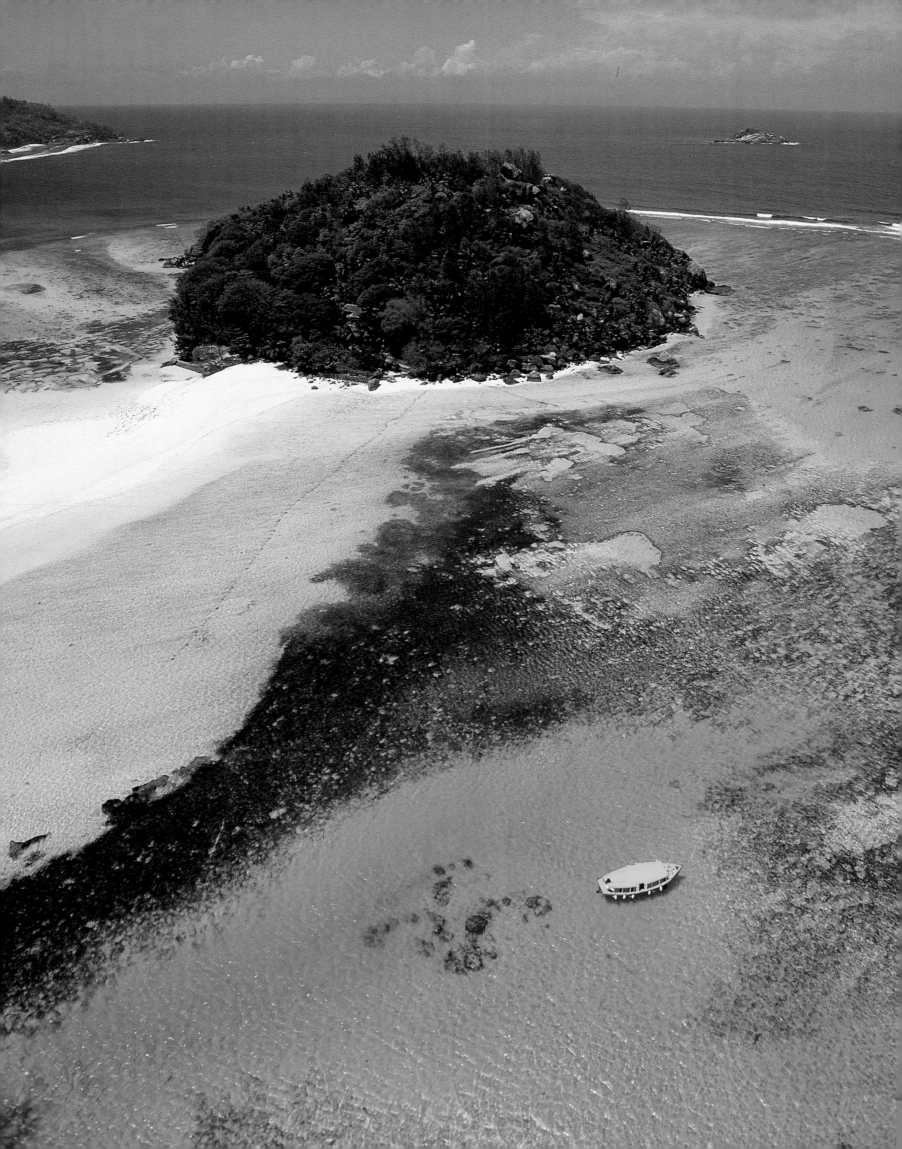

Overleaf: Coconut palms flourish in an abandoned plantation. Until the early 1980s copra was Seychelles' most important export.

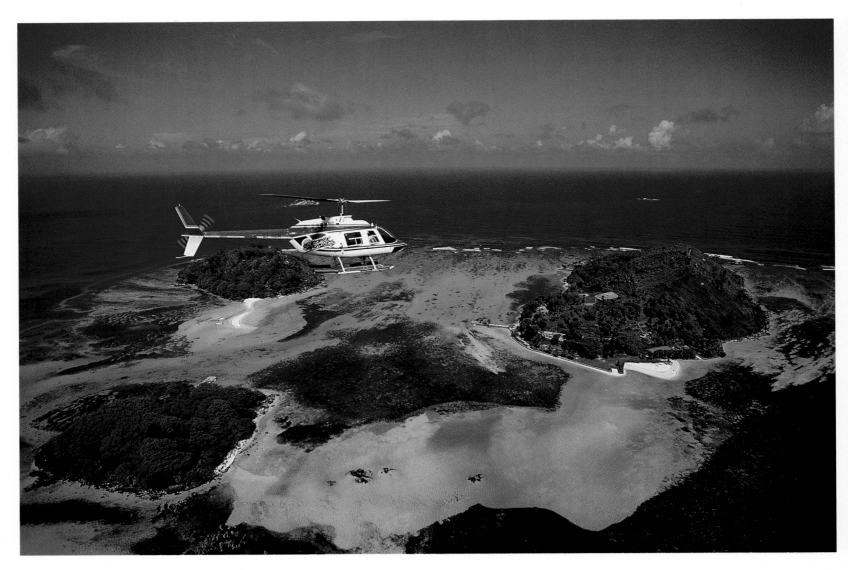

Above: Helicopter above St. Anne Marine National Park frames Moyenne Island with Round Island at left and Long Island at right.

by side with creepers and orchids. Everything is draped with a cloak of moss which greedily soaks up the rain and redistributes it.

As night falls, the silence is broken by the Seychelles bare-legged Scops owl emerging to hunt. No nest has ever been discovered. Its strange call is said to sound like a man sawing wood, and gives the bird its local name, *syer*, meaning woodcutter. Of all the native birds of the Indian Ocean, this is the only one to have its nearest relative in Australasia. It is believed to have affinities with the Moluccan Scops owl, which has a similar eerie cry.

After the oppressive gloom of the mist forests, the open glades of their hillside counterparts come as a relief. It was there that Jourdain's "many trees of 60 to 70 feete, without sprigge . . . very bigge and straight as an arrowe" grew. Even Morphey had to admit that the timber "was an object of consideration".

This search for wood was just the beginning of the devastation wreaked on Mahé's intermediate forests. Hardly any survive intact. Only their remoteness

Opposite: Joyful dolphin frolics in the deep waters of the Indian Ocean that separate the islands of Seychelles.

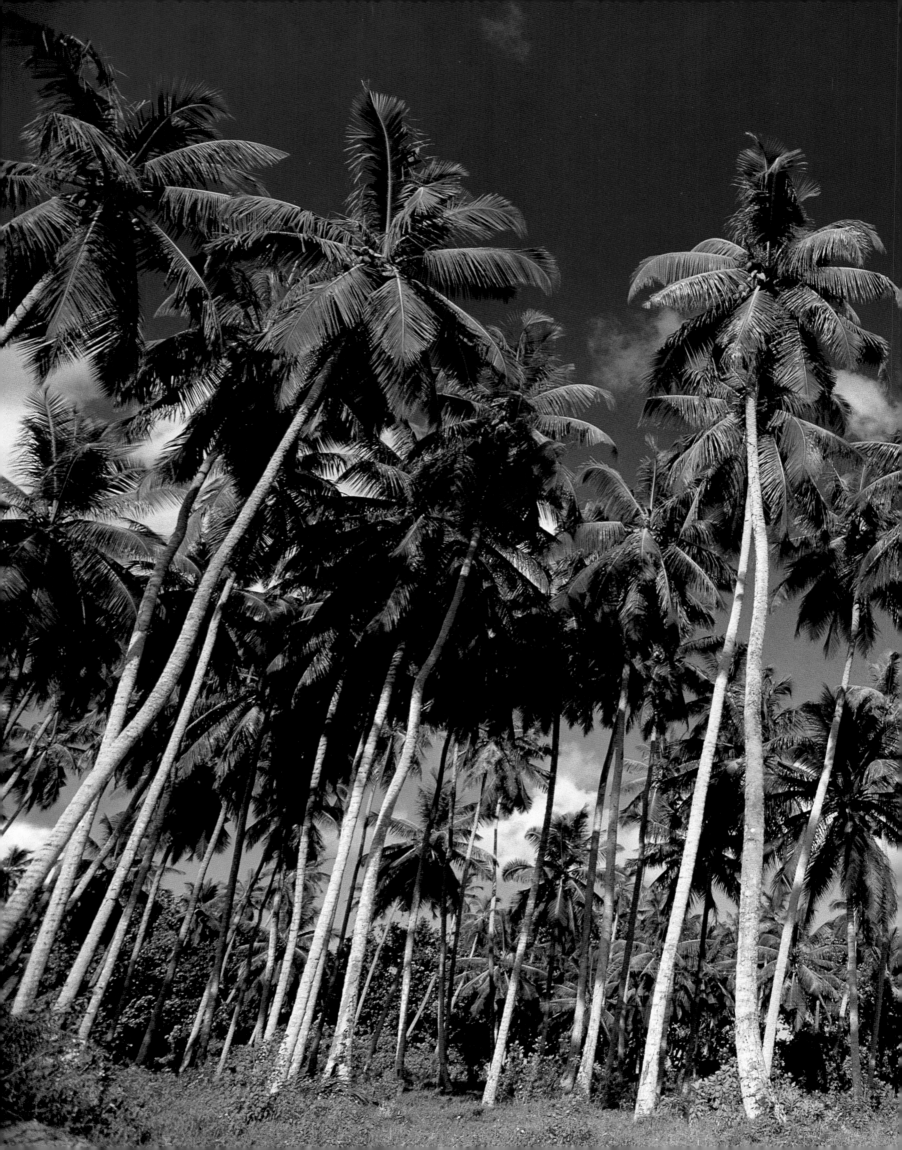

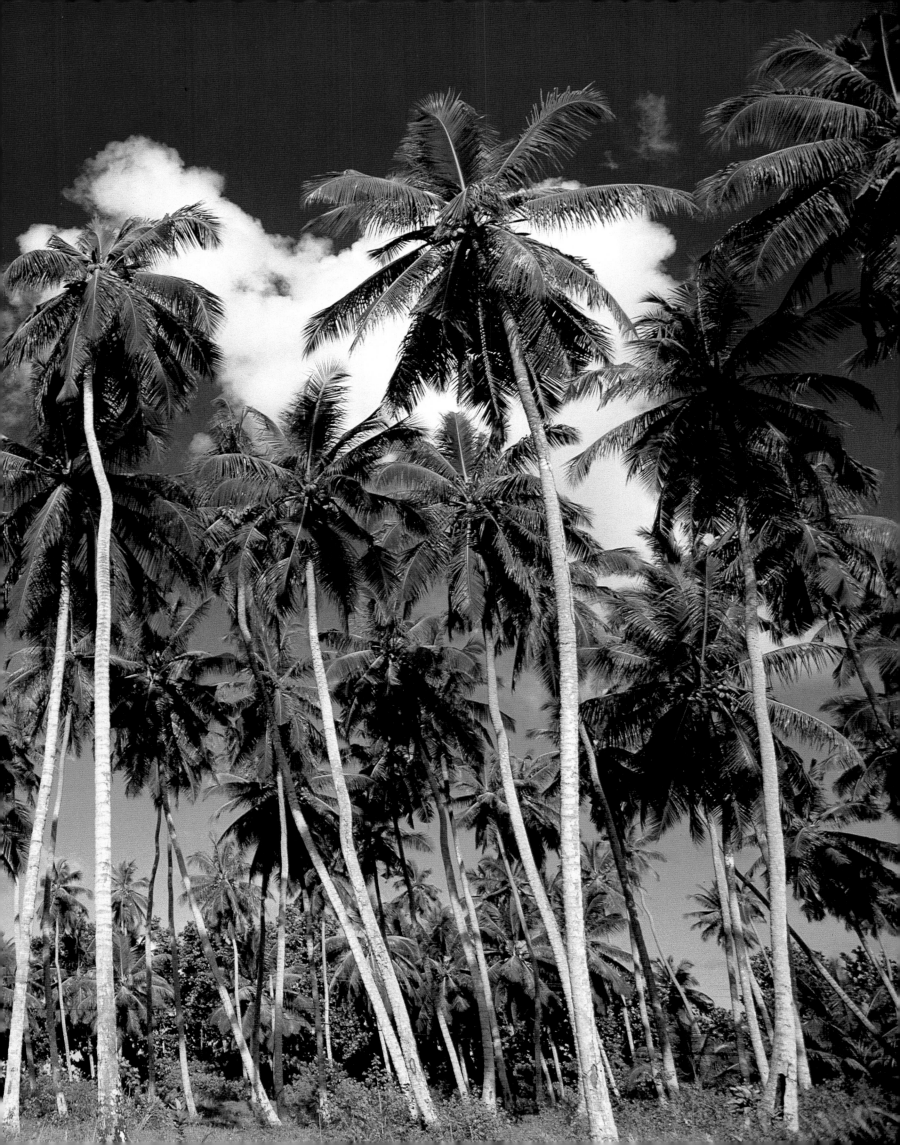

Above left: Sun-dappled glade in one of Mahé's mahogany plantations. Above: Heavy-laden banana tree on the slopes of a Mahé hillside.

saved the remnants of the mist forest on Mahé, and the mountain forests of Silhouette. Lost forever were the well spaced *kapisen*, and *bwa rouz*. They provided excellent timber, as did the *bwa d'nat* and *bwa d'fer*. Only sad, stunted specimens remain. In the ravines, screwpines such as *vakwa parasol* and *vakwa maron* cluster with pompoms of leathery, strap-like leaves and long, stilt roots, investigate the steep slopes in search of soil and water on the cliff ledges.

Amongst the forest interlopers, is the albizia, whose great umbrella tops can be seen marching up the valleys, and orderly ranks of straight-trunked mahogany plantations now cover entire hillsides. The silver bark of *kalis* (white cedar) shines in the dim light, its frail pink flowers scattered on the woodland floor. The sturdy buttress roots of sangdragons snake outwards to form natural stairways and convenient ledges for ferns and tiny native begonias.

A common sight is the delicate cinnamon tree, which has spread as high as Mahé's tallest peaks and as far down as sea level. This versatile species is most striking when covered in bouquets of starry white flowers, or when the new growth of glossy, spear-like leaves flush crimson and copper at the tips of the branches. It also produces purple berries, much favoured by Indian mynahs and Seychelles bulbuls.

Cinnamon quills, sold in Victoria's market, are made by beating the tree trunk then peeling off thin strips of bark. Oil is distilled from the leaves. Seychelles' cinnamon industry reached its peak in the early twentieth century. By the outbreak of World War 1, distillation of cinnamon oil had become very important. In 1940, seventy-one tons of essential oils were exported, and distilleries were dotted around Mahé. To meet demand, trees were coppiced and allowed to spread. To Pierre Poivre it would have been the pinnacle of achievement. Sadly for him it came 200 years too late.

Today, clove and nutmeg trees are not often seen in Seychelles and pepper is no longer commercially grown, but it would have done Poivre's heart good to see the flaming scarlet leaves of his cinnamon trees burning bright in the darkness of the forests of Mahé. The takamaka (Alexandrian laurel) leans out over the beaches, offering its kindly shade, and the *badamnyen* or Indian almond grows readily on undisturbed coastlines, all its leaves turning red as the rains approach, while feathery casuarina (filao) pines make a mournful wailing in the sea breezes, but these shore species are common to most tropical islands.

The pleasant coast forest of *bwa d'tab* (looking glass tree), *bwa-d-ponm*, *bwa zon* (alstonia), and *gayak* (instia), which Morphey described, is now gone.

Today the coast is the most heavily populated area on Mahé, Praslin and La Digue. Gardens around the houses are vibrant with hibiscus, frangipani and bougainvillea, shaded by useful fruit trees such as mango, breadfruit, jackfruit, orange, guava and jamalac. Amongst the takamaka and palms of the shoreline, the shy yellow blooms of the *bwa-d-roz* blush from pink to deepest maroon as the day goes by.

The mangrove swamp, also a feature of Seychelles' coastline, is not so attractive, but it is vital for the ecosystem of the islands that these swamps survive. They filter out and trap silt from the rivers, form new land, and act as a nursery for many species of fish and marine molluscs. A sizable area of mangrove swamp survives at Port Glaud on Mahé.

Modern Lemuria is a happy blend of ancient and modern. Fortunately for Seychelles, isolation has guaranteed the preservation of most unique species. Although some habitats have changed or vanished completely, at least the wholesale devastation found on many Indian Ocean islands, where the hillsides were stripped bare of forest, did not occur here, despite Duchemin's efforts, and each island has its secrets and surprises awaiting discovery.

The conical mountain of St. Anne rises over 250 metres, and looks volcanic. Slopes are forested, and the flat plain below thickly planted with coconut groves. The island has a "lived in" look, scattered as it is with mementos of other times. Hangard, who leased the island after du Barré's settlement failed, reared sheep, goats and chickens which he sold to visiting ships. In the west, near the shore, are the ruins of a processing plant run by the St. Abbs Whaling

Above: Palm spider weaves a glistening web in the early morning sun.

Opposite: Emblematic flower of the tropics, the coral-red bloom of the hibiscus is short-lived, appearing only for a day at a time. Opposite right: Delicate white flower of the frangipani fills the tropical air with its mesmerising fragrance.

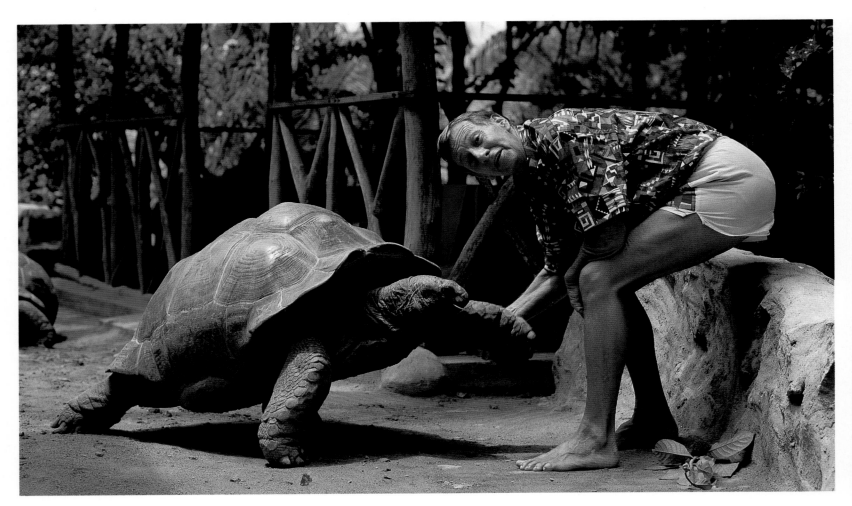

company, which opened in 1832 to service a nineteenth century fleet based there. Now, happily, the Indian Ocean is a whale sanctuary.

The high, round tanks of a fuel depot peep incongruously through the palms, for St. Anne was a Second World War refuelling base for the Royal Navy, and rusting pipelines still occur unexpectedly in the undergrowth.

Nearby Moyenne has no such scars. This eight-hectare (22-acre) kingdom belongs to one man, an ex-journalist who has lived there since the early 1970s. Brendon Grimshaw's island is reputed to be the most haunted in Seychelles, and not all the ghosts are benign. Pirates are said to keep vigil on the spot where their treasure is buried. Once, in a dream, a girl from Mahé had a vision of the treasure and told Brendon where to dig. No sooner had he picked up a spade than two large coconuts fell within a whisker of him. It was warning enough and from then he left well alone. The other ghosts content themselves with "banging on windows and doors, shaking beds" and making a nightly tramp from the cemetery to the old plantation house.

The island's rocky slopes are pleasantly wooded with many trees and shrubs being planted by Brendon, who brought endangered species from other islands,

Above: Retired journalist Brendon Grimshaw greets Derek, oldest of the many giant land tortoises that roam Moyenne, his island home off Mahé.

Above: Travel Services Seychelles run a regular service on the boat La Creole *through St. Anne Marine National Park and to Praslin.*

to give them refuge. It is also a sanctuary for the owner, who enjoys the island in solitude every Sunday, when it is closed to tourists.

Moyenne seems to have been a happy place for its owners. In 1850, Melidor Louange married his sixteen-year-old bride, Julie, and was given the island, probably by one of their fathers. They lived there for forty-two years, then sold it for 301 rupees to wealthy Alfred de Charmoy, who lit his cigars with ten rupee notes. From 1899 until 1915 Emma Wardlow Best, an eccentric spinster from Berkshire, lived there with a posse of dogs. A great animal lover, she would not even allow rats to be killed on the island, and built a House of Dogs, which still stands, as a home for strays which were brought to her from Mahé.

Round Island is a tiny dot of rock rising just twenty-four metres above the sea. The path around the island, which can be walked in a matter of minutes, is silent on many days, except for the monotonous cooing of ground doves beneath the magnificent scarlet-flowering flamboyants. This was once an isolation centre for lepers, but now it enjoys a happier reputation as a Mecca for lovers of Creole food, having an excellent restaurant.

Cerf Island, like her sisters — St. Anne, Long, Moyenne and South-East —

was named by Morphey. He called Round Island, Petite, and this is the only one in the group to have changed names, except for Mahé. Cerf is just three miles from Mahé and, because of its good fresh water and pleasant beaches, is well populated — though not overcrowded. Currently, forty people live there, many of whom commute to Mahé.

It is a sleepy island with gentle hills covered with trees. On the east coast there is a charming Creole restaurant, two tiny churches (now disused) and a tribe of wandering giant land tortoises. Sheltered by the other islands, the sea laps sluggishly at the shores, and tiny silver fish dart about in the dappled sunshine which sparks off the ripples. The island has seen more violent times, however. Due to its strategic position overlooking the port, it was always considered necessary to fortify Cerf. One of the first advisors to visit, in 1787, suggested a battery of four eighteen-pound guns and two mortars on the western side, and a redoubt at the summit. During the Napoleonic Wars, when English frigates attacked the harbour, the governor had a battery on Cerf Island, along with others on St. Anne and at Point Conan. The gunfire from Cerf was such a hindrance to the English that they made a night raid on the island seizing the battery and spiking the guns.

In its past the island was developed as a plantation, but more importantly was one of the earliest sanctuaries for the giant land tortoise. Although thousands still survive on remote Aldabra, the granite islands had two distinct species of their own, Marion's tortoise, and Arnold's tortoise. Both are now extinct. Sadly they were, as the English discovered in 1609, "good meate, as good as fresh beefe", and were hunted remorselessly.

In 1787 it was estimated that 13,000 had been taken by passing ships in four years. The *Petits Bons Amis* alone took 4,000 in two trips. Rats and cats introduced accidentally also took their toll of the young. It was decided that if there were to be supplies of their meat in the future, all tortoises on the main island would have to be collected and put in protected "depots"; one on St. Anne, the other on Cerf. They would be guarded day and night, and the islands planted with vacoas, bananas and other food plants, yet despite these efforts, the tortoises became extinct.

Long Island has always been a place of involuntary isolation. It is the least forested island of inner Seychelles today and has become the nation's prison island. Formerly it was a quarantine station. One visitor forced to stay on Long Island was Marianne North. She was put into quarantine whilst awaiting the arrival of her ship because thirteen people died of smallpox in the colony during January 1883.

At first all was idyllic, and she painted continually for ten days, enjoying the marvellous views. Then she began to fear that her three fellow exiles were trying to trick, rob or even murder her. "God knows the truth" she wrote later.

Opposite: Glass-bottom boat cruises the waters of St. Anne Marine National Park offshore from Moyenne Island.

Opposite: Flowering flamboyant, Round Island jetty and neighbouring Moyenne Island in St. Anne Marine National Park.

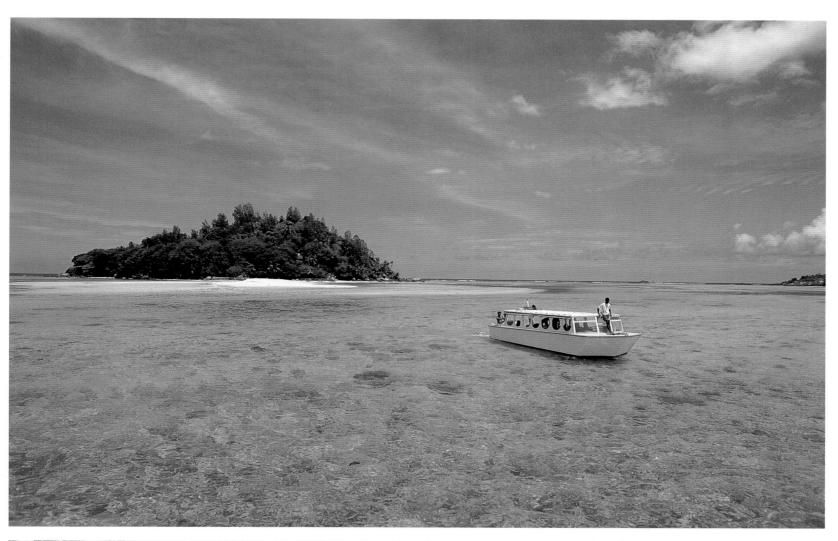

Above: Cheerful windsurfer enjoys a moment of relaxation in the azure waters of the Indian Ocean.

"Doctors say my nerves broke down from insufficient food and overwork in such a climate." She had all her money, £200, stitched into her clothes, and for two days and nights kept her door and windows barricaded.

Long Island became a holiday resort in the 1940s, since it was only used for quarantine once or twice a year.

Anonyme used to belong to an Englishman, and was used as a quarantine station in emergencies, even though water had to be brought the half-mile across from Mahé. Malavois, writing in 1787, had no time for the place. It had sandy beaches, he admitted, but little else; no height, no trees to speak of, no water, no good soil, no turtles, no tortoises There were even very few coconut palms. The only use he could think of for it was the "refreshment" of slaves recently arrived on ships en route for the Ile de France.

Mahé's other close attendants lie off the western coast. Ile aux Vaches is an almost bare dome of rock, bleached white by the sun or guano from nesting sea birds. Roseate terns used to breed there. Today the islet, in the bay of Grand Anse, is almost barren. Its name comes from the French term for dugongs, *vache-marine*. A chart of 1780 notes the presence of "seals" on Seychelles, but this seems unlikely since they inhabit colder water. Dugongs live in warm water, occurring in the Red Sea and elsewhere in the Indian Ocean. They are entirely aquatic yet Duchemin clearly states that a group of twenty *vache-marine* were seen basking on Mamelles.

His officers killed them all. Duchemin tried to preserve their "very beautiful" skins, but succeeded only in extracting a lot of oil, which was good for cooking. It is true that dugongs have a thick layer of blubber, but their rough skin could

Above: Elegant catamaran moored at Curieuse Island.

hardly be described as "beautiful". It remains a mystery and, whatever they were, they are now extinct in Seychelles.

In recent years, Thérèse has become popular as a watersports centre, with beautiful beaches for picnics, swimming and snorkeling. The more adventurous can dive off the island. Although the corals are somewhat damaged, there is much marine life.

The island witnessed only one dramatic event in its history. In 1805 an English frigate seized a slave ship, the *Courier des Seychelles*, off Thérèse, but found no evidence of a human cargo. The 200 slaves had been taken off and hidden on the island by her captain as soon as the navy approached. The English were furious at being unable to track them down.

Conception, just one kilometre away, does not even have that ripple in its peaceful history, perhaps because of the difficulties of landing there. Once it was home to a great many tortoises, but like the others they were hunted out. Ironically, Captain Glaud, after whom the bay opposite is named, was largely responsible for the devastation. He systematically took tortoises from Thérèse and Conception despite protests from du Barré.

Many of the tiny islands in Mahé's entourage have watched history slip by, for the focus of events was on "the big island", and in particular the settlement built on the bay beneath Morphey's possession stone — the seed from which would grow into the capital of Seychelles — Victoria.

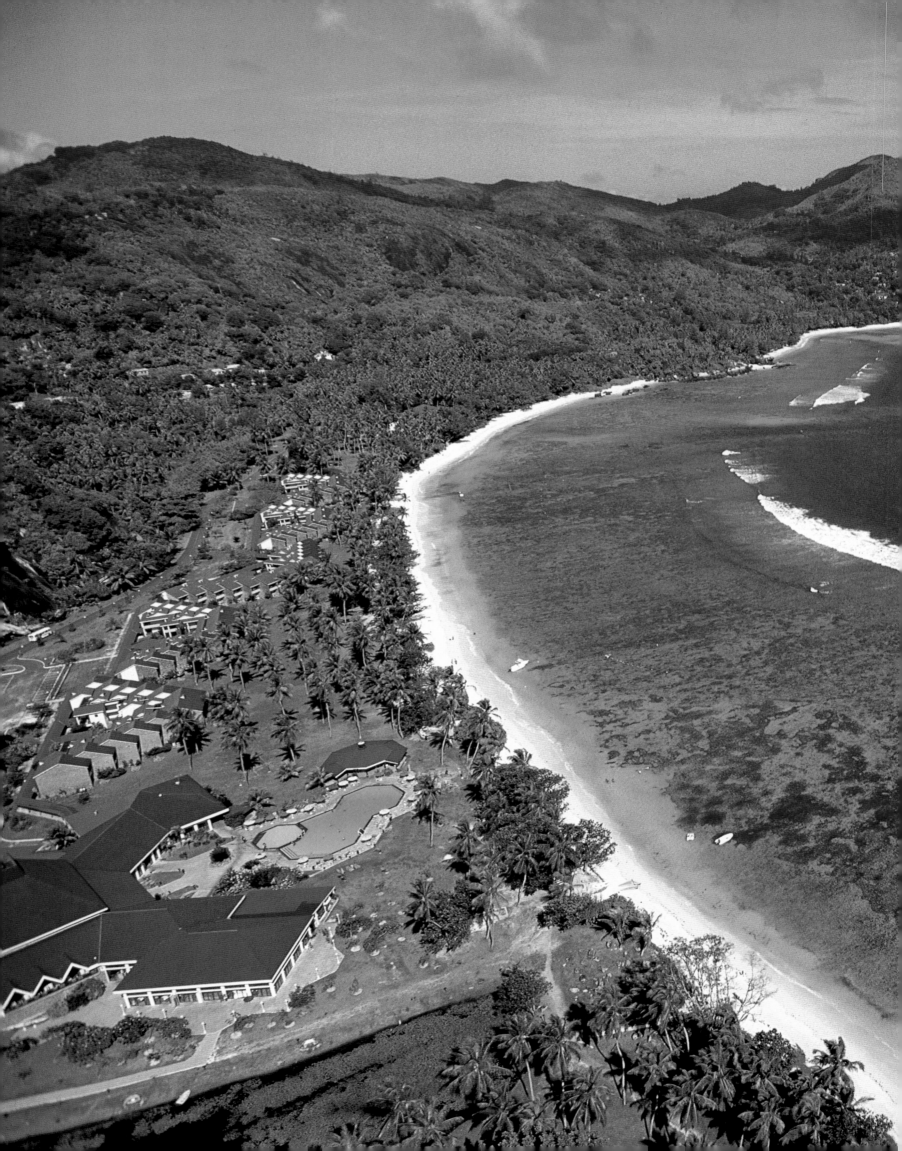

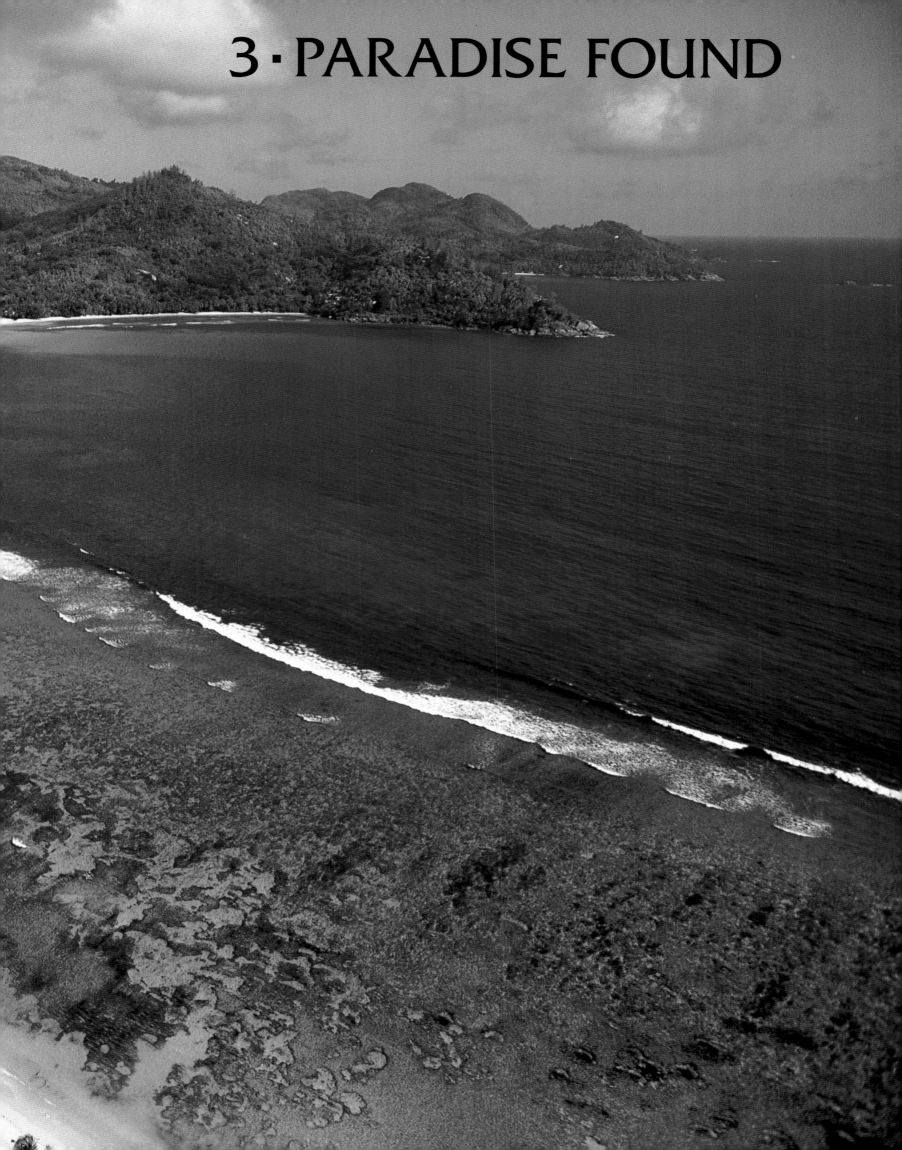

3 · PARADISE FOUND

As the first pale blush of dawn touches the east coast of Mahé, the sun dapples the sheltered waters of the port with a golden mantle, and the casuarinas of the reclaimed land are honeyed in the light. Receding shadows draw back from the dark forest slopes, and trees stand out shining silver, yellow or red.

Mynahs have been chattering since first light, searching for food, revealing their presence with a flash of white and a squawk from their yellow bills. Stately cattle egrets and grey herons strut in the man-made lagoons, where the sea lies trapped behind the new land, and scarlet cardinals are busy in the casuarinas, nipping off the long grey-green needle leaves to weave into their nests.

This spit of land, known locally as the *Konblaz*, has only existed for a handful of years. Dutch dredgers sucked up coral rubble from beneath the sea and neatly filled in the shallow curves of the coast. The new land grew steadily, glaringly white and bare, baking in the sun. Large plantations of hardy casuarinas were planted, and flourished. Soon the white coral desert of the *Konblaz* was greener and cooler.

Other species found their own way there and the blue spikes of *zepible* and the sunny yellow faces of *koket* appeared amongst the grasses. A road was laid and a few small factories built. A school has gone up and, on the horizon, a sports arena climbs skyward. In a sunken area, brackish water has collected and where once had been dense mangrove swamp, mangroves have taken root again, and regular migrants and waders seek refuge, feeding when the tide is high. Birds blown far off course in their seasonal travels arrive exhausted, grateful for this sanctuary where they can feed and rest. Cars speed along the new road, but few people linger, and amongst the casuarinas there remains a world apart.

Just over 200 years ago, this was thickly wooded mangrove swamp where arches of stilt roots reached down into the sticky grey mud, or tenderly touched the surface of the incoming tide with exploratory tips. High above, glossy green leaves stirred in the breezes which could not penetrate the foliage. Below, in a dark world of tangled roots, fiddler crabs gestured with their enlarged claws, and mudskippers — real fish out of water — shuffled along the mud pop-eyed and bulging-cheeked. Alongside the sluggish creeks draining into the sea, crocodiles five or six metres long slept off their latest meal. At this time they were the kings of Seychelles. They had feared nothing for thousands of years. But that was about to change. From the hillside, beyond the swamp, came the hammering of men at work. The year was 1778 and they were erecting the first building at what was to become Seychelles' capital. In thirty years the crocodile kings were extinct.

With war threatening, the French were certain the English wanted Seychelles as an Indian Ocean base. That November a detachment of soldiers; a sergeant, corporal, thirteen men and their commanding officer, sailed to Seychelles from

Above: Unusual twin-headed palm at Anse Intendance on Mahé.

Opposite: Evening tide retreats from lone footprints on a deserted Indian Ocean beach.

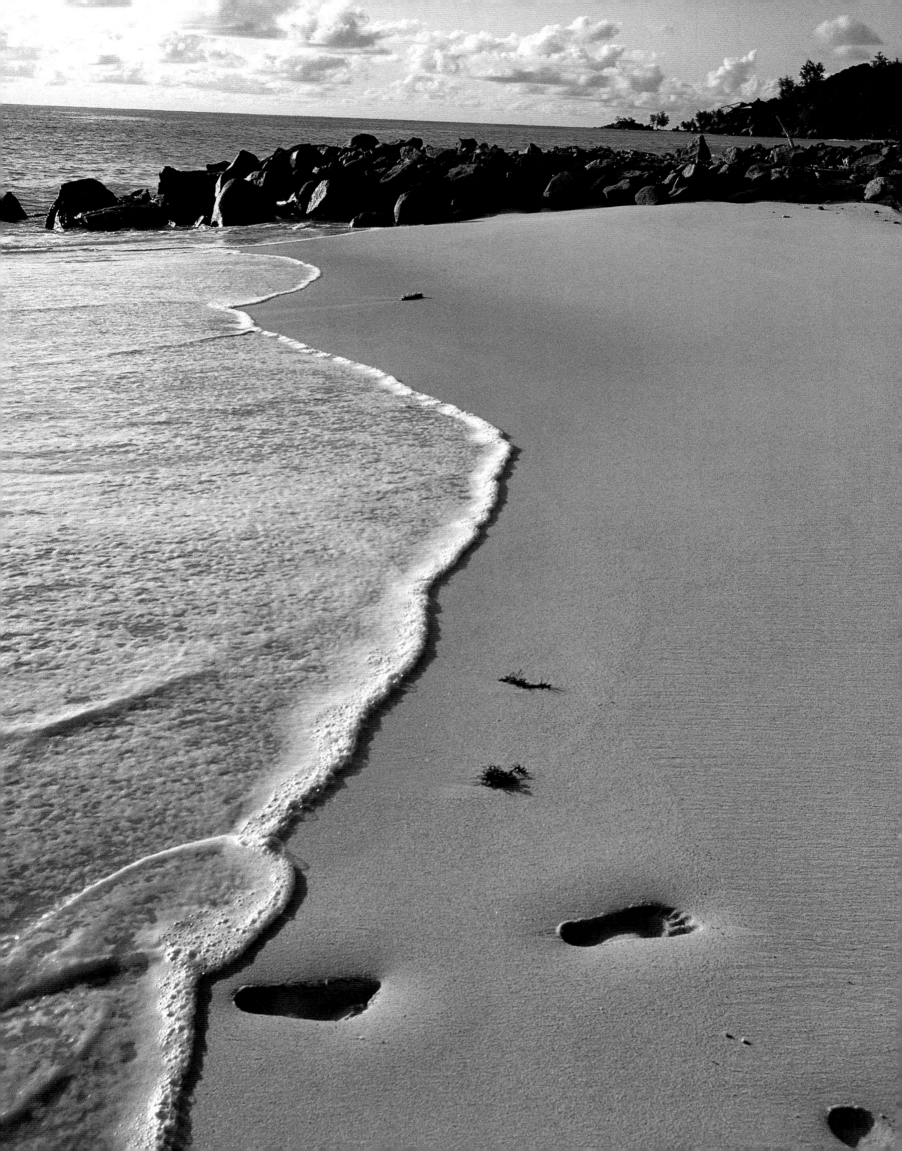

the Ile de France to build a settlement; billets for soldiers, a supply warehouse, hospital and lock-up.

There were master carpenters, carpenters and woodworkers, coopers, locksmiths, blacksmiths and masons earning twenty-five or thirty livres a day. Michel the baker was busy at his makeshift oven, Jean Batiste the tailor tut-tutted over a heap of uniform repairs, and the surgeon watched his house take shape in a clearing, set apart from the others, on the edge of the mangroves. Twelve slaves were also sweating beneath the tropical sun. They were to be housed in a camp away from the settlement, over the river and across another stretch of swamp. Amidst it all, the commanding officer, Lieutenant Charles Routier de Romainville, watched anxiously. He had a heavy responsibility, and he was ill.

In addition to the building work, he had to control the settlers, rationalise their land claims yet somehow "make peace reign". He had to save the forests, conserve tortoises and make a full report on the island, its products, resources and animals.

At nights he sweated in what could be termed the first Government House, a single storey building, nine metres by three-and-a-half. By day, he tried to protect the tortoises from poaching by settlers, in a park on Cerf Island, until at last he had a cargo of 600 of them to be sent back to the Ile de France. To defend Mahé he had just four fusiliers, a sergeant and a corporal. Despite a "liver ailment caused by fatigue and overwork", he managed.

The *Établissement du Roi*, Mahé's fledgling capital took shape between two rivers which drained into the swamp. The barracks and hospital were provided with kitchens, and a guest house built for visitors. His colonists on Mahé included Monsieur D'Offay, a retired officer, the entrepreneur Hangard and nurseryman Gillot, and a Monsieur Laurent and his son, who had a small farm. Monsieur Lambert, a retired captain, was still living on his thirty *arpents* (about thirty acres) on Praslin with his thirteen slaves. On Frégate, a Monsieur Savy had an arpent of land and four slaves. Altogether he had seven "official" settlers to worry about, with their 123 slaves and nine *pirogs*. The handful of simple stone buildings was an inauspicious beginning, but nothing was to change at *L'Établissement* for years.

It was the Napoleonic Wars which prompted the town's development. The British took over the islands in 1811. By then there were 100 houses and, where once the lieutenant had built his barracks, two billiard saloons now stood. To the south, beyond the surgeon's house, an area called Le Chantier became the boat-building centre. Houses were single storeyed, made of wood, and the enclosure around each home was usually planted with mango, guava, paw paw and orange trees.

In 1839 a market was built, a short pier replaced the old wooden jetty, and

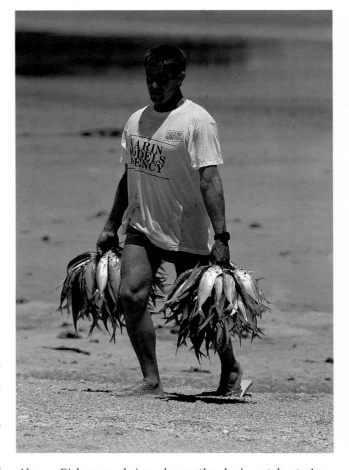

Above: Fisherman brings home the day's catch at Anse Boileau, Mahé.

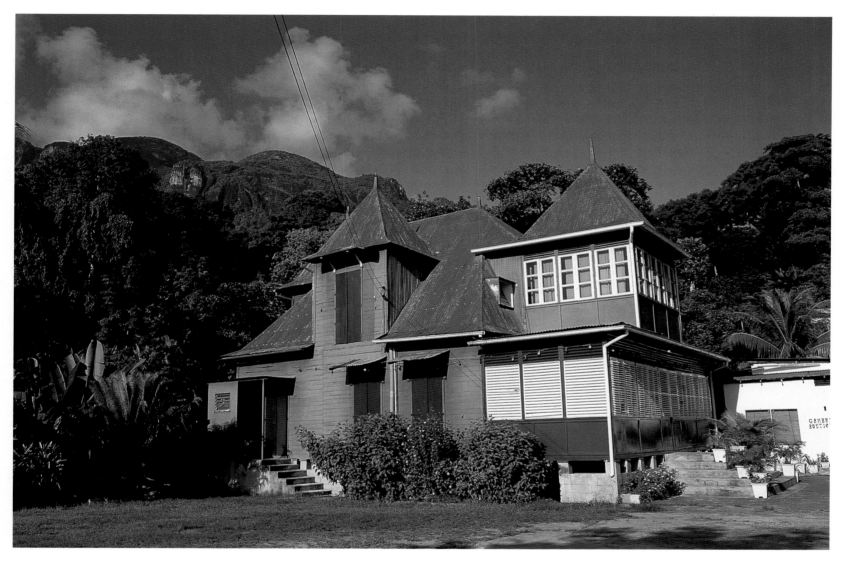

Above: Marie Antoinette restaurant overlooking Victoria occupies a traditional colonial building and serves excellent Creole cuisine.

Mylius' Wharf took shape. Today it is known as Long Pier, but it was originally named after C A Mylius who was Civil Commissioner from 1839 to 1849. He had a grant of just £50 to build the pier, of which only sixty-one metres was complete when he left Seychelles. He also laid out Albert Street, where traffic now files past the modern supermarket, but where the balconies of old Indian and Chinese emporiums still lean enquiringly overhead, their tin roofs a collage of rust reds and amber.

Albert Street is typical of old Victoria. Pavements are uneven with vast storm drains below. The road is narrow and busy. Where rickshaws once hurried planters to afternoon drinks, pick-ups now jostle for parking space. Stores squeeze against each other along either side of the street. Some are tiny, dark caverns, their doorways and rafters festooned with a treasure chest of goods.

The confusion of Albert Street spills into Market Street. The trading area is laid out beneath mango trees and, over its entrance, boasts the grand name of

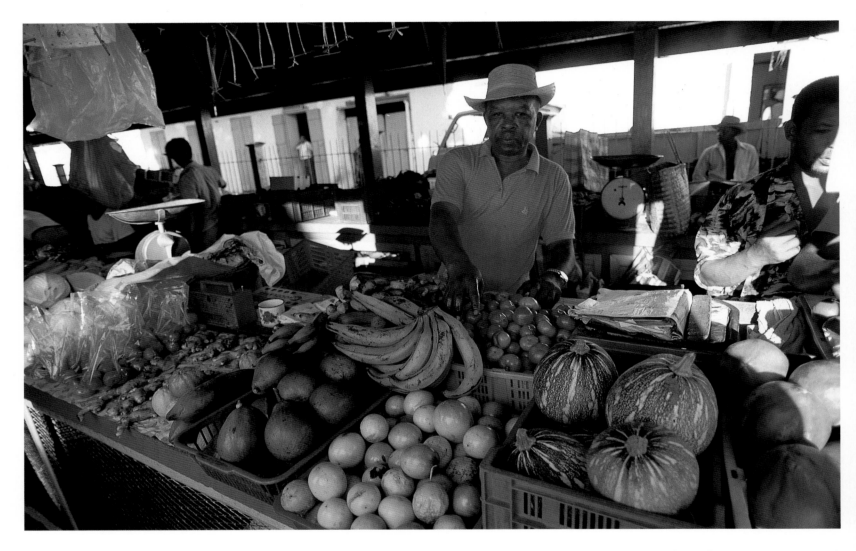

Above: Fruit and vegetable stalls in the shadows of Victoria's market.

Sir Selwyn Selwyn-Clarke Market. The milling crowd gossip or argue over the price of fish. Oblivious to it all, cattle egrets, known locally as Madam Paton, strut among the debris, searching for titbits.

The smell of fish pervades everything. For a nation whose staple diet is fish, these stalls are the very heart of Victoria. Steely *bonit* stare glassy-eyed and mournful, and the enormous red *bourzwa* looks reproachful. There are mixed fish on strings; yellow *kordongnen*, *kapitan blan* and turquoise parrotfish. Sometimes stalls are piled high with bunches of mackerel, their rainbow flanks still sandy from the beach. There may be slimy masses of octopus, or thick steaks of sailfish, tuna or shark, threaded with string for carriage home.

On other stalls there is a colourful confusion of fruit and vegetables. You will find bright red and green chillies laid out on squares of newspaper, or pickled in old whisky bottles. Other bottles contain "Hellfire" (the local chilli sauce), coconut cream, or milky *kalou*. You can buy hands of the tiny, sweet *mil* bananas, or the long *san zak* which is only eaten cooked. There is local spinach

and Chinese cabbage, sweet potato, pumpkin and cassava — all the ingredients for a typical Creole meal.

This little town officially became Victoria in 1841, and with its grand name took on a smarter aspect, though it still had a long way to go. It lacked proper roads to link it with the rest of the island. People arrived by boat, walked, or rode along narrow tracks beside the coast. Those rich enough were carried in hammocks by slaves or, later, servants. Once in town they hired rickshaws or *pous-pous* to get around. Eventually the planters paid for a road from town to Pointe du Sud. When road-building got underway, the British Colonial Development Board took over responsibility.

Heading out along that pioneering stretch of road, past the once-grand emporiums overlooking Fiennes Esplanade, it is hard to imagine that the sea once lapped at the wall on the other side of the road. The land on which the stadium now stands, and where the new National Library has been built, is all

Above: Many of the older houses on the islands retain elements of a former colonial era.

Above: Old Plantation House, at Anse aux Pins, Mahé, now houses the Craft Museum inside the Craft Village. Refurbishment was funded by the United States.

reclaimed. One of Seychelles' first hotels was built there, in what must have been a pretty spot, overlooking the sea and the bobbing fishing boats.

It was run by a formidable lady known as *La Princesse* and had a reputation with "all the old sea dogs . . . in the Indian Ocean". It was already an old house in 1895, with crumbling walls, a few tables with the "traces of numerous libations", and an *à la carte* menu of turtle — or turtle. The *Princesse* closed her doors in 1906, after "twenty-five naughty years" and died in poverty.

The street running down to Le Chantier roundabout was once called Victoria Street, and was another creation by Mylius. Together with Rue Royale, leading up over the hill towards Beau Vallon, and Albert Street, this is the grid upon which central Victoria was designed. Somewhere behind all this development is the spot where Morphey laid his Possession Stone. No one knows exactly where, because it was stolen, and its original location forgotten. It was recovered and is now safely housed in Victoria's National Museum.

The striking monument at the Chantier roundabout portrays unity, and marks the end of modern Victoria. From there the old coast road leads back into the past. Once again pavements undulate over storm drains, and the road weaves between the little shops and tin houses, shutters wide to the breeze. Chickens scurry about houses built on precarious columns of rock to keep them cool and prevent termite infestation. Here and there, grander houses, set back from the road, are reminders of the time when this was a fashionable and peaceful suburb where government officials had their homes, or planters — who lived in remoter areas — had their town houses. Imposing stairways leading to the front door, verandahs and balconies and complicated roofs, are the badges of their status. Their modern equivalent, the neat concrete bungalow, appears in increasing numbers, dotted up the hillsides, climbing higher every year.

The hospital, at the head of a side road, was opened by Governor Byrne in 1924 to provide care for "those unable to secure proper medical treatment in their own homes". It is a charming building; two storeys high with a carefully wrought iron balustrade around the balcony. Tall windows and doors open all around to admit light and air. Its beauty is its downfall as far as modern medicine is concerned. To the rear a modern, utilitarian, but far more hygienic annexe has been built.

The hospital overlooks the sanctuary of the Botanical Gardens, laid out in 1901 by Paul Dupont, a Mauritian. There are sloping lawns, large old trees offering generous shade, a tinkle of water and a cooing of ground doves — fifteen acres of peace. The red, white and blue Seychelles blue pigeon makes its display flights over the trees, falling stiff-winged through the air. Sunbirds gather excitedly beneath the majestic dome of the Pride of Venezuela tree when the cave of leaves is almost lit up by the bright scarlet globes of its flowers. It looks as if someone has interrupted a game of bowls on the lawns opposite where the elephant apple tree has shed its large, round, heavy fruits, redolent with the smell of rubber.

Dragonflies skate over the surface of the pond where arums, water lilies and the lovely lilac water hyacinth grow. A small café nestles under the trees. Dwarfed by tall Cook pines, it is the perfect place to enjoy the quiet. Paths meander amongst the trees and the aerial roots of a great banyan hang down in curtains from the branches above. The strange cannonball tree nearby has twisting, spiny branches. Its waxy pink flowers have a menacing look as if they might take a nip at your finger. They grow directly from the trunk and round, cannonball-like fruits eventually develop.

In addition to those colourful tropical favourites — the bougainvillea, hibiscus, red ginger, canna lily, poinsettia and peacock flower — there is a marvellous palm collection. The tall talipot palm is very primitive, flowering

Above: Splash of bougainvillea brings joyful colour to Victoria's Botanical Gardens.

Opposite: Palms and shrubs in the shelter and warmth of Victoria's renowned Botanical Gardens.

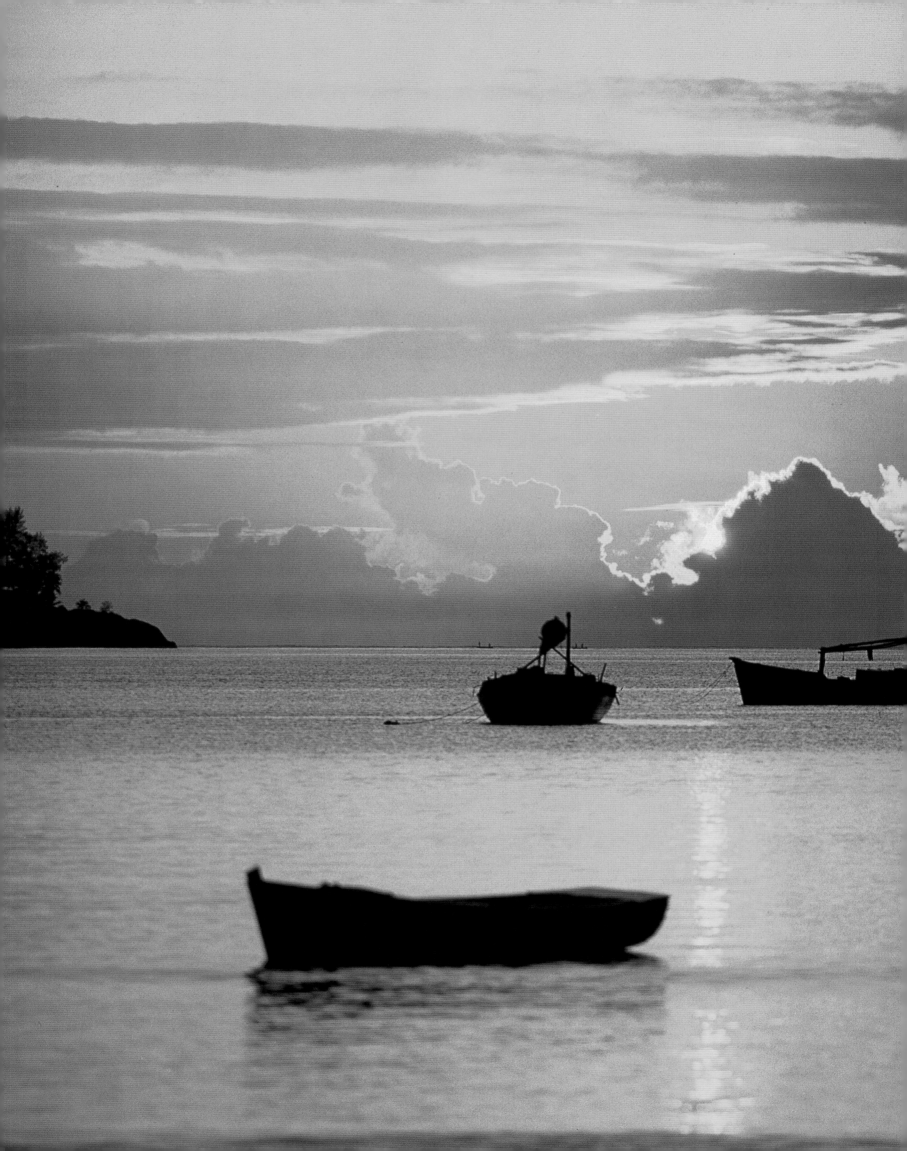

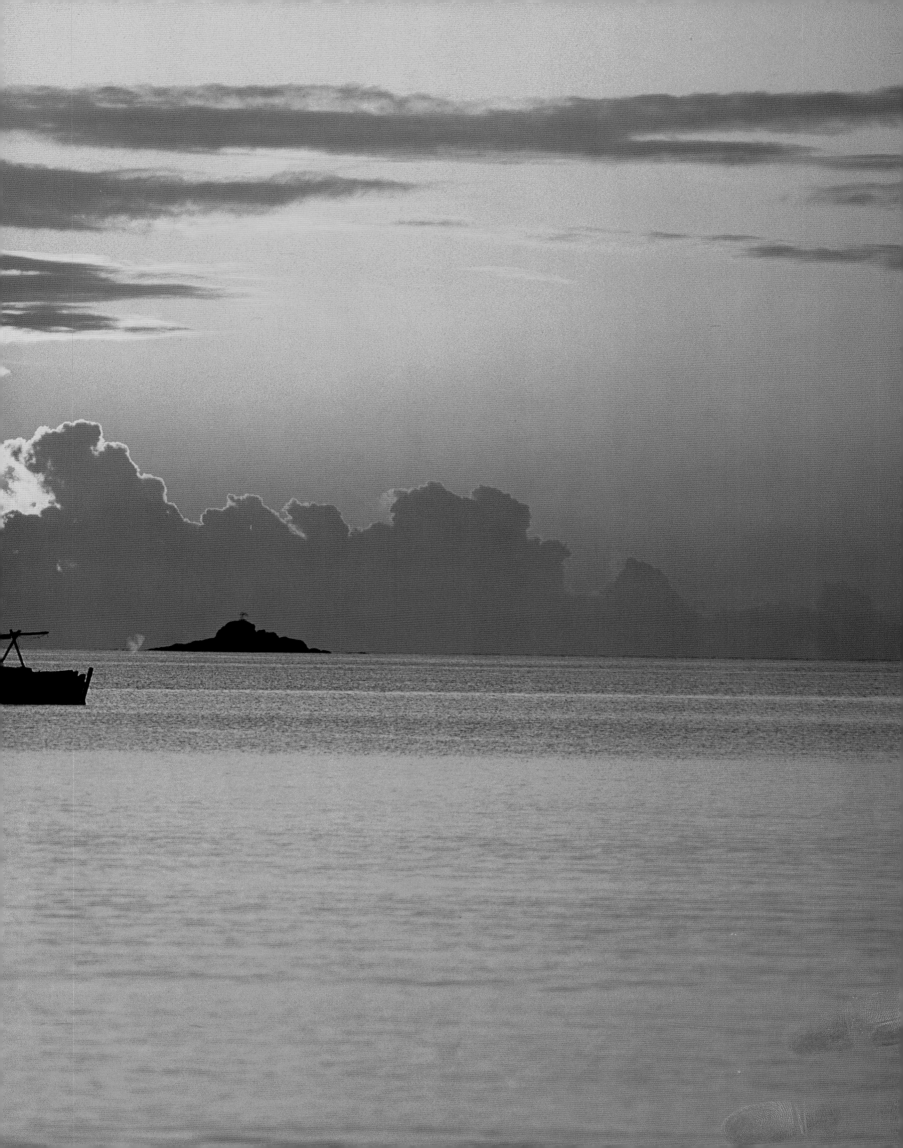

just once in sixty years, after which it dies. Tiny bottle palms, barely reach five feet; they are endemic to Round Island, Mauritius, where they are now almost extinct. Seychelles' own king of palms, the coco de mer, is there of course, and in a pen beneath a female tree are a colony of Aldabran giant land tortoises.

Beyond the Botanical Gardens houses thin out, replaced by trees, shrubs and waste land, and it is easier to imagine yourself on the old planters' road. In 1895 you might have brought your horse and carriage along there.

Chateau Mamelles stands out now as then, as one of the most elegant houses along the way. Picked out in white against the green backdrop of the hill, its simple beauty sets it apart. Built in 1804, it is probably one of the oldest buildings in Seychelles. It is from there that a tunnel is supposed to lead to St. Anne, and Hodoul's treasure.

Another famous old house, La Rosarie, is further ahead, though hidden from the road. It is a more typical Seychelles house, well shaded by grand old trees, surrounded by neat gardens and lawns. At the head of a spreading stone staircase is a wide verandah, and several tall, narrow doorways open off into the comfortable living room. Cooling breezes slip through a gap under the eaves of the tiered roof. Imposing as La Rosarie is, it has a homely feel, and an exile, who spent twenty-four years there, came to love it. He was Nana Prempeh, King of Ashanti, now Ghana in West Africa.

Under British rule, Seychelles became an "ideal health resort for deposed potentates . . . and all persons of like ilk". Between 1875 and 1940, the islands were rarely without exiles, and the custom continued, to a lesser extent, into the years beyond. Exiles came from Perak, Uganda, Somaliland, Zanzibar and Palestine. There was even a plan to intern up to 2,000 Boer prisoners of war on Curieuse, Frégate or Félicité. Archbishop Makarios of Cyprus was one of the last internees, arriving in 1956.

Prempeh landed there in September 1900 with his fourteen chiefs, thirteen women, thirteen children and twelve personal servants, besides an additional entourage. Among the womenfolk were three of his wives, and the Queen Mother. He was accused of slave trading and human sacrifice, though the British had their own reasons for wanting him deposed. In Ghana, Baden-Powell, British Army Officer and founder of the Boy Scout movement, described how "the great fetish-tree, in whose shade hundreds of victims have been sacrificed, was blown up with gun-cotton". Among the roots were "the skulls and bones of hundreds, possibly thousands of victims".

Prempeh arrived looking "every inch a bold warrior" in a leopardskin, and some expected the new exile to be a "depraved bloodthirsty savage". Others found him "repulsive", but he was also reported to be "a striking and marvellous personality". Despite discovering he could no longer enforce the death penalty on his servants, he settled down well. The Adam family had

Opposite: Several species of bamboo grow on mountain paths in Seychelles. This example towers over forty feet tall.

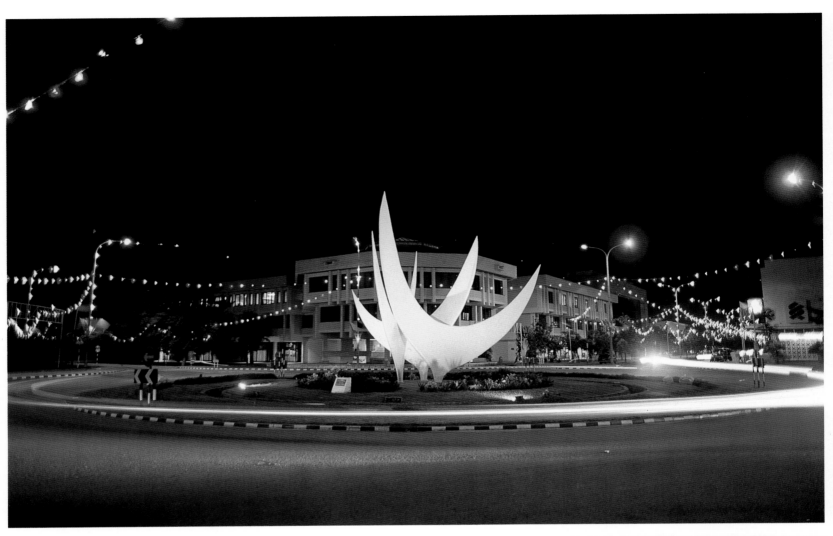

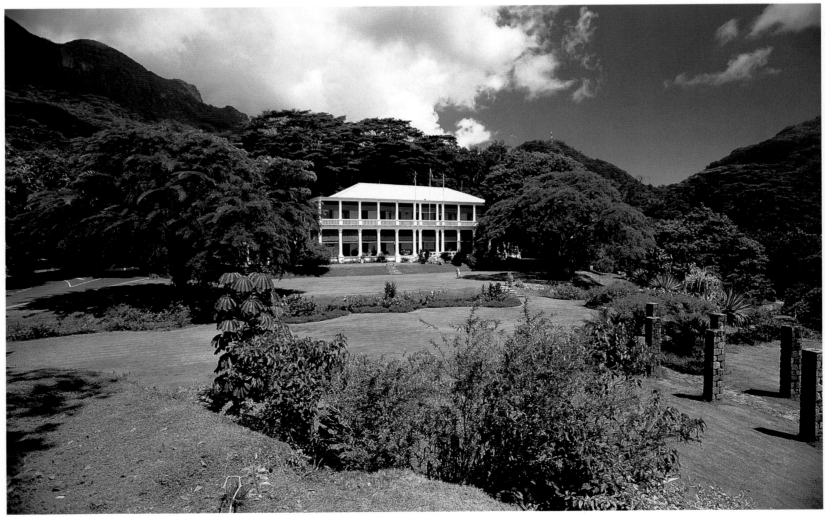

Opposite: Victoria's floodlit bicentennial monument — Trwa Zwazo — symbolises the three races, African, Asian and European, from which the Seychellois culture is melded.

Above: Devotees to the game can pit their skill against a delightful nine-hole golf course at Anse aux Pins on Mahé.

Opposite: Manicured lawns sweep up a Mahé hillside to frame Victoria's elegant State House in a mantle of green.

rented La Rosarie to the government, and the retinue camped in the grounds. Prempeh chose a pleasant room on the ground floor of the house, amusing himself with the gramophone and pianola. He now wore a morning coat tailored in London, spats, cravat and top hat. He also became a member of the Church of England, like King Edward VII, "for we kings must be together". He wanted to be confirmed, but to do so he had to set aside two wives. He sent them home with a gift of 120 rupees and a monthly pension of ten rupees.

Now Edward, King of Prempeh, his life seemed "singularly guileless", and his captors had growing sympathy for him. He was a regular church-goer, and tried to convert all the Ashanti with him. He built a school for the camp children, where they learned Creole and English.

The king, considered a "cultured . . . gentleman" and "thinking Christian", was also lonely. His father, mother and brothers were all dead, as were most of his chiefs, and he wanted to go home. He was released in September 1924,

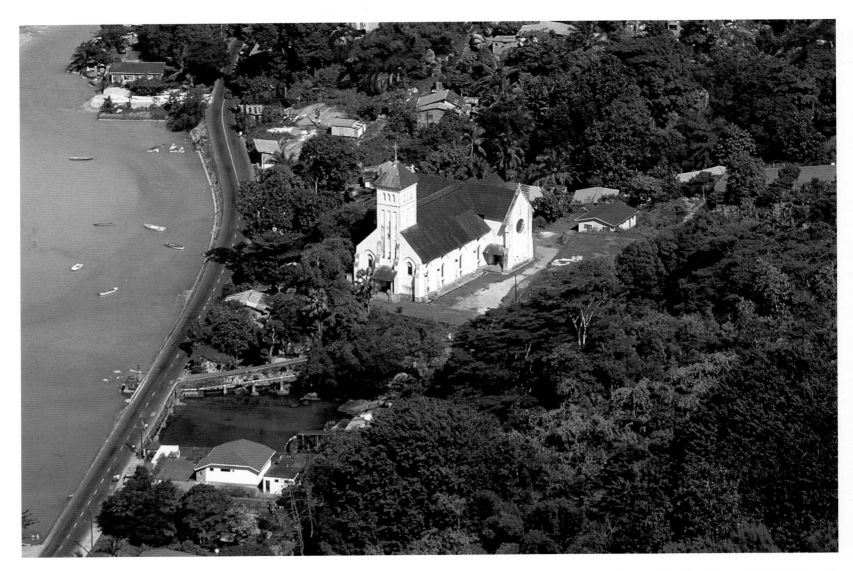

Above: Set in a sylvan glade, the elegant Catholic Church near to Cascade on Mahé.

returning to Ghana with just twelve of his original following and fifty-nine children. He wrote that he would never forget the "unfailing courtesy and respect" he had found on Mahé or the "beautiful sight of Seychelles". He signed himself "sincerely forever, Edward Prempeh, ex-King of Ashanti".

From this site of exile, the coast road twists and turns, shadowing the sea. It is tarmacked now, but in 1935, when Adolphe d'Emmerez de Charmoy imported the first motor car, roads were dirt tracks, or laid with crushed coral. The arrival of the car took Seychelles by surprise, and some speed regulations had to be hastily improvised. The Austin 7, at a cost of just over 2,000 rupees, was later considered to be the best vehicle for Seychelles conditions.

At Cascade the view of the bay opens out, with the incongruous sight of aircraft tails glimpsed through the trees. Sometimes the road takes a precarious course. With the mud and rocks of mangrove swamp to the right, and the sea to the left, there is little margin for error. Massive boulders are spilled about, some

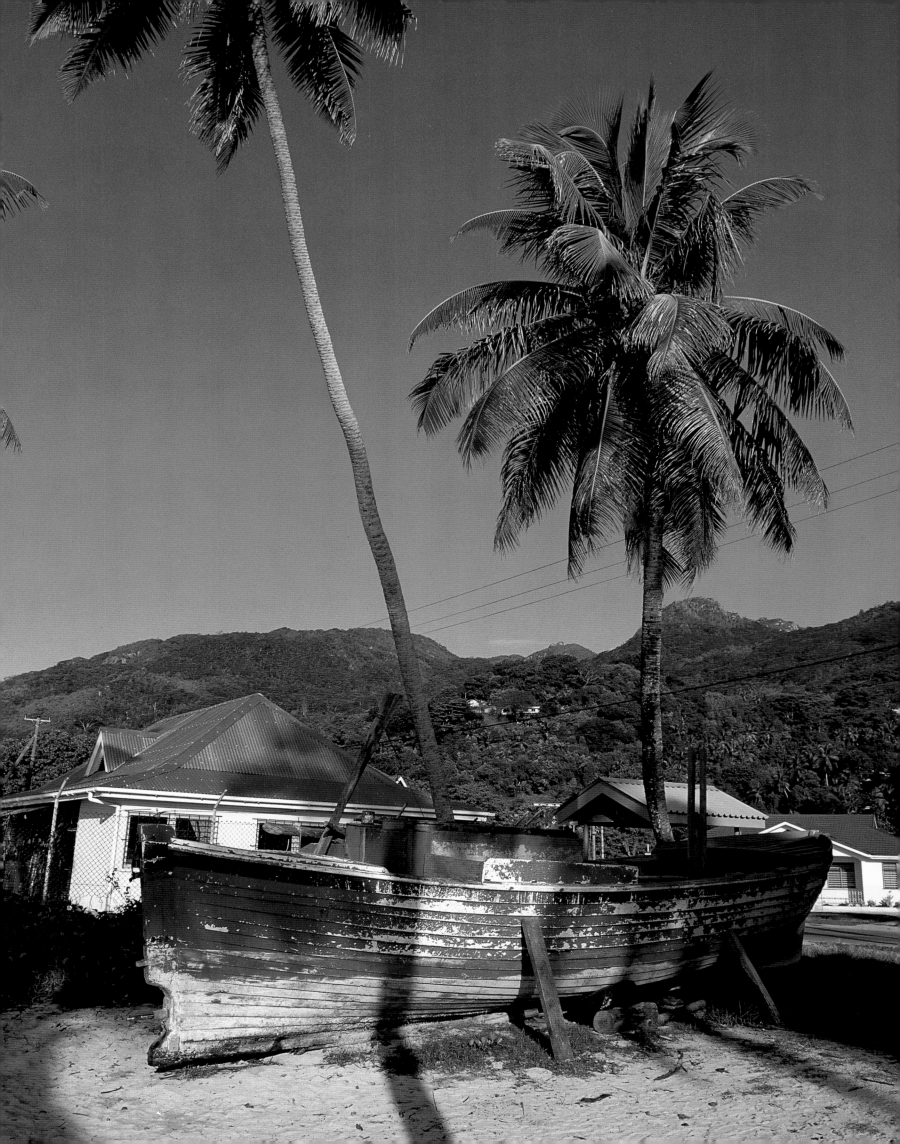

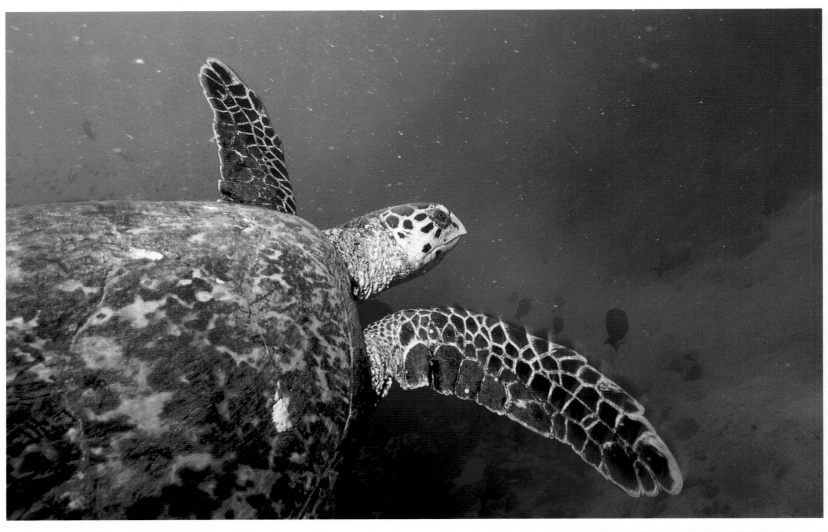

of them with houses perched on top. Beside the white church which looks out over its flock, a little waterfall tumbles down. It used to turn a water wheel serving a small coconut fibre factory, making rope. In 1992 it was restored and now tumbles round simply for aesthetic reasons.

Turn the corner at the airport, heading south, and the brilliant blues of the sea are glimpsed between the trees as the road skims over the plateau of Anse Aux Pins. Lines of palms — former plantations — stretch inland towards the mountains. You can now enjoy a round of golf under the palms, now plantation days are gone.

Out to sea horizons go on forever. Shallow reaches of turquoise and sapphire water wash over silver sands, and the reef roars in the distance, a thin line of white, bubbling water, slashed through with blue. Around each bend there seems to be a secret cove, shaded by palms and takamaka trees. At low tide, Seychellois wander out on the reef in search of octopus. The local fishing canoes bob at their moorings, and larger, more traditional *pirogs* in sombre black livery are drawn up above the high water mark. Fishermen sit under trees mending nets, or playing a noisy game of dominoes.

Beyond Le Cap, at Plaine St. André, is the family home of the Jorre de Saint Jorre family. Seychelles had a "plantocracy" rather than an aristocracy, and the Saint Jorres were members of it. Their descendants came to Seychelles from Normandy in the early days. On a plantation of 250 acres they lived a gracious, cultivated life. Meals were served on silver and porcelain. Wine was a luxury, saved only for special occasions, but then it was brought in directly from France, as were the latest fashionable clothes. On Sunday afternoons, the plantocracy visited each other, sipping vermouth and local rum on verandahs in a way of life which vanished with the tortoises and the forests.

Anse Royale is a typical Seychelles beach — coral sand like caster sugar, leaning takamakas to picnic under, and scatterings of granite boulders for shelter and privacy. The sea is colourful and calm.

A typical Seychelles village sits alongside this bay, consisting of a clinic, police station, a few shops, a social centre and a straggle of houses. Anse Royale has always been a bit special, however. It is the Royal Bay, site of the Spice Garden of which Poivre dreamed, and for which Antoine Gillot sweated and suffered. It was not the pretty beach which attracted him; he wanted the flat land, rich black soil, and marshy area well supplied by streams.

Gillot's time in Seychelles was unhappy. His home on the Ile de France was plundered and all his slaves lost; he was shipwrecked, neglected, threatened by runaway slaves and other settlers, almost starved to death, and when it was all over, he had lost his rank in the militia, so he could not go back to the Ile de France. To cap it all, the Spice Garden was destroyed by his own people, to prevent it falling into British hands.

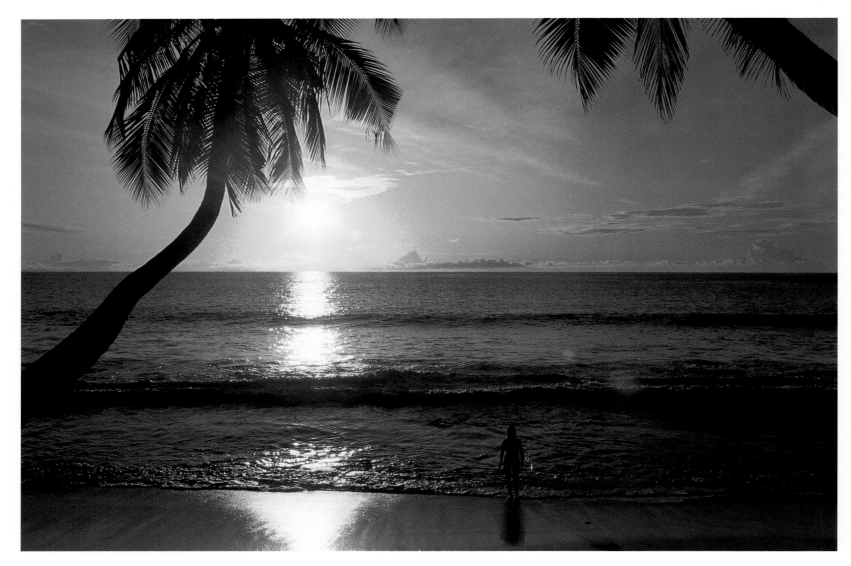

Above: Lone swimmer salutes the end of another perfect day at sundown on Mahé's famed Anse Takamaka.

The other name for Pointe du Sud, the southern tip of the island, is Cap Malheureux. There the sea changes, sweeping in uninhibited by sheltering reefs or islands. It snaps at the rocks of Takamaka, or washes into the beautiful wide bay of Intendance in mighty rollers. It is a sudden reminder of the power of the ocean, and the fragility of these tiny islands.

The mood becomes tranquil once more at Baie Lazare. The church looks serenely over the bay towards the hills shadowed, shining or backlit as the day goes by. Over the headland is the strangely named Anse Aux Poules Bleues, Bay of the Blue Chickens.

Duchemin mentioned the blue hen in 1768. One of his landing parties reported a bird like a big chicken, with blue feathers, a large, flat, red beak and red legs. They saw them for several days as they walked around North West Bay. It may have been just a moorhen — still fairly common on most islands — although they do not wander the mountain forests where Duchemin's blue hens

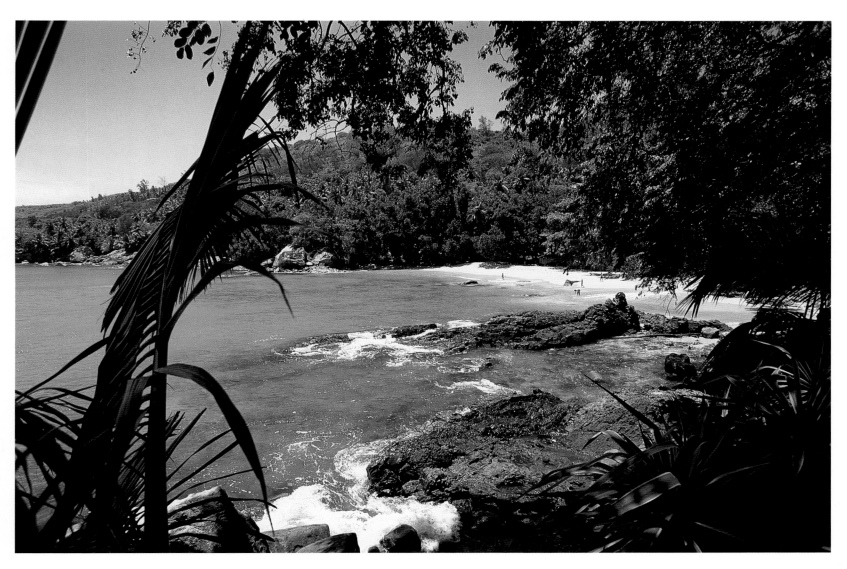

Above: Waves swirl around granite rocks that guard the glistening coves on northern Mahé.

were seen. Perhaps granitic Seychelles had a flightless rail, such as Aldabra's, or a giant pigeon like the hapless dodo of nearby Mauritius.

The lazy atmosphere reaches its height in the sheltered bays of the south-east. At high tide at Anse à la Mouche the sea labours up the shallow sloping beach. The water heats in the sun and becomes a warm bath. Whimbrels probe the sand with their curving bills. If startled they utter their strange haunting cry, which seems so out of place on this tropical beach. Sanderlings skitter where the water hisses onto the sand, and mynahs chide from their vantage point.

Everywhere there are remnants of coconut plantations. Barbarons was one of the biggest. You can still see the orderly ranks of palms disappearing into the hills. The age of the coconut plantation dawned around 1840. By 1842, St. Anne was a "forest of coconuts". In the 1860s, coconut oil was almost the sole export. This boom lasted until the late nineteenth century, when vanilla became a major export. By 1906 the price of vanilla had fallen, and planters turned to coconuts

once more. Copra, rather than oil, was now the crop, but during the First World War, ships did not call at Port Victoria. Only one copra cargo left the island in 1918, and the resulting depression had a severe impact on the population.

In 1933 there were about 28,240 acres of coconut palms but Seychelles could not produce copra cheap enough for the world market and trade has declined.

From Barbarons on, from almost every angle, the coast is overshadowed by the white domes, or "golf balls" of the US Tracking Station on La Misere mountain. The hills there have another, less dramatic but very special occupant — the *bwa mediz* or jellyfish tree; one of the rarest in the world.

Unprepossessing and growing only to eight metres, it has an unexceptional leaf and flower, and seeds like jellyfish. Yet botanists find it fascinating. It is unique, its flowers so different that the tree is in a family of its own — the *medusagynaceae*. It is endemic to Seychelles, but found in few locations, and regenerates so poorly that there are thought to be just forty trees left.

No road completes a full circuit of the island. At Port Launay, beyond the National Youth Service camps, the road peters out into a forest track. Crossing the Du Riz River, skirting the mountainside, we reach the Cap Ternay Estate near which once lived a man of mystery.

Pierre Louis Poiret kept to himself. He grew cotton, was well-respected by fellow planters, had a family of seven daughters and four sons — and a secret, revealed in 1856, in his seventieth year, when he lay dying from gangrene. Delirious on his deathbed he babbled about the French royal family and the Revolution. Then came the amazing revelation. "I am the son of Louis XVI and Marie-Antoinette", Poiret declared. The missing Dauphin . . . King Louis XVII!

A priest who had been summoned asked gently: "Why do you say you are the son of Louis XVI when everyone knows he died in Temple prison?"

The planter replied: "My God, my God, I am humiliated! . . . I have only a few more minutes left to live and I go before God, who will judge me. I repeat — I am the son of Louis XVI and Marie-Antoinette". Pierre Poiret — or King Louis XVII — died during the night.

At the little bay of Anse Major, the sea glistens, the sand glares and at once everything is light. This was part of the vast estates of Madame Guillon. She was a rich, lonely widow, who brought her sister from France for company. But when she eloped with a Seychellois, Madame Guillon cut her out of her will, died childless, and left her land to the Roman Catholic mission.

They made a settlement there, distilling cinnamon and patchouli oil, drying copra and harvesting fruit. All the produce was taken out from the bay by *pirog* for there was no road. In 1940, a British official confidently anticipated that the road from Bel Ombre would soon join up with the road from Port Launay. The terrain was "very rugged and precipitous", and it would be "a difficult piece of engineering work", but it opened up a prospect which then must have seemed

Above: Jetski rider enjoys the thrill of splash and speed.

Opposite: Dazzling display of aquatic delights off Beau Vallon Beach.

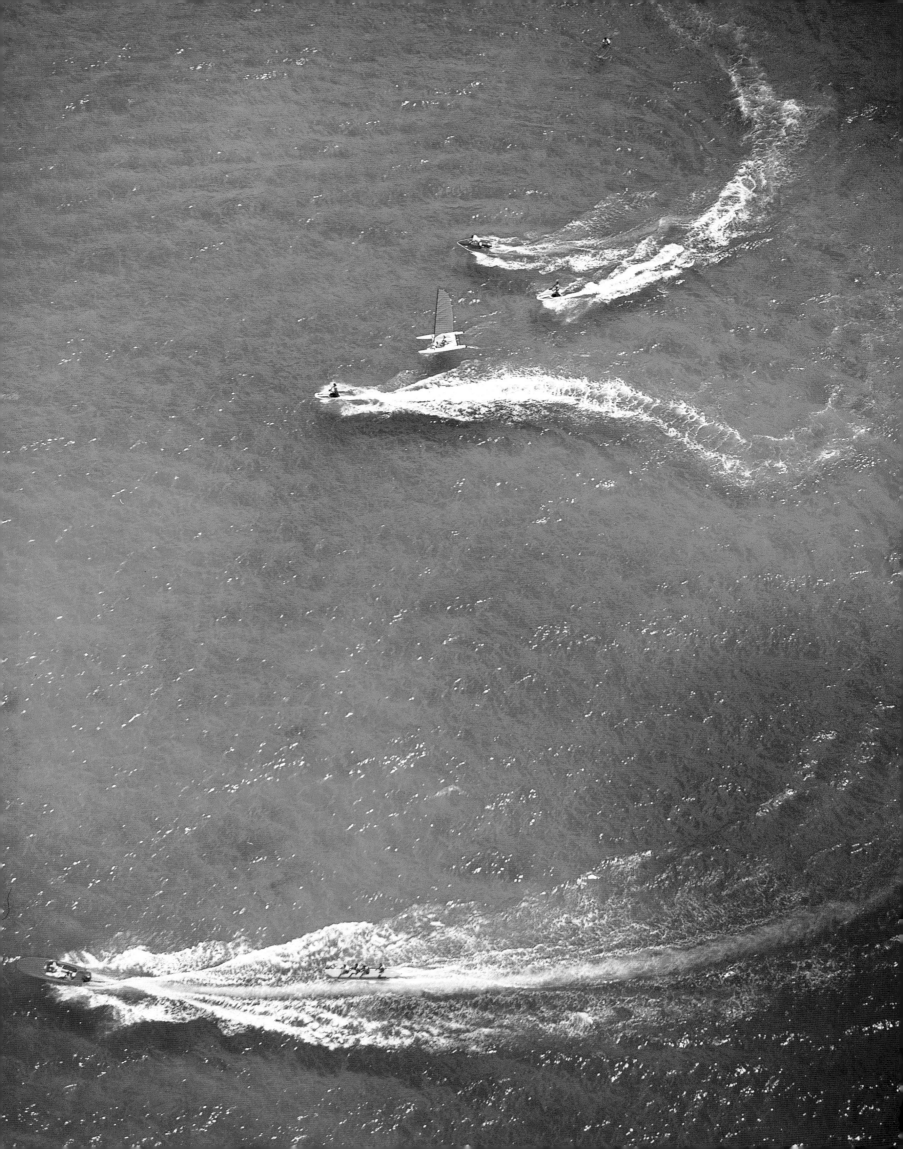

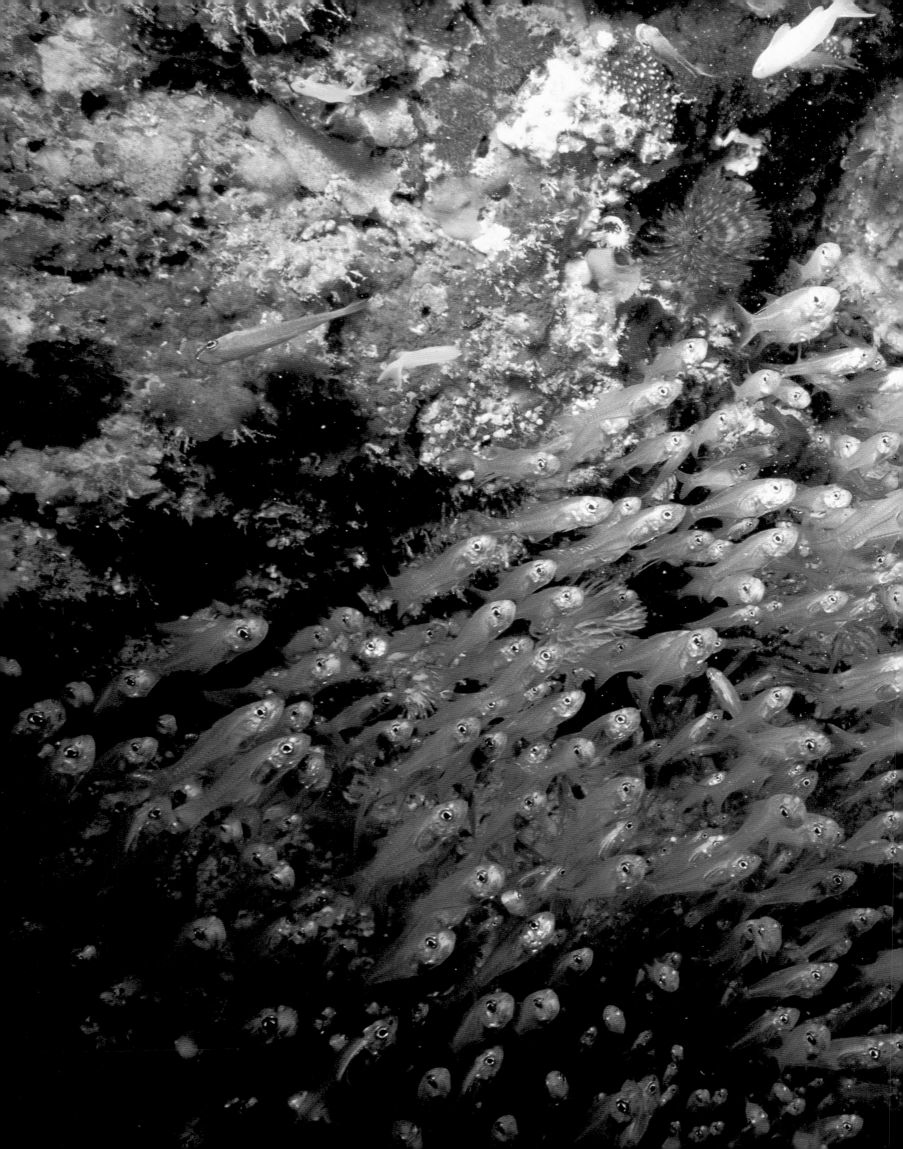

most exciting — the possibility of making "a complete tour of the island by car in a couple of hours".

A true circuit of Mahé is still not possible, but anyone who walks today from Danzil to Anse Major will shed no tears about that. Beside the path dramatic sweeps of bare, streaked granite glacis plummet towards the sea. In the ravines, *vakwa maron* grows, propped up on stilt roots, its tousled head of strap-like leaves peeping from crevices. On little bushes which brave the baking granite slabs, Seychelles vanilla tangles and flops, the thick green vine occasionally sporting beautiful white flowers, their trumpet-hearts blushed with softest peach. The plant is endemic to Seychelles and produces no leaves. Despite the name, it produces no vanilla pods either. Perched in higher clefts are sprays of tropicbird orchid, the national flower of Seychelles. From a rosette of leaves, a flowering stalk appears arrayed with white and green flowers, each with the long, graceful spur which gives them their name, because of its resemblance to a tropicbird's tail.

The path descends to Danzil, with fabulous views at every turn. The sea stretches blue out towards the sky, and below the cliffs it roars and swirls around the rocks. At Bel Ombre the coast is tamer, the sea content to lap the sea wall. Bel Ombre was once the property of Hangard's mistress. He does not seem to have married, but lived with one of his slaves, Anette. Later he freed her, and gave her land at Bel Ombre. Her daughter, in turn, owned land there. She married a man named Le Beze, which is appropriate for this area, because this is where the great treasure of his near-namesake, the pirate Olivier Le Vasseur, nicknamed La Buze, is supposed to be buried.

The workings of one man who believed he was on the treasure's trail, can still be seen on the sea side of the road. His son continued the quest his father began. Reginald Cruise-Wilkins was a Grenadier Guardsman, invalided out of the army in 1941. He ran hunting safaris in Kenya, but came to Seychelles after a bad bout of malaria. He stayed in Beau Vallon, where an old Norwegian whaling skipper showed him a cryptogram. Cruise-Wilkins copied it to puzzle over while waiting for a ship.

A Mrs Savy of Bel Ombre further fired his imagination with tales of treasure hunts and showed him documents she had copied from the Mauritian archives. She told him of strange drawings on the rocks at Bel Ombre, showing dogs and horses, tortoises and people. Two coffins had been found with human remains. A third set of remains was found nearby.

Cruise-Wilkins was intrigued. Mrs Savy had another cryptogram, some maps, letters and a paper with four strange signs on it. He worked on the problem eighteen hours a day and came up with a theory that the riddles guarded La Buze's treasure. So strongly did he believe in his theory that his first action on returning to Kenya was to form a syndicate to finance a dig.

Above: The Beau Vallon Bay Hotel is situated on a glorious three-kilometre-long curve of white sand.

Seychelles' government provided labourers, who, after just eight hours of toil, unearthed a rough stairway leading from an underground cavern, to the massive black face of granite which glowers over Bel Ombre.

The cavern was blocked. "There could be no easy access to the treasure — Le Vasseur did not intend it", Cruise-Wilkins said. He kept searching in vain until the end of his days. But at Bel Ombre the search continues.

What strikes the onlooker today are the walls built to hold back the tide whilst extensive tunnels below sea level are explored to find the cavern where the treasure was supposed to lie.

The original search cost over £30,000 and followed a game Le Vasseur is thought to have laid out over an area of sixty acres behind Bel Ombre. It was based on mythology and astronomy. Anyone in search of the treasure had to perform the Twelve Labours of Hercules, finally descending into the underworld — the underwater cavern — to claim his fabulous reward. En

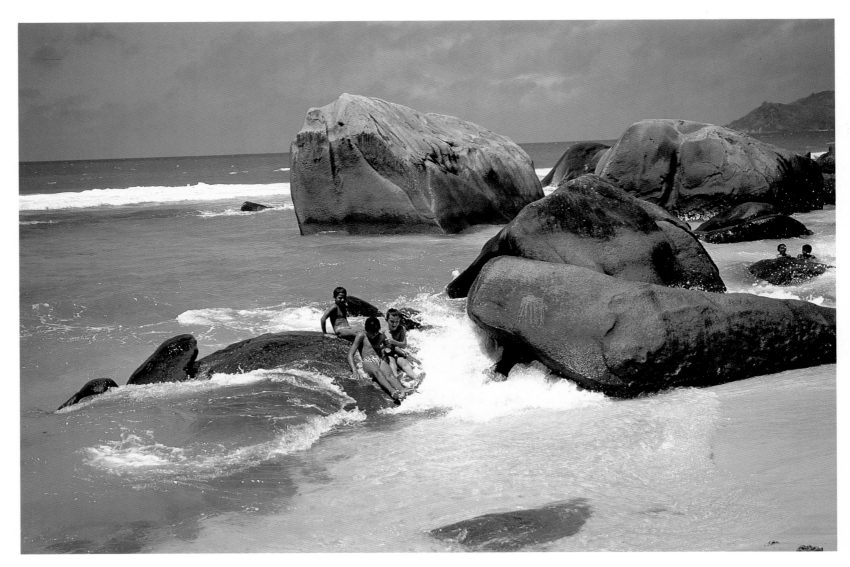

route, Cruise-Wilkins found only a sword blade, a coin dating from Le Vasseur's time, a flintlock pistol, pieces of a wine jar and some carved figurines.

The northern coasts are rocky and dramatic, but within the granite embrace of these tumbling boulders some magnificent coves and beaches are to be found. Beau Vallon "three times as long and twice as nice as Waikiki beach" is a case in point. Nearly five kilometres of stunning white beach and clear blue water, it is the fulfilment of a dream for most tourists. There are no high rise blocks here. By law, no building outside Victoria may over-top the palms. The discreet hotels are hidden from the sea, concealed among the trees.

The Northolme, perched on its promontory at Glacis, is no exception. It was built by an eccentric retired colonel, sometime before the First World War. His hobby was astronomy and he had an attic room built with sliding panels, each with a porthole so that he had an all round view of the stars. Compton Mackenzie was happy enough in that room to write *Hunting the Fairies* in record

Above: Youngsters play among the foaming pools and granite boulders of Bel Ombre Beach, near Beau Vallon Bay, Mahé.

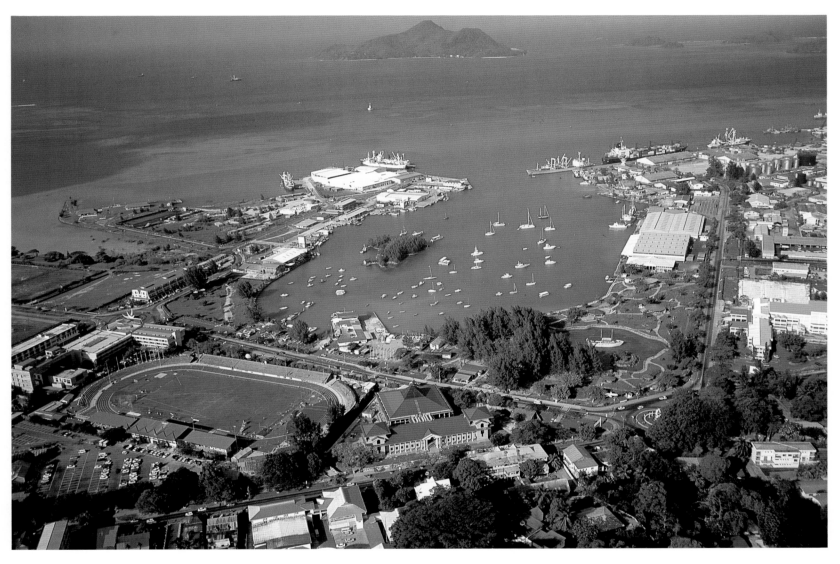

Above: Against a backdrop of St. Anne Island sleek craft lie at anchor in Victoria's yacht basin while freight and fishing vessels line the dockside. It was built on reclaimed land as was the national arena, Stade Populaire, in the foreground.

time. He recommended it to Alec Waugh, brother of Evelyn, who liked the Northolme very much. He enjoyed its happy-go-lucky atmosphere, even if the fridge did not work, there was no electricity after 9.15 at night, and guests and cooks could not both have a simultaneous supply of water.

As the sun slides behind Silhouette, the terrace of the Northolme, graced by the lengthening shadows of evening, is still one of the best places to salute the passing day with an ice-cold beer.

Those who do not cross Cap Ternay headland to head for the Northolme, turn inwards to make the steep, snaking climb over Sans Souci pass to Victoria. It skirts the dramatic peaks of Morne Seychellois, the summit of the island some 900 metres above. Before reaching the old house where British colonial governors came for rest and relaxation — now the residence of the American ambassador — you pass the ruins known simply as the Mission.

This is a place of silence, the ruins smothered in greenery; ferns and shy

begonias peep from every crevice. When Marianne North visited in 1883, however, the hush of the forest was disturbed by "children's happy voices". A school was established in 1875 by the Church Missionary Society to provide an education for the children of newly liberated slaves. By 1883, Marianne North could not discover *whose* children were supposed to be at the school, but "they all seemed very happy and did not puzzle their brains with too much learning".

Known as Venn's Town, after a Missionary Society official, its location was "one of the most magnificent in the world". From the hill, the view was "of wild mountain coast, and many islands, some 2000 feet below". Nothing has changed in that breathtaking view since 1883.

Back in Victoria the modern age returns. The port with its recently-built tuna quay, the orderly concrete office blocks of the last few years lining broad, pavemented streets, and roundabouts to deal with the volume of traffic, are all laid out below. For this is the growing capital of a developing nation.

But the old quarter remains a warren of little streets with every type of house from modern concrete bungalow to dilapidated tin home. In areas such as this, legends of the past are told and refined to hand down for generations to come. Not far away, in Bel Air cemetery, lie men whose lives are the stuff of legends, such as the corsair Hodoul, and a mysterious giant who, it is said, still haunts this neglected place.

In the villages of the south there still remain people who have only dreamt of the streets of Victoria, and who have "not seen the Clock Tower" — the local expression for a country bumpkin.

This incongruous monument, a quaint piece of silver painted Victoriana, stands at the heart of the little capital. One writer described the Clock Tower as "a stunted imitation". Athol Thomas called it "a miserable piece of tinsel in the shadow of the mountain", but most Seychellois are fond of their *orlaz*. This idiosyncratic landmark has become very much a part of Seychelles. It is a replica of a clock tower on Vauxhall Bridge Road in London, and was erected by public subscription in 1903 to celebrate Seychelles' new status as an independent colony. As the pieces were lovingly unloaded from the ship, the pendulum was dropped over the side and lost. The public works department made a substitute, but it never quite fitted. The clock would keep time, but it would not chime. It was erected "in loving memory" of Queen Victoria, who probably knew little of her tiny colony.

In 1903 they also unveiled a drinking fountain in the Queen's honour. This stood nearby and was later flanked by "two howitzers . . . captured from the Germans in East Africa during the war 1914-1918".

Seychelles rupee of 1840 bearing the head of Queen Victoria.

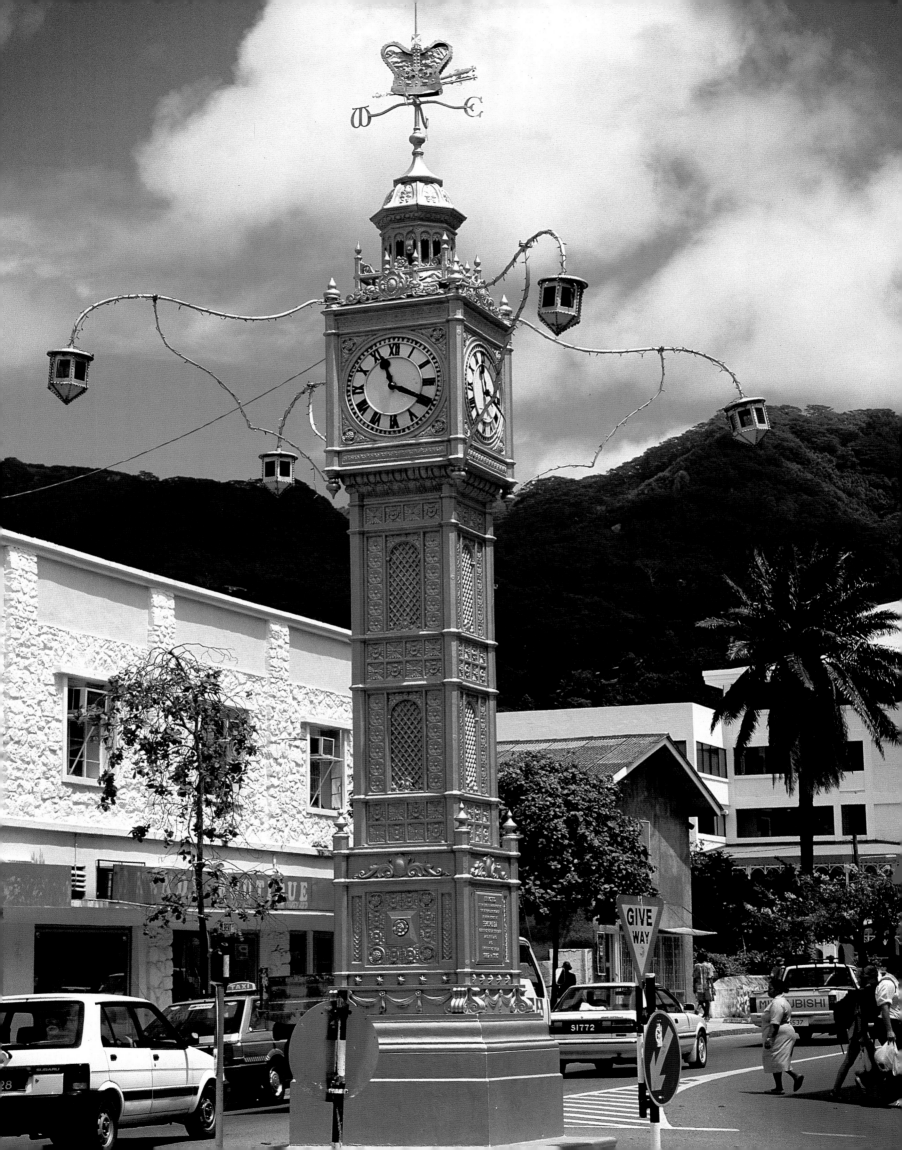

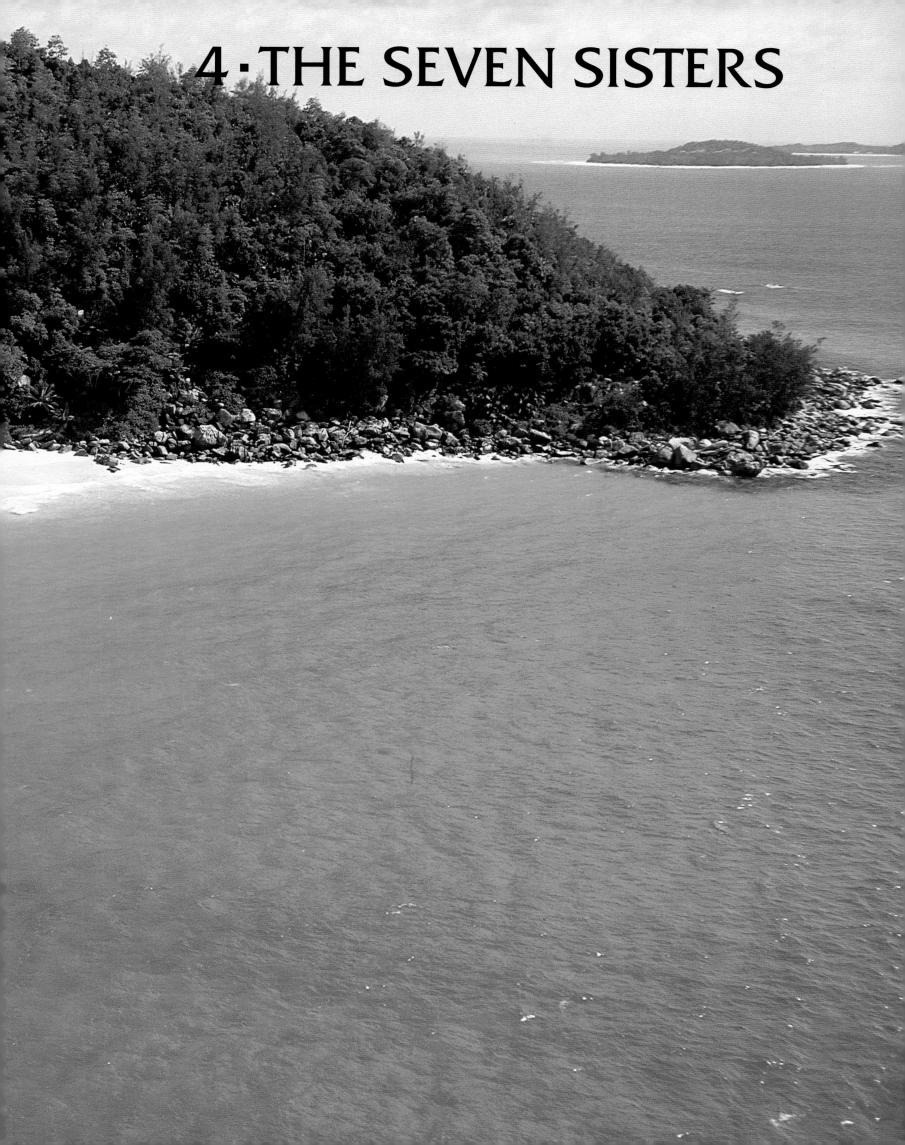

4 · THE SEVEN SISTERS

October heralds the season of temperamental north-west winds which either rage like a demon or vanish completely. During these months the sea may settle into a torpid pond. The heat is heavy, thick with moisture like a sodden blanket pressing against the skin. The sky might be clear and blue or sullen and grey, with sheet lightning flashing on the night horizon.

On Mahé, clouds settle in ominous grey masses on the mountains until, preceded by a furious wind, they roll down the hills, seeming to devour everything in their path. The land disappears in a dense sheet of rain. Sharp as knives, it bounces off pavements, and trees. In seconds you are soaked and in minutes roads are streams as muddy water pours down hillsides.

Storm drains roar as they overflow and flat areas of Victoria are soon inches deep in water. On the mountains roads become rivers so powerful they can sweep a car aside. As the soil becomes sodden it crumbles, sliding away with the flow, often undermining trees and granite boulders.

Downpours such as this caused the infamous avalanche of 1826. After hours of rain the storm peaked around ten o'clock one October night. It centred above Victoria, around St. Louis. An enormous slice of hill collapsed, tumbling into a great churning mass of water and mud, spiked with trees, boulders and bushes. This choking cocktail bore down on the town sweeping everything before it — trees, rocks, houses and people.

Victims were battered in the torrent and borne along in a mass of mud which rolled on, gathering tombstones from Bel Air cemetery and trees from Government House before being turned aside at last by a small hill and sent careering down Royal Street —now Revolution Avenue— headlong into the sea.

At least seventy people died and entire families were lost. A school was destroyed, and two of the sisters who ran it died with eleven pupils. Father Jérémie de Paglietta was engulfed in mud and it took four hours to dig him out.

Such storms are exceptional as Seychelles is outside the cyclone belt. Weatherwise, the islands are at their best during the south-east monsoon when day after day, temperate winds blow dry and constant from eight every morning until nightfall. The pattern continues from May until the next unsettled transition in October. While the south-east monsoon brings a welcome freshness to the islands, it does not please everybody. Some people long for a day when the wind is not constantly in their face.

After weeks of such provocation, the seas build up, and island hopping by boat becomes uncomfortable, though speedy if the wind is in your favour. Those months between October and April must have been anticipated with dread by people bound for Praslin. Adverse winds meant a tortuous eleven-hour sail. Today, Praslin is a fifteen-minute flight in a small plane or an enjoyable three- or four-hour sail by schooner, which have the option of an engine these days.

Previous pages: One of the joys of a voyage through Seychelles is the discovery of yet another unspoilt beach.

Opposite: Anse Lazio on Praslin is voted by many visitors as the most magnificent beach in Seychelles. Its glittering turquoise waters are offset by the purest coral sand and lush vegetation.

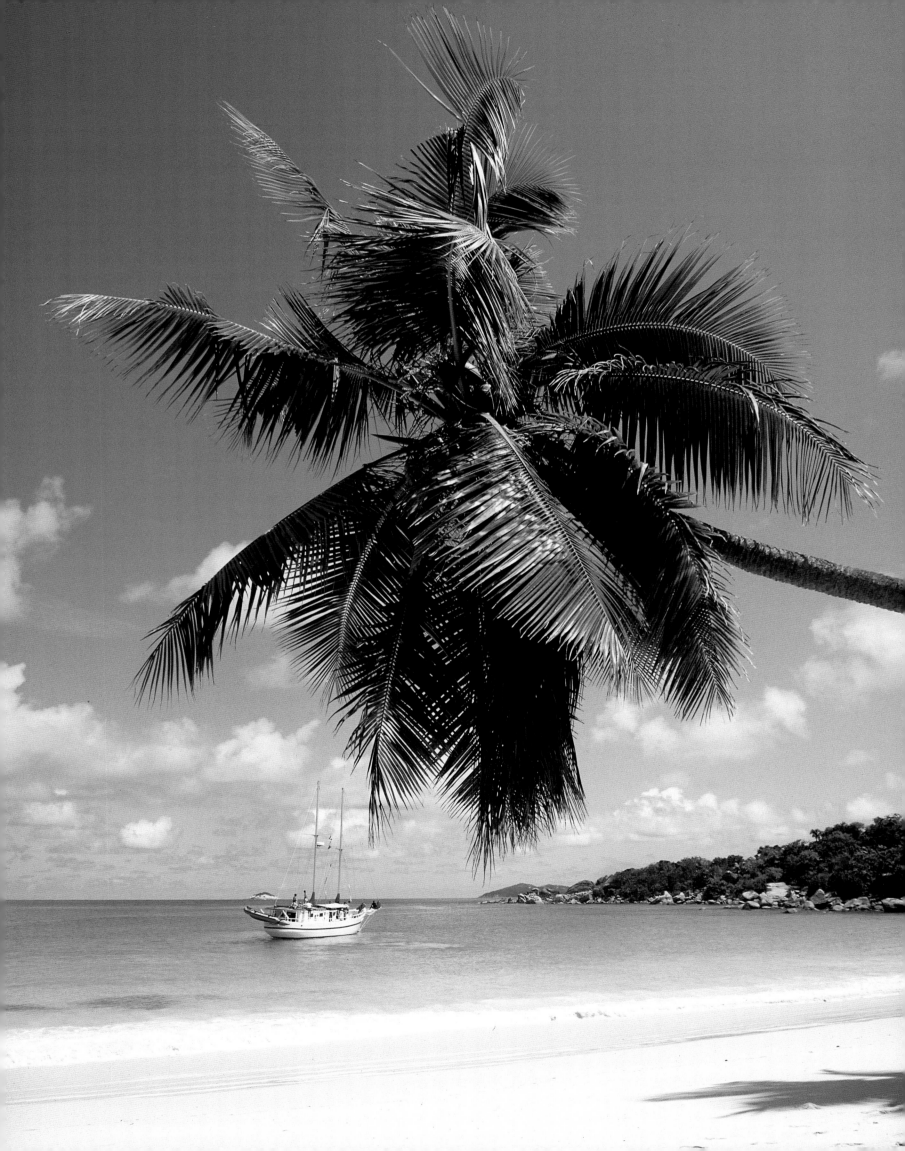

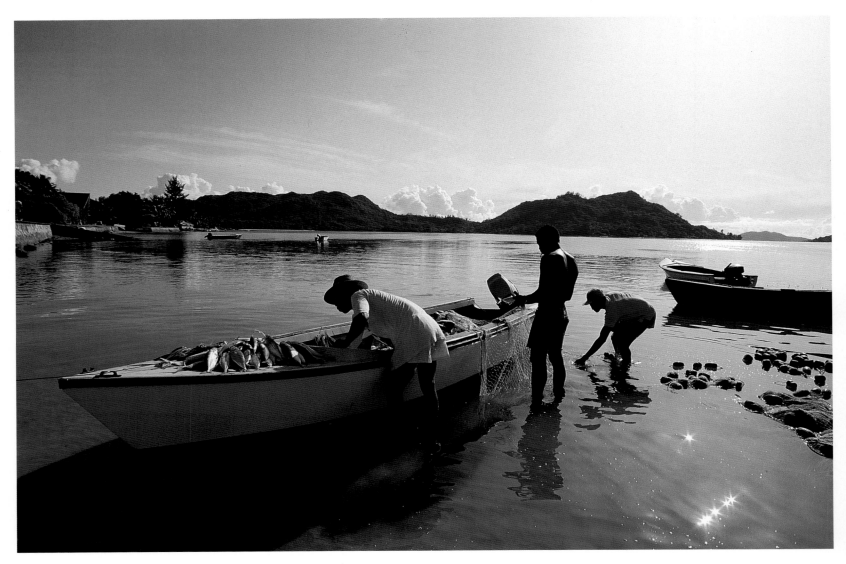

Despite its accessibility, Praslin is a world away from bustling Mahé. There are far fewer cars and a slower tempo to life.

The hills look threadbare after the sumptuous green abundance of Mahé, but these mountain slopes once supported a very different sort of forest — in the ecology of which fire probably played a regular role. Much of the forest has been deliberately cleared for agriculture in more recent years, but hidden in pockets and valleys you can still find a strange forest of "palmiste" which so little impressed Lampériaire.

Palms, including several endemic species called locally *latannyen*, and screwpines or *vakwa* grew there, rather than hardwoods. The tinder-dry debris of a palm forest is highly inflammable, and the fires which were a hazard then are still a threat. Yet the species somehow manage to survive and regenerate. Only in the deep ravines could the more usual mountain forest species establish themselves alongside the palms.

Above: Westering sun welcomes Praslin islanders to Baie St. Anne as they bring home the day's catch.

Above: Fishing boats high and dry at low tide on a Praslin beach.

Lampériaire would have been amazed to learn that today there are about 5,000 Praslinois, and their chief source of income is from tourists who come to look at the double coconut. The island is also useful as a base from which to explore Aride, Cousin, Curieuse and La Digue. Quiet though it is, Praslin belongs to the tourist as Mahé never does. There are few cars, beyond the chirpy Mini-Mokes, and peeping out along the coasts are discreet hotels and guest houses. But Praslin is not a tourist trap. Its beautiful beaches are pristine and undeveloped. The only debris on the sand are strings of seaweed washed up along the south coast. Coves are still secret places which invite exploration. Life rolls on slowly, and the passing of the day is marked by the changes in the tides.

Some concessions to the twentieth century have been necessary. There is the airstrip at Amitié, where more than twenty flights a day come and go between Praslin and Mahé. The Air Seychelles island-hoppers dip in low over the palms, waver a little in the updraft from the land before touching down with a bump,

startling the plovers and whimbrels searching the airstrip for a meal. The tiny airport, once a simple wooden building with a thatched roof, is more sophisticated now, but most visitors still consider it "quaint".

The village of Grand Anse, which skirts a long, sheltered beach, could be considered Praslin's capital. It is the largest settlement. Years ago it boasted just one "comfortable hotel", the Grand Anse Ideal Home. Choice of accommodation now includes hotels for every taste, from clean simplicity to moderate sophistication.

From there to the only other village of any size is a demanding, but rewarding walk or an easy drive. The coast is a succession of one idyllic beach after another; Anse Citron, Anse Bateau, Anse Takamaka, Anse Bois de Rose, Anse Consolation . . . names which conjure up images of these lonely, peaceful bays with their fringing trees and bobbing *pirogs*. The road leads up through the forest of Fond Ferdinand, where coco de mer palms still grow in good numbers,

Above: Praslin is an ideal base from which to explore other islands and visitors can take a regular ferry service from Baie St. Anne.

Above: Windsurfers power through the sparkling waters of the Indian Ocean.

though you can also see the scorched areas where fire recently swept the hillside. Although coco de mer trees cope with the fires and regenerate, they grow slowly and a forest fire may destroy in a few hours that which has taken centuries to grow. The Vallée de Mai, main sanctuary for the coco de mer, is protected by fire breaks and the relatively fire resistant *kalis* tree is planted around its edge.

France Jumeau, "a rich and travelled man", used to own part of the Vallée de Mai. He had a factory which made rope out of coconut fibre but took "more pleasure in the originality of his self-devised machinery than in the profit". Less industrious was the retired colonel who lived in a rented bungalow on the beach and did "absolutely nothing".

As you top the last hill, the view over broad, sheltered Baie St. Anne opens out. Village houses straggle along the path beneath fruit trees. Chickens forage in the bushes; children play on the rocky track, or carry home battered oil cans,

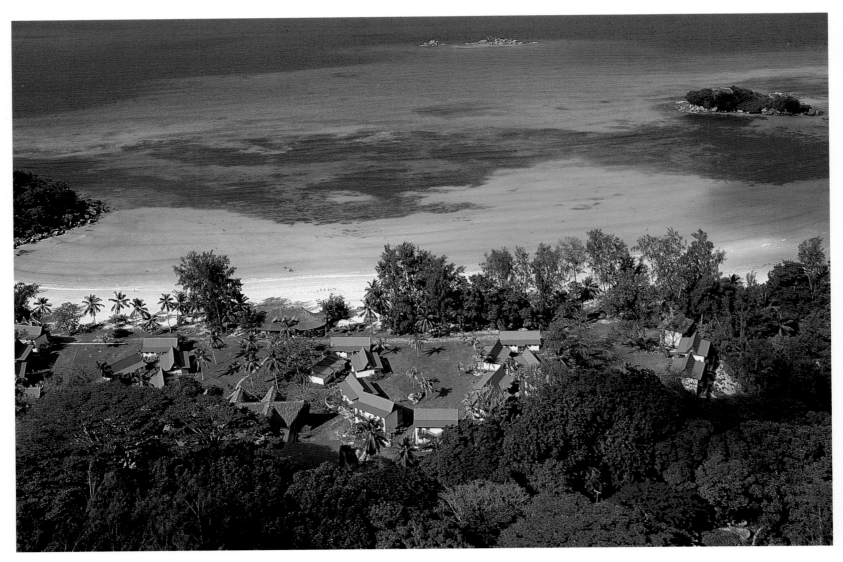

filled with paraffin to cook the fish. The local radio station blares out from dark house interiors. Baie St. Anne is the place where the inter-island schooners dock, yet the village is even quieter than Grand Anse.

Côte d'Or, which borders the sandy bay of Anse Volbert, is just over the headland from Baie St. Anne. Marianne North described the scene, and it is little changed. "We passed close along the shore among beautiful boulders of salmon-coloured granite, grooved and split into fantastic shapes by heat or ice. Many of the little islands had waving casuarinas on their tops, while bright green large-leaved 'jakamaka' bordered the sands of Praslin, varied by patches of cocoa-nut and breadfruit. Above were the deep purple-red stony-topped hills, with forests between, the famous coco de mer palms shining like golden stars among them."

Again and again this mysterious tree lures visitors towards its last safe haven, the Vallée de Mai, the secret heart of Praslin. The beaches beguile and

Above: Côte D'Or offers an empty white beach where every attempt has been made to blend tourist development with the natural beauty of Praslin.

Praslin seems a sleepy paradise, but the Vallée de Mai is the real Praslin; the island before man arrived.

No one leaves the Vallée de Mai unmoved by the spectacle. It is a silent, dark spot and there is no welcome beneath the trees. General Gordon thought he had found the Garden of Eden there, though most would like Eden a little less sombre.

The enormous umbrella leaves of the coco de mer palms close overhead, cutting off sky and light. In the canopy above, squabbling lizards clatter from tree to tree, the sudden noise heart-stopping in the cathedral hush. As if from far away you hear the mournful whistle of the Seychelles black parrot, an endemic sub-species. It uses the hollow trunks of dead coco de mer trees for nesting, but is not often glimpsed in the valley itself.

At the very least, this is an intimidating place. One writer felt he "was not wanted in that dark, silent, utterly secret place". Perhaps it is because the Vallée de Mai is no part of man's heritage. It is a fragment of another age which has slipped into our world and been trapped.

Many other trees grow in the Vallée de Mai. Most notable are the six endemic palms and screwpines. *Palmis* is tall with a smooth column of trunk just under the leaf crown. From this people used to take palm heart or millionaire's salad. This meant killing the whole tree, so the *palmis* is now protected and gourmets must content themselves with the heart of the humble coconut palm. *Latannyen lat*, another type of palm, looks as if someone has laid a bonfire at its foot. Around its base it sprouts a mass of stilt roots. The leaves of *latannyen milpat* ripple in the breeze like a shiver of movement along the legs of the millipede. *Latannyen fey* has handsome leaves, once popular for thatching. Delicate *latannyen oban*, the Cinderella of the endemic palms, is less common there. It is dwarfed by other palms, its slender trunk struggling to compete with the robust columns rearing up around it.

Every pathway is dotted with young palms like displays in office foyers. Fragile as they may seem, some are armed with circlets of ferocious spines which once perhaps protected them from hungry giant tortoises.

The lines of the Vallée de Mai are vertical — slashes of straight trunks, the downward pull of stilt roots and dangling lianas. No tree is content until it has reached the canopy and fought for its piece of sky. The eye is always drawn upwards, to the chinks of white light peeping through, and the soft green light which eventually filters down, deepening as it falls on the debris of the forest floor. An occasional giant leaf falls with a terrific crash which reverberates through the valley. When the wind blows, the leaves clatter in fury and a coco de mer nut might plummet to the ground with an impressive thud.

The coco de mer evolved in isolation, millennia ago. Having found a successful formula for life, there was no need to change, except that, because it

could grow taller, or larger or heavier, it did. Like the giant tortoises which browsed at its feet, it gave up on innovation because there was no competition. The coco de mer was king.

There are male and female trees. At present, the tallest male trees reach about thirty metres and the females twenty-four metres. The sturdy trunk heads straight for the light, pushing skywards an impressive crown of enormous leaves, each some fourteen metres long and five metres wide. The structure is quite rigid, unlike the spindly coconut palm which bends in the wind. The coco de mer depends for its flexibility on a sort of ball-and-socket joint at the base. The roots pass through a large bowl, which is full of holes, and the entire trunk therefore moves relative to the socket when the wind blows.

This is a tree with all the time in the world. The first leaves spring from the nut only after nine months to a year of germination. Slowly they multiply and push upwards, a trunk forming after fifteen more years have passed. The tree then has ages to reach its niche in the canopy. It will not mature for twenty to forty years.

Having established itself, the male tree begins to produce catkins, which are suitably shaped to complement the anatomy of the female nut. They grow up to two metres long and are starred with tiny yellow flowers, often frequented by green geckos enjoying the nectar and pollen. A female flower does not look like a flower at all, being a rather ugly brown cup with a tiny stigma surrounded by large bracts. Pollinated by wind or insects, the slow business of producing a coco de mer nut begins, a process which takes six to seven years — a suitable gestation period for the largest and heaviest seed in the world. They are usually bi-lobed, but some with three or four lobes are produced. They reach a weight of about twenty kilos each, and a female tree often has twenty-five to thirty-five nuts developing, so keeping upright is a hefty challenge. At first they contain a translucent jelly, sometimes served as a delicacy on special occasions. After a year this jelly begins to harden into a whitish ivory which can be carved, though only with limited success since it cracks easily. It was once used for the white dots in local dominoes.

Then at last the nut falls, and the whole weighty process begins again, year after year, century after century. Suggestions that some of the trees there are 800 years old may be inaccurate, but some could be up to 400 years old, and almost certainly there are trees in the valley today which were alive 200 years ago.

The valley is protected as a World Heritage Site. It first became a nature reserve in 1966, and since then it has been policy to root out introduced species in the park. Many were brought in after 1928 when Captain Jouanis, who owned a large tobacco plantation at Côte d'Or, and France Jumeau bought the valley. Jumeau had "a paternal love of plants and trees" and the Vallée de Mai was his hobby. He ran it as a botanical garden and brought in many exotic species, as

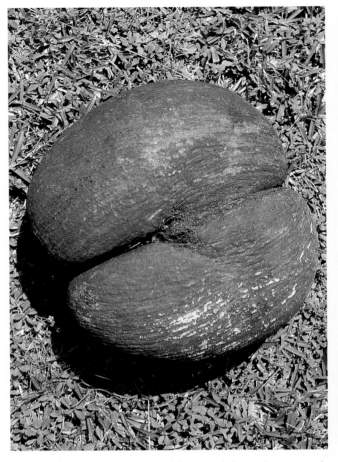

Above: Curiously shaped double nut of the unique coco de mer palm tree which in its natural state grows only on Praslin and neighbouring Curieuse.

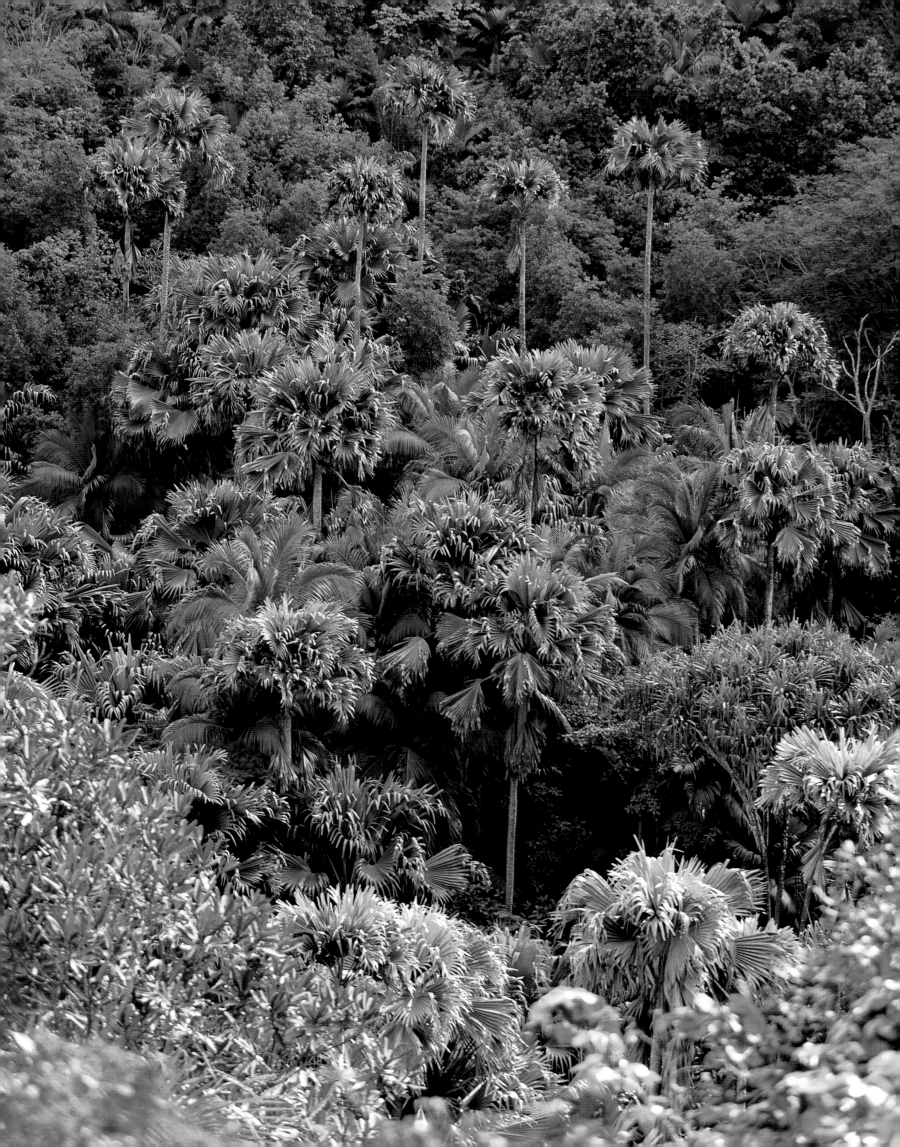

well as conserving the coco de mer. In 1948 the government bought the land as a water catchment area, and so began a process of official protection for this remarkable tree.

Even the layman cannot fail to be impressed by its sheer scale. General Charles Gordon visited Praslin in 1881, and the coco de mer left him in awe. He believed this valley was the Garden of Eden, propounding his belief in a scholarly work entitled *Eden and its two Sacramental Trees*. The coco de mer, "truly unique among trees . . . the Prince of Palms" was the Tree of Knowledge of Good and Evil. Gordon included it in his design for Seychelles' coat of arms, on which it still appears.

Curieuse, Picault's Ile Rouge, is about two kilometres offshore from Praslin, or just an half-hour row for Marianne North. It was renamed in honour of Lampériaire's ship in 1768. Its rounded hills seem very barren, and it may have suffered more than Praslin from bush fires. In 1817 the island was given to Monsieur Sériès, but was taken from him ten years later when the government decided to transfer all those suffering from leprosy from Mauritius to Seychelles, to be housed on Curieuse. They arrived in 1833 and a year later, Dr Patrick Robertson took charge of the settlement. Later the colony was closed down, and the island leased out again.

The coco de mer occurs naturally only on Praslin and Curieuse, and has fared less well on the latter. Today there is a reafforestation programme on Curieuse, and coco de mer palms are being replanted.

Curieuse has lovely beaches and spectacular tumbles of rocks forming natural archways around the coast. Isolated there, the lepers could perhaps find some solace in the beauty around them. The island was again used as an isolation centre between the years 1938 and 1965. The ruins of the colony, and the Doctor's House, which is said to be haunted, still stand beneath the trees behind Anse St. Jose.

To the east, Laraie Bay's shallow waters are bounded by a stone causeway. Inside the lagoon thus formed, turtles were kept alive ready for shipment or consumption. Today you can walk along the causeway and continue through an extensive mangrove swamp via a wooden boardwalk. It is hard to picture the massive crocodiles which once basked there. They were reported to grow up to six metres long. An average specimen was four-and-a-half metres. Usually they shied from contact with man, but some were bolder than others. During his visit to Seychelles, Rochon complained that "these monstrous crocodiles . . . throw themselves on any man who is careless of where he is walking", and Gillot wrote nervously that they were "very large and hungry".

During Duchemin's expedition several crocodiles invaded his shore camp. "One bit at a hammock and severed the rope. Someone fetched it several blows with an axe and it retreated . . ." One crewman woke to find his hand in a

Above: Man's best friend joins the thrill of windsurfing in the turquoise waters which surround Seychelles.

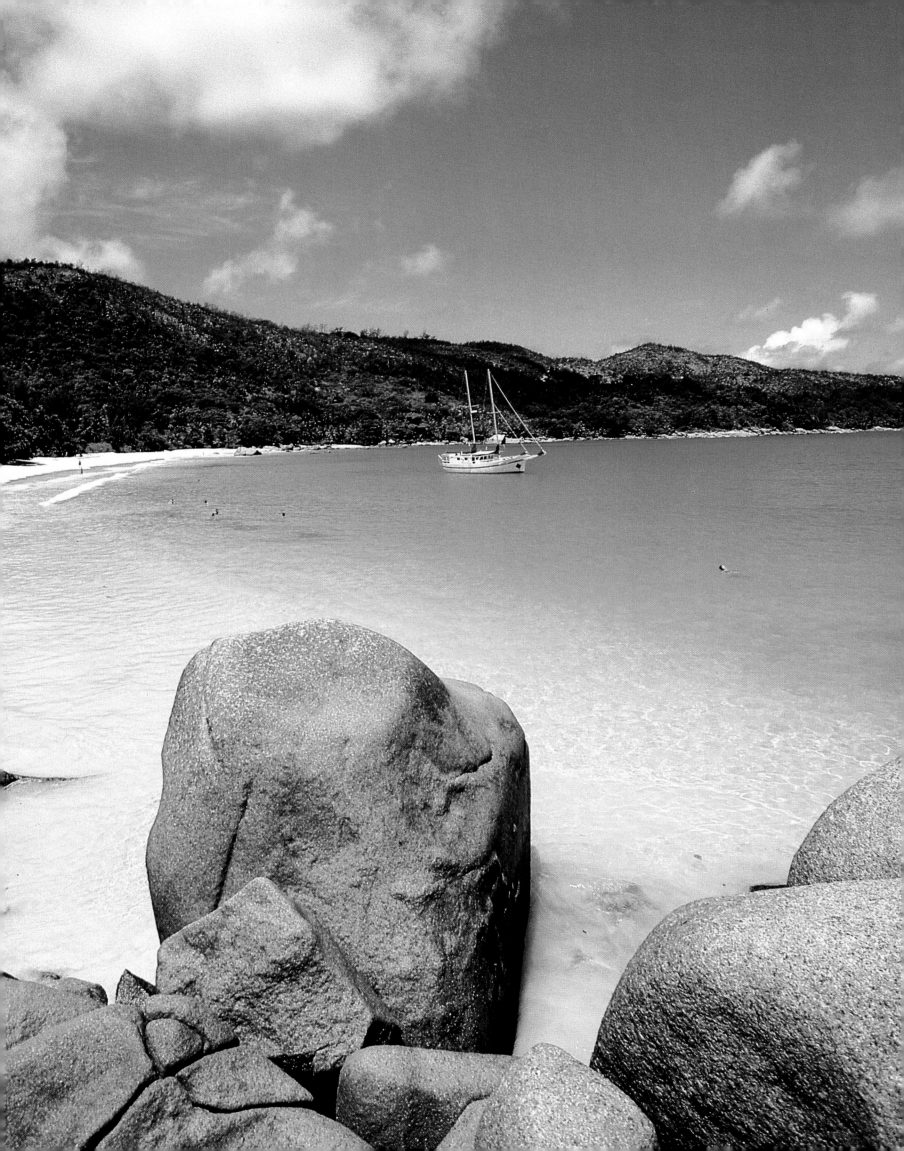

crocodile's mouth. Luckily for him it was a young reptile and he was able to shake it off. During the expedition to Praslin, Lampériaire's men fled from crocodiles, dropping their water casks as they ran from attack. Men killed them whenever they could.

In December 1770 an expedition was sent to quell misgivings about the safety of Grenier's new route to India. There were two ships, the *Heure du Berger*, and the *Etoile du Matin*. During their visit, a launch, in the charge of an officer called Charles Oger, was sent to nearby islands, previously unexplored. The largest of these covered about ten square kilometres and lay four-and-a-half kilometres off Praslin. There was a steep backbone to the island running north to south-east, rising steadily to a peak of about 333 metres. To the south, the ridge descended through a series of low hills. Duchemin had called it La Digue.

Oger set off early, and by nine was off the south-east coast, trying to decide how best to approach, for landing on the island was very difficult. Now there is a small breakwater opposite the main settlement of La Passe, and the gap in the reef is clearly marked, though even this is not an easy entry. The captains of schooners from Praslin are experts. They make the journey several times a day, and slip into the sheltered bay waters without a moment's hesitation. Once inside, they tie up at the little pier, which is always the centre of activity. The island has no landing strip and is entirely dependent on schooners for supplies. The stone quay is often piled high with building blocks, timber, beer crates, boxes of tinned goods, new fridges; all the paraphernalia of modern life.

However, Oger's men took a ducking when a squall blew up and flooded their boat. Their food, surveying instruments and the plans Oger had made of other islands were lost. The boat very nearly went too. Eventually they made shore dragging the boat, and collapsed on the sands. The rudder was so badly damaged they had to anchor the launch, swim to Praslin and climb from Baie St. Anne to the other side of the island for help. Yet they had little to report about La Digue. There was some land which could be cultivated and there were crocodiles. However, Oger left a document on the island formally annexing it to France. The document was deposited in a bottle and covered with a stone cairn.

The marshy plain on the east coast of La Digue was the obvious site for a settlement. Malavois described it in 1787 as "a sandy plain covered with bois de natte and several takamakas at the bottom of which one sees a small marsh and a stream of very good water which falls to the bottom of the mountain". The attractive woodland has a gentleness not found in the forests of the mountains. Trees spread their branches wide, and the sun slips through leaves of green, gold and red. The *bwa d'nat* is gone, but the takamakas survive, and *badamnyen* fill the gaps. Here and there are little pools of standing water. Overhead the rare black paradise flycatcher hawks for insects.

This bird is the symbol of La Digue. Apart from a few birds in the Côte d'Or

Above: Fruit bat, also known as a flying fox, hangs from its roost on La Digue Island. The creatures are regarded by many islanders as a delicacy suitable for a curry.

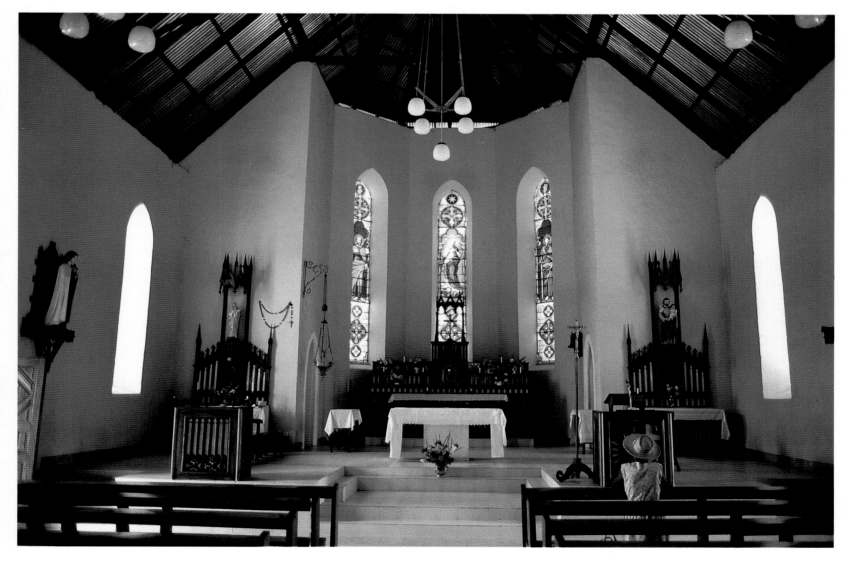

Above: Stained-glass windows backlight the altar in the cool, lofty interior of St Mary's Church, La Digue.

area of Praslin, it now occurs only on La Digue. A reserve for the birds has been established at La Passe, preserving an important area of takamaka and *badamnyen* forest on which the birds depend both for nesting and feeding. The trees are in demand from the boat-builders of La Digue, while the expanding population also threatens the birds' habitat, but with the advent of tourism, islanders now take pride in their unique inhabitants.

Male flycatchers are blue-black with tail feathers longer than their bodies. These long dark feathers give the bird its local name, *Vev*, meaning widow, due to their resemblance to widow's weeds. Females have chestnut brown upperparts, white underparts and a black head. A single egg is laid in a nest built at the end of a branch. Most breeding attempts are from November to April, though some nests may be seen at any time of year.

Beyond the woods, the marsh has been drained to allow the planting of gardens for vegetables and the inevitable coconut palms, which now grow even

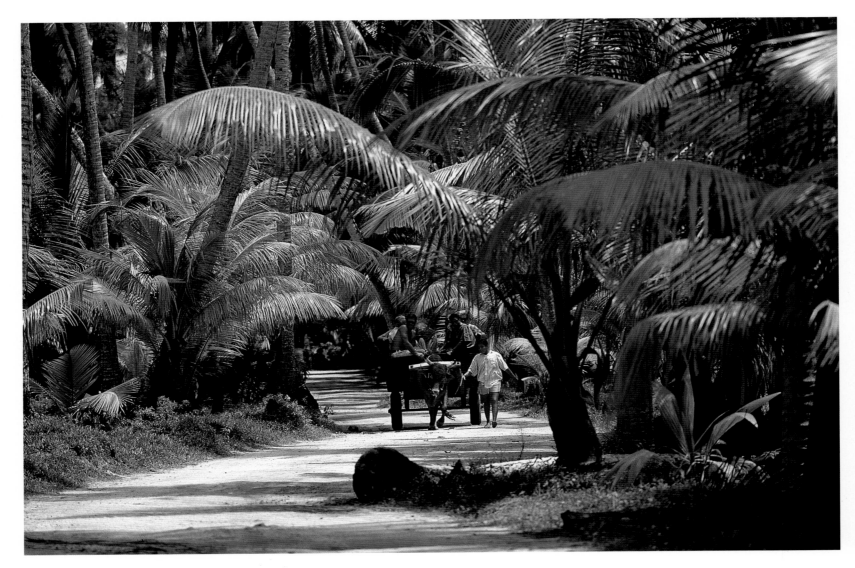

Above: Tourists wend their slow way by ox-cart along a palm-shaded La Digue dirt road.

on the highest peaks. All the evidence suggests a very fertile island with an easy terrain, welcoming to farmers, yet Malavois reports that several attempts to settle La Digue failed. He thought a family of "freed blacks, with a dozen slaves, could find a subsistence here".

In the end a party of deportees from another Indian Ocean island, Reunion, finally settled on La Digue in July 1798, led by Etienne Belleville, and a priest, Jean Lafosse.

On La Digue the roads beneath the trees are sandy pathways and rarely see a motor vehicle. There are just a handful on the island. The most common transport is the bicycle, but ox-carts are still used to transport people from the jetty. In former times the pace of the ox set the pace of life for slave and master alike. It was its strength which turned the oil mill, and its power which drew the carts loaded with sugar cane, maize, vanilla pods or coconuts. The rhythm of life was that of the creaking ox-cart wheel and the beam of the oil press as the ox

Opposite: Fishing boats at anchor in La Digue harbour, a sleek inter-island schooner is berthed alongside the stone pier.

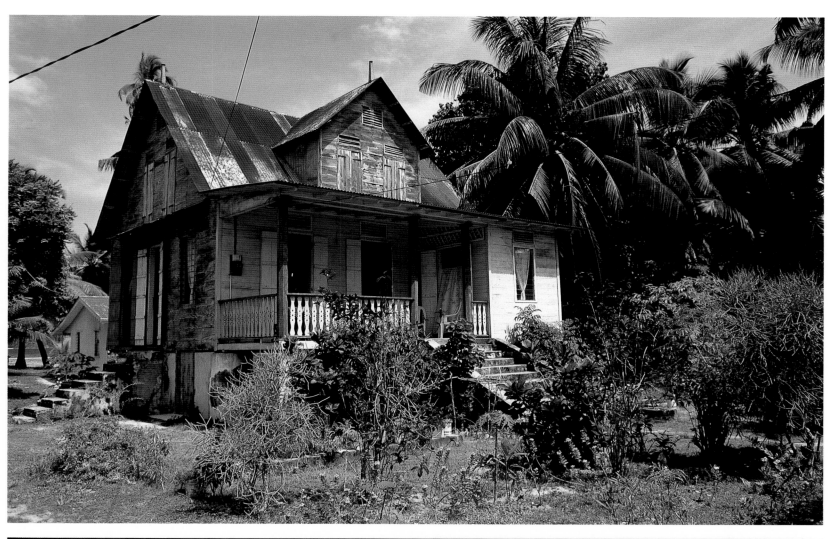

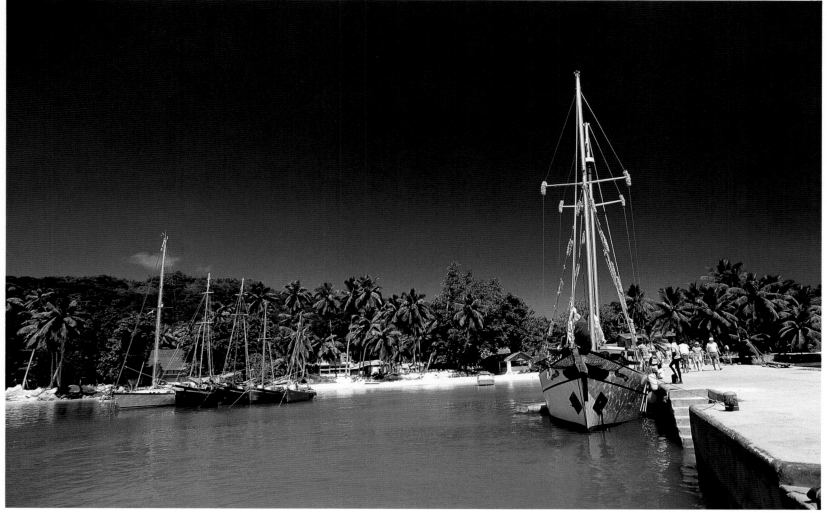

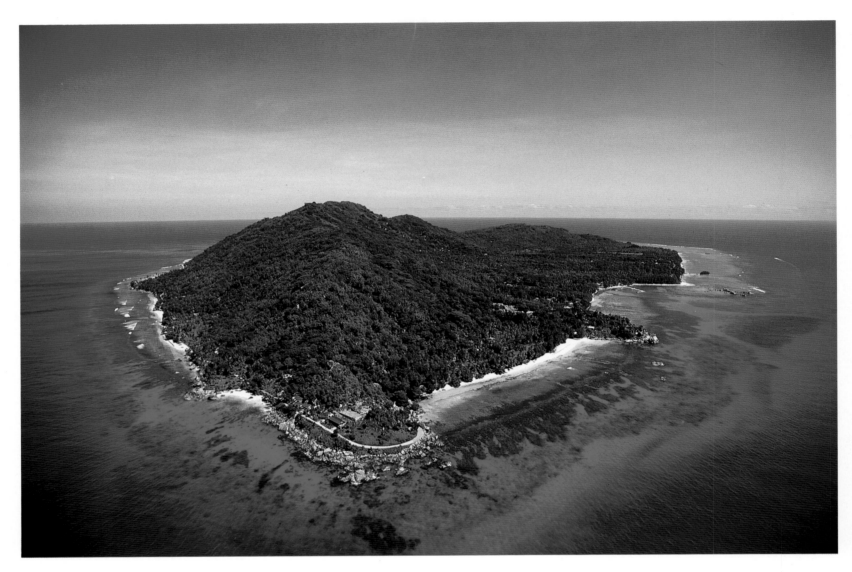

Above: Aerial view of La Digue, fourth-largest island in Seychelles, with the "capital" of La Passe and its pier in the bay on the right.

patiently plodded around a well-worn circle, a yoke from its shoulders powering the heavy wooden pestle.

Marianne North said that the population in her day was 600, "who possessed grand coco-nuts and consequent riches". It showed in the neat little planters' houses lining the track from La Passe, in a tropical garden suburb. Since access to different parts of the island was often by *pirog*, most plantation houses were built near to the coast. They are always raised off the ground as protection from termites, but this also provided a lockable "basement" for crops.

In the early days, life, even for the planters, was simple. They survived on slavery and a system of barter between settlers and visiting ship captains from whom they obtained luxuries to vary a monotonous diet of rice, sweet potatoes, turtle, fish and a few vegetables.

For amusement, the settlers had "cards, billiards and dancing . . . of the two former, the men are passionately fond, while the women are devoted to the

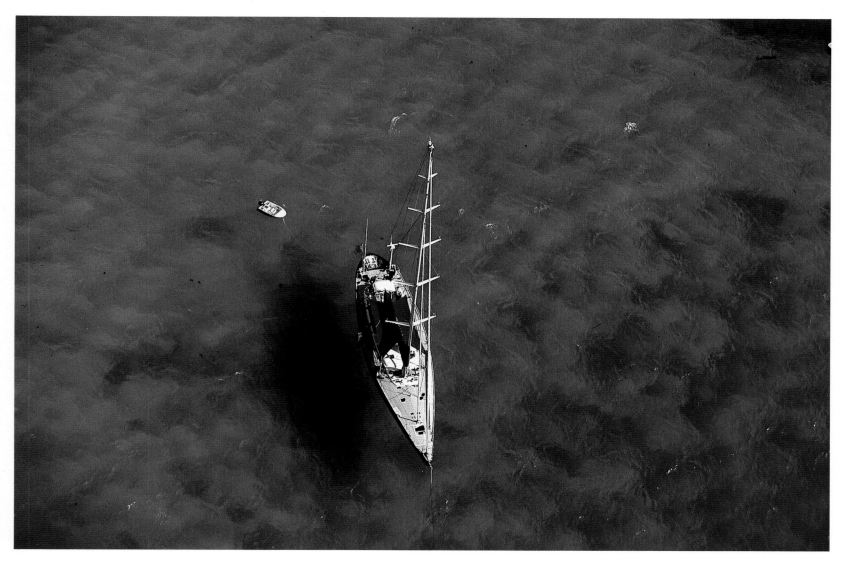

Above: Sailing boat anchored in the deep crystal-clear waters of La Digue.

latter". They also went visiting each other's plantations, even if this meant going to other islands. In 1824 Captain Owen remarked that "at the close of a party it sounds rather novel to a stranger to hear: 'Madame Chose's canoe!' instead of carriage, announced as in waiting; torches are at hand, they are lighted to the water, where some stout negroes, almost in a state of nudity, await to transport the ladies and gentlemen".

The wealthy did remarkably little, although all visitors to the islands were impressed by their hospitality. Windows were shuttered and doors curtained to keep out the heat, and in that semi-darkness they did little except talk and complain about the heat. "We never permit our daughters to work," one planter reported. "Our sons yes, if it must be. But not our daughters." Perhaps this was just as well considering the women were done up in short sleeved, white muslin dresses, covered in lace and frills, with a large hat to protect the face from the sun.

A dinner at Government House was the highlight in the empty social calendars of these ladies. A typical menu might be "turtle soup and cutlets, fresh fish, with an entree of flying foxes. For vegetables, bread-fruit fried, spinach from leaves of 'La Papaye' and 'Bread-making-tender-tree', curry of fresh crabs, a jelly of Iceland Moss picked up on the sea-shore. For salad, palmiste with large cakes of manioc toasted very hot and buttered".

Some occasions were shared with the slaves. New Year was a two-day festival marked by the giving of presents of clothing and blankets. The *grand blanc* family may have been invited to join in with the dancing in the camp. Back at the plantation house, the local rum flowed, and if someone had a fiddle, a *kanmtole* might get under way.

Few settlers were actually farmers, or came from farming families. Often they were retired soldiers or seamen who decided to stay, attracted by the hope of quick profits on timber, tortoises, and turtles. With no tradition in husbandry they dabbled in one crop after another until, for whatever reason, it failed, and they moved on to the next. One example was the cultivation of vanilla, which enjoyed a brief boom in 1877, peaking in 1901 and trailing off during the First World War, after the invention of an artificial substitute for vanillin. Most vanilla grown today is cured on La Digue. If you stop off at L'Union Estate during a leisurely cycle tour, you might see trays of it sweating in the sun.

Shady paths hug the coast, and crisscross the island. As each corner is turned, some of the most beautiful beaches in the world are revealed, each outdoing the other in perfection.

Life on La Digue centres on the busy quay and fish market at La Passe. Should you choose to leave the bustle behind and walk, ride the ox cart or hire a bicycle, you will enjoy the views as you set off from the village. A white cross is dazzlingly imprinted against the blue of the ocean, and reminds us of that once hazardous landing, and those who failed to make it. The shade deepens under the old takamakas as you pass the little hospital and enter a tunnel of greenery by La Digue Island Lodge. The tall hedges on either side are of *kanpes*, which produces shiny black seeds with a bright red end, and *glirisidya*. Vanilla vines need support, and *glirisidya* provides it.

Through the dappled shadows of coconut plantations old and new, the road continues over the flat land of L'Union farm, until it becomes undrained marsh. Here moorhens stalk warily on large yellow feet, and in the early morning you might glimpse the shy Chinese bittern. Frogs pipe, invisible amongst bulrushes, marsh ferns, sedges and water hyacinths. This is the habitat of the *soupap*, or freshwater terrapins. There are three species, but they are rarely seen in the wild these days.

Cattle now graze on the flat grassland that was once marsh, just before the Grand Anse River. Women wash their clothes in this fresh mountain water,

Top: Coconut husks laid out to dry in the sun on La Digue Island. When crushed, the husks will become copra, once the major industry in Seychelles.

Above: Sign greets visitors to La Digue where they travel by cycle, ox-cart or on foot.

Overleaf: Twin sister islands of Marianne and Félicité off La Digue.

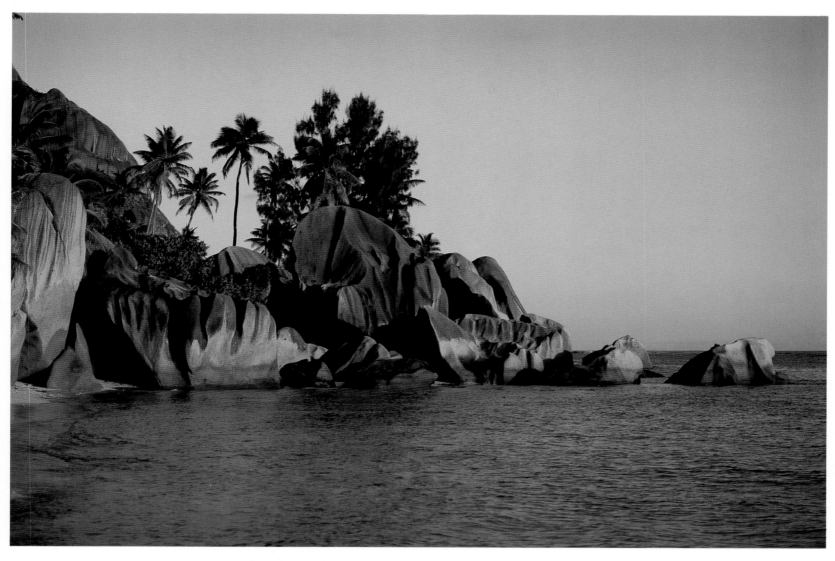

Above: Sunset casts a golden glow over Nature's granite sculptures on La Digue.

spreading them out to dry on the grass and boulders around their homes in a colourful collage. Climbing past a disused quarry and a ruined house, you descend towards Grand Anse on a path fringed with takamaka and *badamnyen*, reaching a marsh at the foot of the hill. The beach there is beautiful, but has treacherous currents during the south-east monsoon. You might venture on to explore the strange rock formations of Pointe Belize, or the little bays further up the coast. Whatever you do, La Digue will reward you with its old world charm, peace and beauty.

Beyond La Digue lie other islands — the Sisters; Grand and Petite, Félicité, and Marianne. They are all green and palm-fringed, lovely to look at but rarely visited. Félicité lies five kilometres off La Digue and covers about three square kilometres. The island is steep, with a rocky ridge running from north-west to south-east, with a central peak at 231 metres. There is little flat land, but the whole island is swathed in coconut palm. Only traces of original forest survive

beside the dramatic slabs of glacis, such as Glacis Rouillé in the north-east, where some takamaka and *badamnyen* grow.

Félicité's steep slopes were home to another of the British empire's "deposed potentates", the Sultan of Perak in Malaysia, who was sent to the island following the murder of a British government official in 1875. Abdullah Khan and his ministers, together with their wives, children and retinues, were first accommodated just outside Victoria, but were soon sent to Félicité, where they remained until 1879. They then returned to Victoria until their release in 1895. Now there is an exclusive holiday lodge on Felicité, with luxuries the Sultan would have appreciated.

Marianne was once a bird-watcher's dream. Three kilometres east of Félicité, one-and-a-half kilometres long, running north to south, it now has coconuts from shore to peak. An early account of the island dismisses it as a mass of huge rocks covered with bushes, with a few small land tortoises and no fresh water for most of the year. Unpromising as it might sound, it suited the local bird population, hosting Seychelles magpie-robins, Seychelles warblers, the chestnut-flanked white-eye, Seychelles fody, Seychelles blue pigeon and Seychelles sunbird.

Only the sunbirds and pigeons remain. The native forest was felled eighty years ago to plant coconuts. It was considered a "valuable" island and had a population of sixty. Today the plantation is abandoned, and there are some signs of forest regeneration, but it will never again play host to such a marvellous array of birdlife. Rats now live there, and the extinction of Marianne's original forest seems also to have spelt extinction for the chestnut-flanked white-eye.

Opposite: Sweetlips find safety in numbers by schooling; when attacked by a predator they can move with great speed and agility.

Opposite: Colourful example of lace coral and red soft coral, which are abundant in the underwater world of Seychelles.

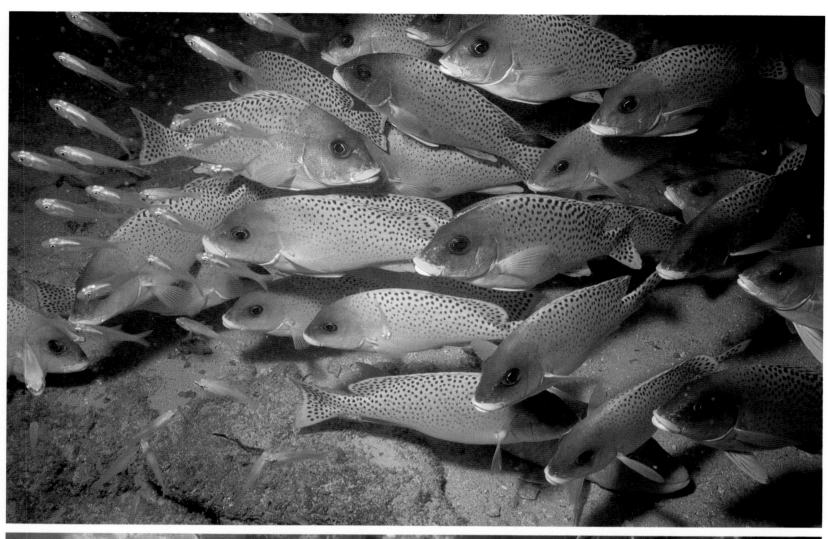

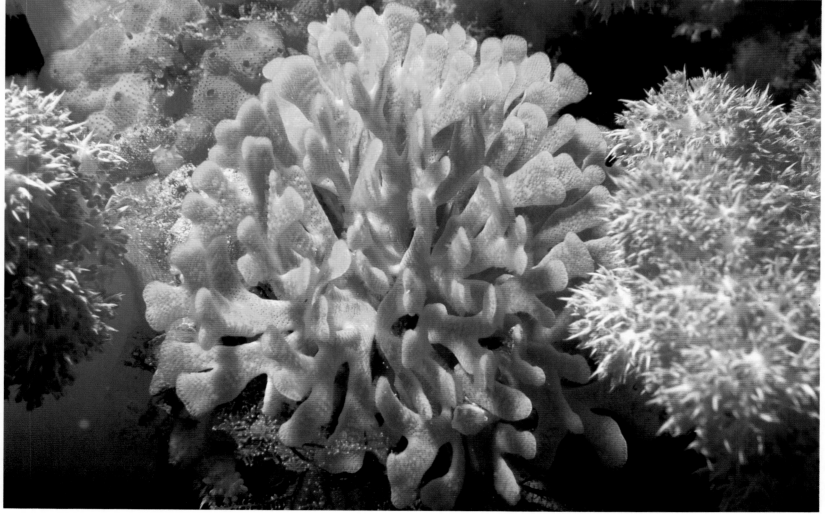

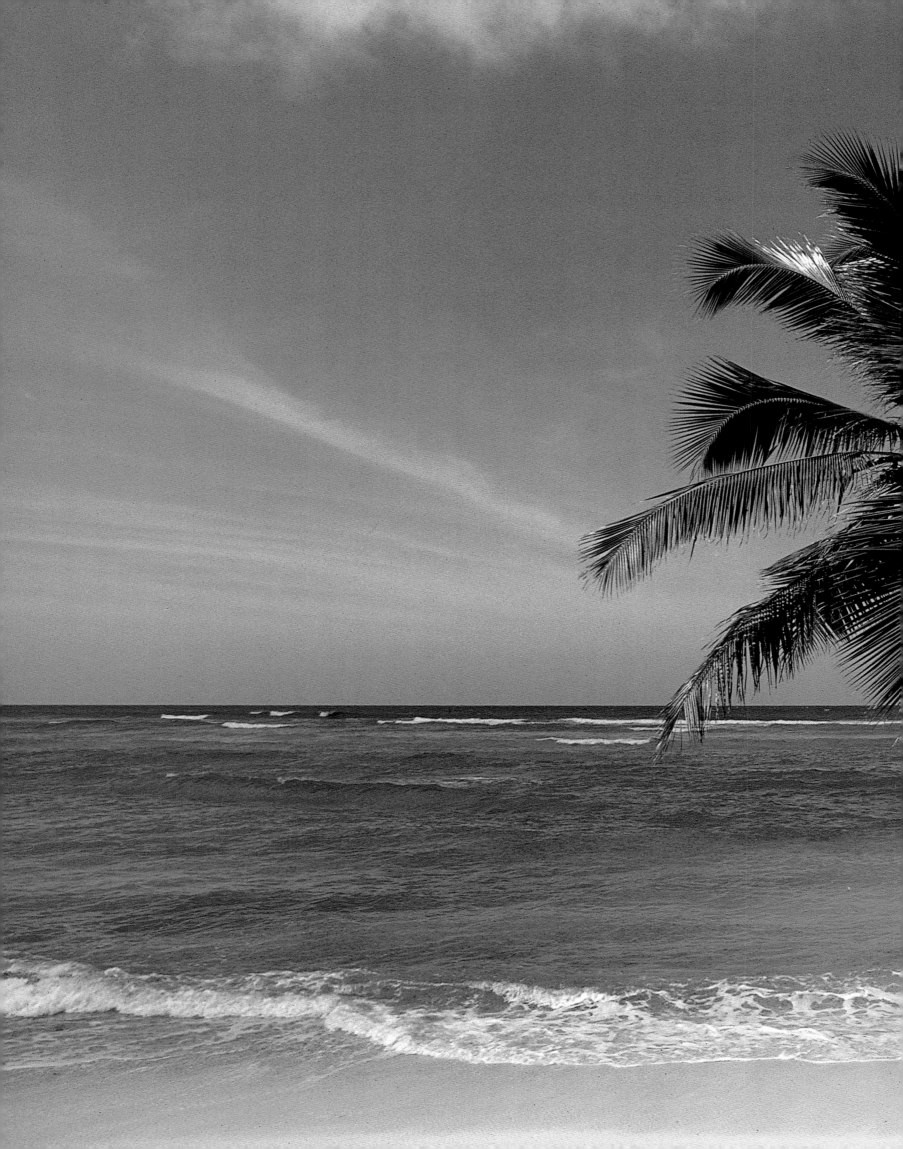

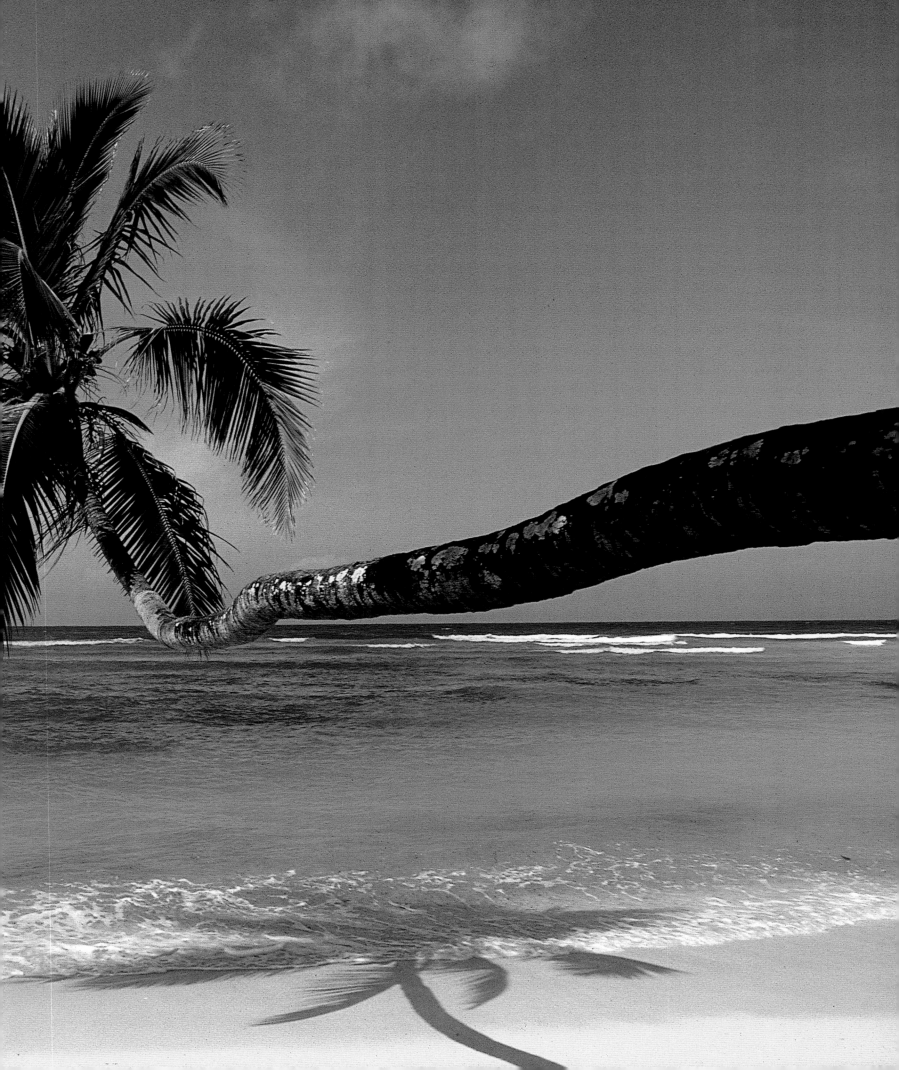

Previous pages: Lone palm guards glorious solitude of one of Silhouette's reef-fringed beaches.

Opposite: Thick, impenetrable and ancient rainforests, punctuated by gaunt and massive granite outcrops, cloak the mountainside of Silhouette Island high above the 'capital' of La Passe.

Seen from the sea, Silhouette must be one of the loveliest islands on earth. Sitting perfectly on the horizon, the steep hill rises to a central peak, often shrouded with clouds. Its air of mystery haunts the skyline — beckoning the visitor to see what it is really like.

As nascent dawn lifts a rose-tinged veil to reveal early morning, the island is a soft grey ghost against the sky. When the sun climbs, the hillside forests turn green, and silver streaks of waterfalls flash luminescent among the shadows. The slanting cliffs of *glacis* and the tumble of rocks skirting the coast blush pink. As daylight fades the forest blackens, hugging the folds of the mountains. The contrast of rock and forest becomes hazy, colours merging into dark blue and purple. As the sun finally sets the island is an obsidian outline, truly earning its eponymous epithet.

It did not take its name from this evening transformation. Etienne de Silhouette was the French minister of finance when the island was named by Dufresne's 1768 expedition. He enforced stringent economic measures and people complained that he was wearing them into shadows of themselves, so giving the word "silhouette" to the world's lexicons. It was Lieutenant Oger who took possession of the island in January 1771, claiming for France an island covering eight square kilometres lying about nineteen kilometres off the north-west coast of Mahé. There are two ridges of steep mountains. The Châine Catherine runs east to west and the island's highest point, Mont Dauban, 740 metres high, dominates the skyline. The ridges end abruptly in precipitous *glacis* and sheer cliffs. Four main valleys open up between the mountains, and to the east and west there are sandy plains where the main settlements have grown up.

La Passe is the only large village, almost hidden beneath the trees opposite a gap in the reef. A short sturdy pier with an open sided storage shed was the only hint of a settlement there until some concrete warehouses were built in the last few years. A handful of fishing *pirogs* float as though suspended in mid-air on the sheltered crystal waters inside the reef. Their hulls slap gently against the tiny ripples and eddies of the tide as they tug at their mooring ropes, tied to the takamakas which line the long streak of beach.

The village is dominated, as it has been for 130 years, by the grandeur of the Plantation House. Set back from the beach, looking sternly out to sea, the wooden house with its verandahs, tied back shutters, separate kitchen and outside bathroom, looks ready for an imminent family visit. But though it is beautifully maintained, the house is silent and empty. The track beneath the trees leads into the village, with its scattering of old and new houses. The wooden ones have taken on a silvery patina with age, and with their rusted tin, or untidy thatch roofs, look as if they have grown here like the trees.

Shutters are open, making black rectangles in the walls. From inside comes

Above: Sprays of spectacular bougainvillea grow in a riot of colours from deep purple to orange and white.

Opposite: Breakers foam across the reef which guards the long jetty at La Passe, "capital" of Silhouette, third-largest island of Seychelles. The river mouth in foreground forms a lagoon, quiet anchorage for island dinghies and fishing boats.

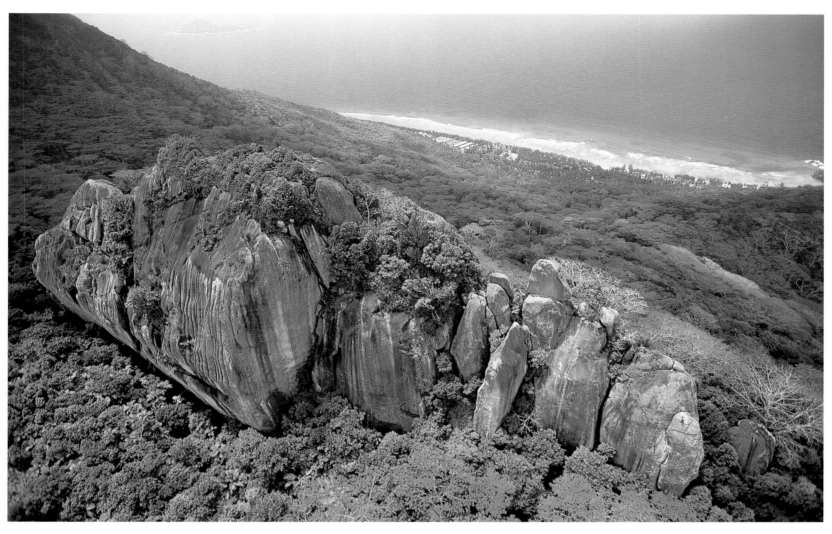

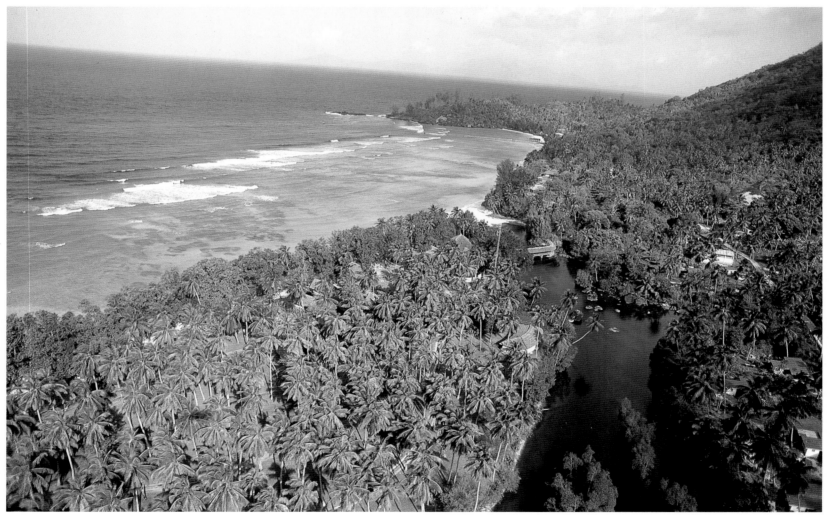

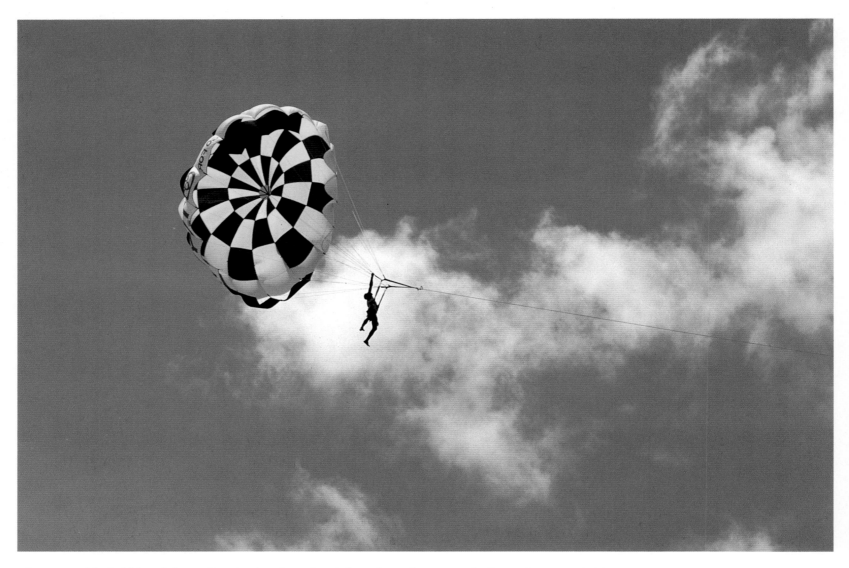

Above: Hauled by power boat, a parasailer takes to the air above the waters of a Seychelles beach.

the inevitable babble of the radio. At the door, brightly coloured curtains belly out in the breeze. Children play in the sandy dust among old paint tins planted with marigolds and Madagascar periwinkle. Chickens forage the ground in the shade underneath the raised foundations.

Beyond the trees, the beach glistens in the sunshine and old palm trees seem to prostrate themselves to kiss the sand, growing horizontally towards the sea. In a quiet marsh, moorhens rustle amongst the ferns, where a surprise awaits. A beautifully secret hotel for the ultimate in get-away-from-it-all holidays, laid out beneath the trees; a cool, hidden place where the mood is always relaxed. Even the handful of day visitors to Silhouette are asked to leave the hotel in peace. Nothing must disturb the tranquillity of the sleepy lagoon.

Behind the village lies the trail which climbs over the island to Grande Barbe. It begins as a steep scramble through fruit trees, but settles into a broad track, used almost daily by the villagers. Children from Grande Barbe must make the

Above: The Seychelles balance of sun and rain encourages the proliferation of a wide range of tropical flowers including the Armanda Christine Alba orchid.

daily journey to La Passe school and back. Steeper tracks up into the mountains with their eerie forests, are only for the serious walker equipped with a machete and guide. The forest there is tangled, the terrain steep, and the paths overgrown. It is such difficult country that, despite the world's greed for timber, much of the original forest of Silhouette above 300 metres survives.

In this jungle-like forest, rare and endemic animals, insects and plants survive, some found only on Silhouette. There is a profusion of life, even though the rocky slopes have virtually no soil on them, just a thin scattering of leaf litter. In some areas, a species of pisonia tree, only discovered in 1983, is dominant. It grows to about fifteen metres, and produces an open canopy so that the forest is quite light, allowing the growth of ferns, tree ferns, epiphytes, begonias and *latannyen*. All this is threatened by an introduced weed, *clidemia*, first recorded there in 1987, which now grows right up into the high-altitude forest.

Mont Pot à Eau takes its name from the large number of pitcher plants which grow near to the exposed *glacis* on the top. The creeper drapes over low bushes, and produces neat pitchers with lids. They are green, sometimes flushed with red, like apple skin. Each pitcher contains digestive fluid with which it breaks down the nutrients from the decaying bodies of trapped spiders, termites, ants and flies.

There are endemic scorpions in the high forest, seen for the first time in 1990 since their discovery in 1908. An endemic stick insect, formerly known only from one specimen, was also rediscovered in 1990 by an Oxford University expedition. There are tree frogs and caecilians, (very primitive, legless amphibians), chameleons, geckos, snakes (non-venomous) and skinks to be found in the forest, but the number of birds is surprisingly few. It was once hoped that the only full species of endemic bird ever wiped out in Seychelles, the Seychelles green parakeet, might survive in these remote mountains, but it now seems unlikely. Seychelles blue pigeons coo sadly, noisy Seychelles bulbuls chatter and crash through the trees, a few Indian mynahs whistle, and the Seychelles sunbirds dart, but no green and red parakeet flashes by. There is more reason to hope that the Seychelles grey white-eye might just survive there. There was a possible sighting in 1979, and in some areas, its favourite tree, the clove, grows in large numbers.

In contrast with this unspoilt and still largely unknown region, the coast has a more familiar and open atmosphere. There are the inevitable coconut palms, *badamnyen* and takamakas, besides mango, breadfruit and cinnamon trees. Behind the bay at Anse Patates, there is a dense mangrove swamp. Perhaps it was there that Oger saw the many crocodiles he reported. Anse Lascars once had a settlement, now abandoned. Hidden among the scrub at the head of the beach are twenty strange stone circles. Tradition has it that these are Arab

graves, and there is a theory that the headstones of some point towards Mecca.

A far more splendid burial place lies in a marsh just beyond the houses which huddle around the old and new kalorifers, or copra driers. It is Seychelles' strangest monument; a tiny Greek-style mausoleum in which lie members of the family who once owned the island, the Daubans. Marguerite Young, "a good sister", died in February 1864, aged twenty-six. Poor little Eva Dauban was just two years old when she died. This is a sad corner of Seychelles, a reminder that life was sometimes as harsh for the privileged plantation owners as it was for their workers.

In the early morning light, La Passe begins to stir. The community gathers to collect their share of the newly arrived haul of fish as it is thrown ashore, still iridescent with life. The shutters of *Gran Kaz* bang open to let in the daylight and fresh air, and there is the rhythmic sound of sweeping from every household. Today men set off to the farm in a tractor instead of a bullock cart, the chickens are raised in batteries, and no one goes up the mountain to harvest the cloves, nutmeg and pepper, tend the vanilla vines or tap the rubber trees which once grew there.

The Dauban family began their new life in the grand house at La Passe in 1860, and if you walk over the pass to Grande Barbe, that seems like yesterday. This village, dominated by its own *Gran Kaz*, has no electricity or piped water and there is no refrigeration. In front of the plantation house, cinnamon bark dries in the sun. The bark is harvested by the women, who are also responsible for salting any surplus fish the men bring home. At night paraffin lamps and candles flicker at the open windows of the houses. At weekends, the population of about twenty get together to listen to the radio, dance, swap stories and gossip. But for Grande Barbe change is on the way. Corrugated roofs are replacing thatch, and soon there may be a generator and a radio link to La Passe.

North, Silhouette's sister island, just five kilometres offshore, was also once a plantation but is now abandoned. Very little remains of any native vegetation, apart from a few screwpines clinging to pockets of soil in tiny clefts on the *glacis*. The soil is poor because of the guano taken from the island. However, coconuts grow well, and the island was famous for its cabbages. Once North Island was a tourist attraction, where beach barbecues were enjoyed in the shade of the decaying plantation house. Now it plays occasional host to day trippers in charter boats who snorkel in the brilliant waters. There are deep caves at the waterline, lashed by the curling waves, and a journey around North's coast is a spectacular trip.

The history of Frégate Island, many miles to the south-east, shadows that of Silhouette. It too was an efficient plantation, growing varied crops, and the name of one family in particular weaves in and out of its past.

Above: Colonnaded mausoleum of the Dauban family — whose patriarch, August, a former lieutenant in the French army, founded the plantations on the island of Silhouette — echoes the grandeur of life and death in America's deep south. The mausoleum, designed along the lines of Eglise de la Madeleine in Paris, contains the remains of August, his wife and their two daughters — all commemorated by weathered marble tablets.

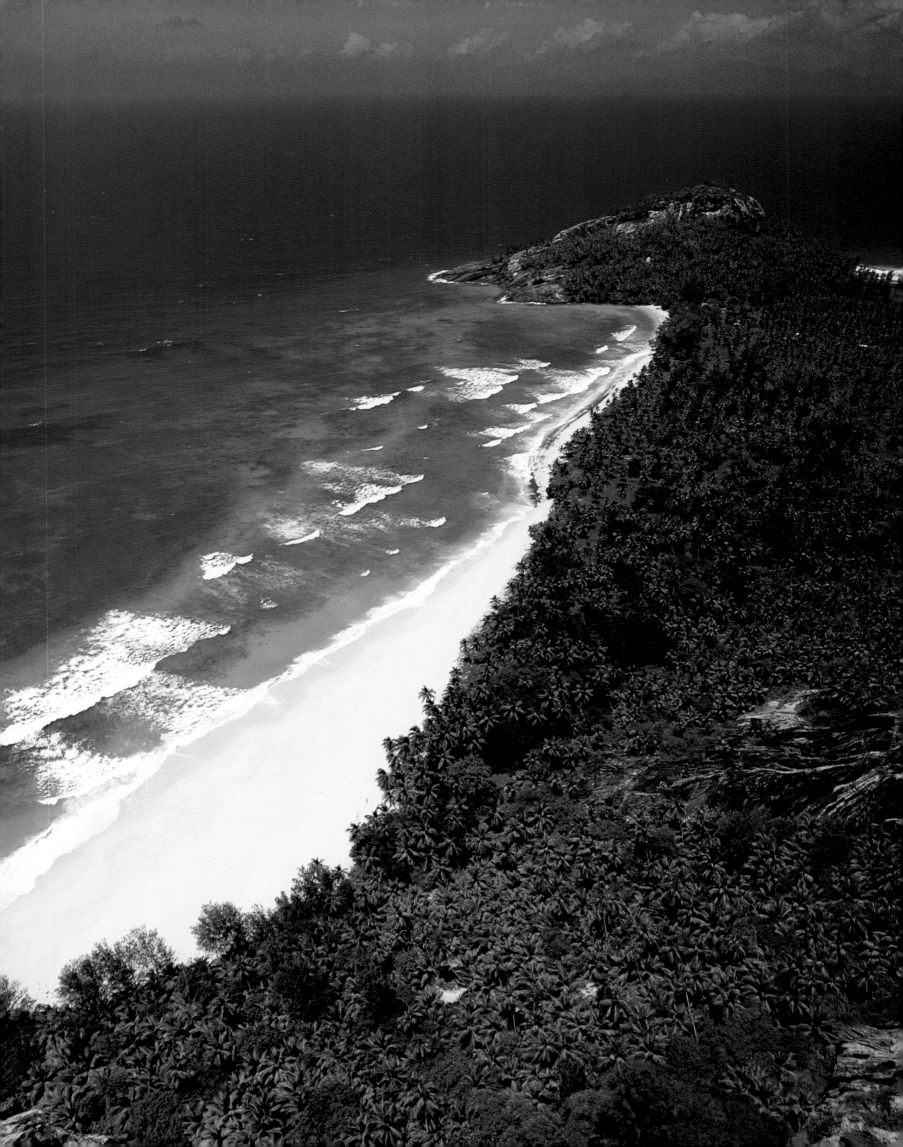

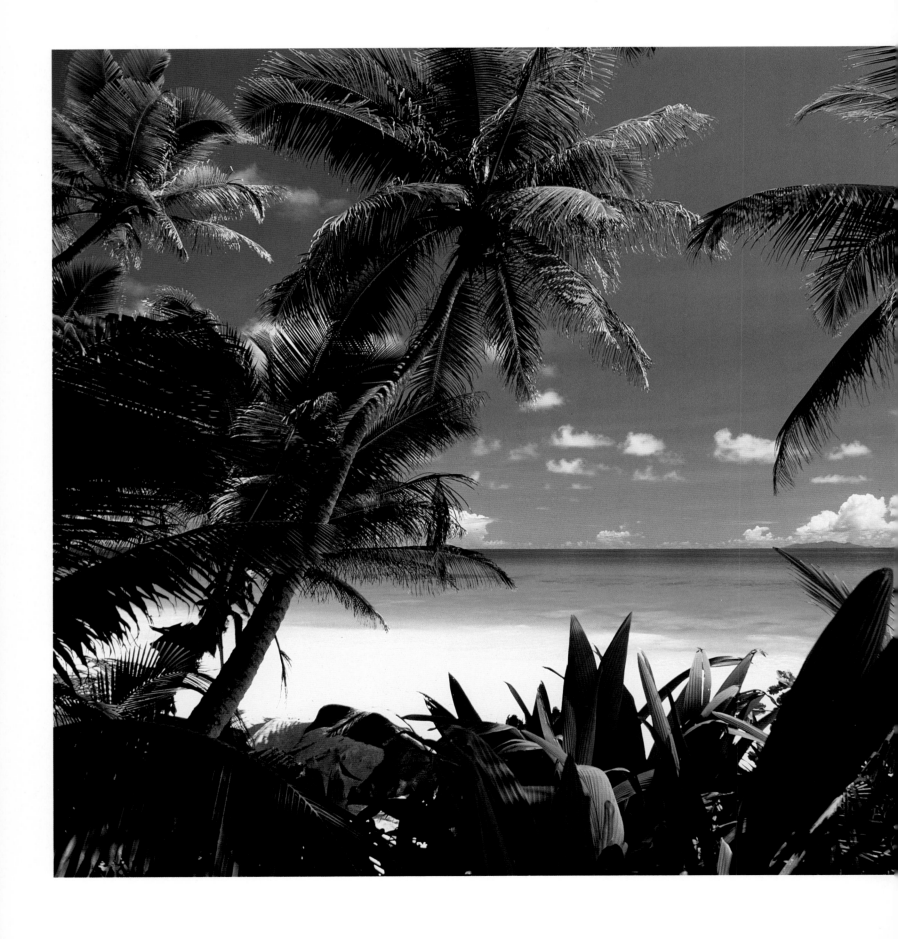

During its transformation from plantation to resort, Frégate has lost none of its happy atmosphere. Where copra once dried and men harvested rich crops of oranges, limes, bananas and paw paw, vanilla, pepper and coffee, tourists now wander as idly as the giant land tortoises which range free. There is still a rich bounty of local fruit and vegetables which go to supply the hotel. After the Second World War, the island was owned by the Savy family, who also ran a shipping agency in Victoria. Produce from Frégate provisioned visiting ships in those days, as it probably did further back in history, in 1785, when Monsieur Savy, "lieutenant of Frégate", had an *arpent* of land and a handful of slaves. The island was the property of the Savy family in 1813, and has had several owners, including English planters. It is still privately run.

Frégate has no easy landing place for a boat, but is nowadays just a fifteen-minute flight from Mahé. Visitors are led from the airstrip through the tangled trunks and hanging roots of a massive banyan tree into the welcome shade of the plantation house, now a luxury lodge. But the tropical cocktails awaiting arrivals sadly do not contain the local rum for which Frégate was once famous.

It might be thought that this rum fuelled the legend of Frégate's ghost; a headless woman living in a deep cave in the centre of the island. Her reputation kept neighbouring fishermen from Frégate's rich fishing grounds until it was discovered that the story had been concocted by locals to keep the plentiful supply of hawksbill turtles to themselves.

Frégate has always been associated with treasure legends, and ruins of so-called pirate settlements are still visible. A visitor in 1838 was shown "a large chest full of china from different countries, pikes from Holland, knives, battle axes and broadswords", allegedly left behind by pirates, besides the ruins of a deep well and a drain which supplied drinking water to the settlement from a spring. Early settlers reported a tall teak mast erected on a masonry base, coral tombs strewn with bones, copper sword hilts, and piles of rusty cannonballs. One visitor also saw "Spanish piastres and other coins called cruzados . . . on the shore where they have been cast by the sea". Add to this strange inscriptions and "cabalistic" signs scratched on the rocks, and you have more than enough food for thought when wandering around Frégate.

Although most of the original woodland is gone, the island is still green with trees, most of them exotics such as breadfruit, malay apple, mango, banyan and golden apple. There are many cashew trees, and a few ylang-ylang. The oil from ylang-ylang flowers was once extracted for export, but the days of this small-scale cultivation are gone.

Burrowing in the soil in search of invertebrate prey, are many caecilians. There are seven species in Seychelles. Like Silhouette, Frégate also has a scorpion population hiding under the rocks. They look fearsome, but their sting is not feared as much as a bite from the large centipede, and scorpions are not

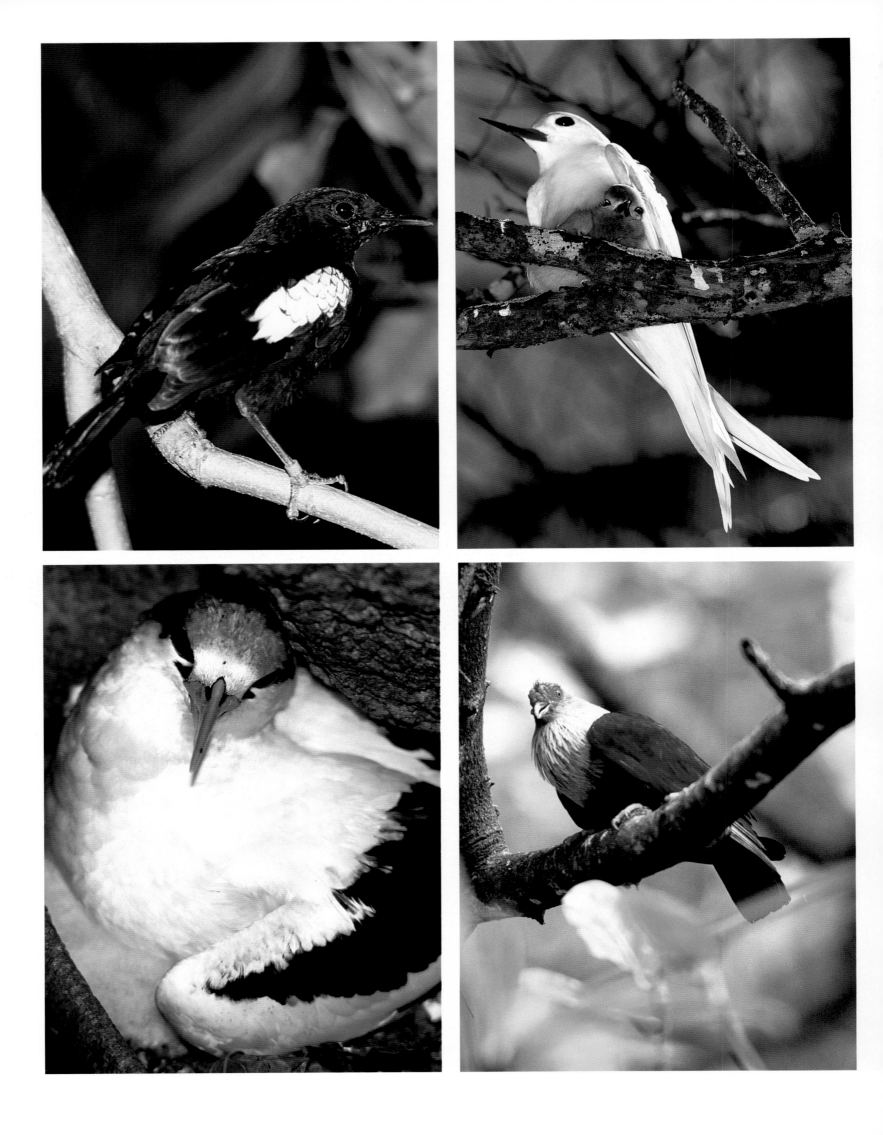

Opposite left: The magpie robin is the rarest of the unique birds of the granitic islands of Seychelles. Today, almost all the forty or fifty Seychelles magpie-robins are confined to Frégate Island. Opposite: The elegant white fairy tern lays a single, slightly spherical egg on a bare branch. A newly hatched chick possesses almost fully developed feet to enable it to perch on its precarious home for up to two months before fledging.

Above: Tourist takes a dip in the warm waters of the Indian Ocean.

Opposite left: The white-tailed tropicbird is one of the world's three species of tropicbird, two of which are found in Seychelles. It is the more common with major colonies of up to 2,500 pairs on Aride and 1,000 pairs on Cousin. Opposite: The Seychelles blue pigeon is unique to Seychelles, and fairly common. It is one of the most attractive birds of the islands, with a scarlet wattle on the crown and forehead, a white bib and an indigo-blue body.

often seen. Frégate even has its own species of beetle. It looks like an overweight spider, and although it belongs to the tenebrionid beetles, which are usually tiny, it is a giant of its kind.

The greatest rarity of all on Frégate, is the Seychelles magpie robin. Once it was fairly common on all the granite islands but was already in serious decline in 1864 when Lady Barkly in Mauritius obtained one from Seychelles as a cage bird. It lived for about two months, and on its death she gave it to Edward Newton, who then described scientifically, for the first time, only the fifth bird species recorded from Seychelles at that date.

Newton later visited Seychelles and learned that the *santez*, as it was known locally, was considered extinct on Mahé due to the "ravages of rats, and cats and dogs which have taken to the bush". Only on Praslin, Aride and Marianne was it thought to survive, Frégate being relatively unknown at that time.

Like many naturalists of his day, Newton was a collector. He found the

Left: The unique giant tenebrionid beetle is found only on Frégate and is usually seen clinging to the flanks of the sangdragon tree.

magpie robin to be "the boldest and most familiar bird I ever saw. It will approach within a few feet, and when sitting on a branch of a tree will allow itself to be knocked down with a stick". It was this trusting nature which almost spelled doom for the species, together perhaps with competition from introduced Indian mynahs and the practice, common in Newton's day, of taking young birds to keep in captivity. It was fortunate the Frégate population lived on in obscurity.

Today, in contrast with that obscurity, each individual magpie robin on Frégate is constantly monitored and the species is more closely studied than almost any other of the world's birds. A recovery programme implemented in 1990 has given hope for the future. Fledgling success has been improved, adult mortality has declined, and new territories have been opened up by planting over 2,000 trees and clearing scrub land to give the birds more open areas for feeding. All the same, the world population is still only a perilous forty or so individuals.

But the signs are good that the Seychelles magpie robin will not after all join the ranks of the many species which vanish from the earth each year. What is learned on Frégate could give renewed hope and fresh impetus to other projects throughout the world where the march towards oblivion seems unstoppable.

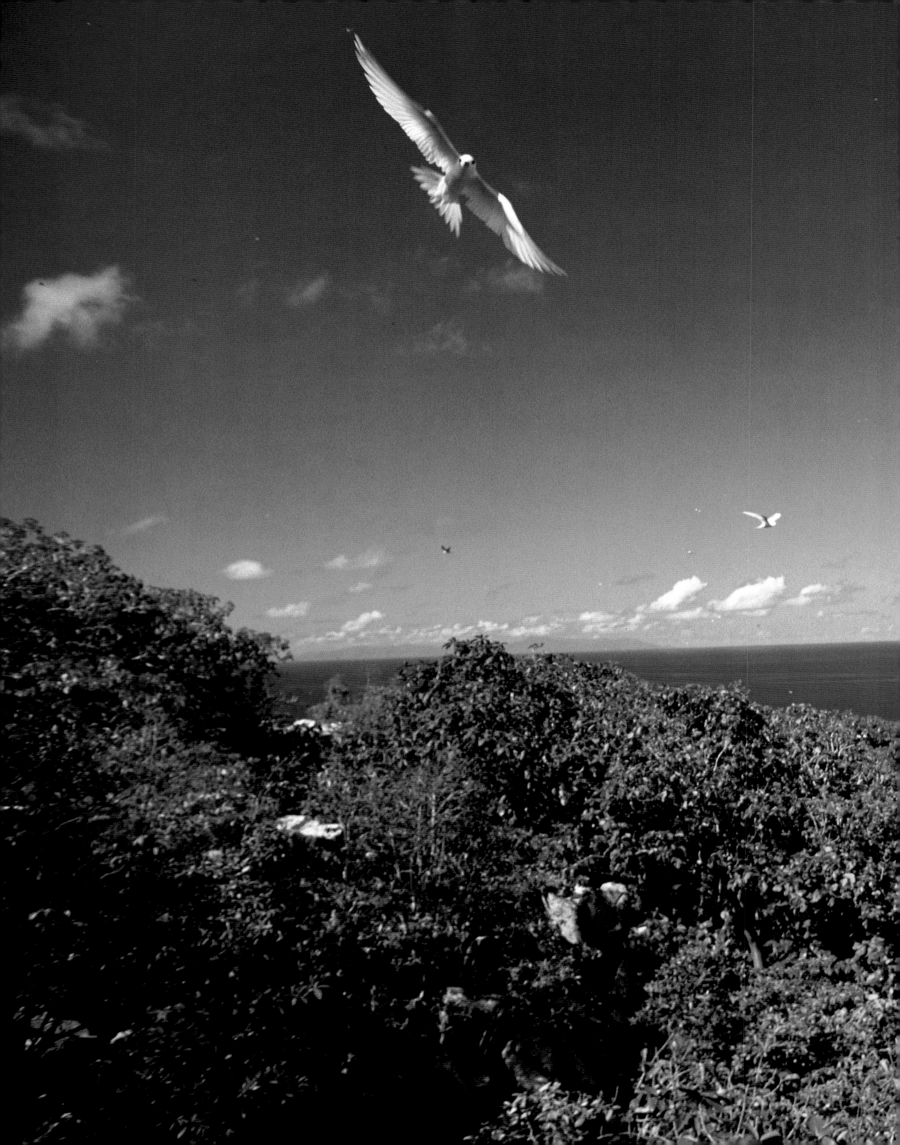

The islands where seabirds have bred in relative peace over the years have a different atmosphere from the rest of Seychelles. The air is full of the sound and smell of them.

The seabirds of Aride are one of the ornithological wonders of the world. Many are to be seen all the year around, but the huge tern colonies are most active during the south-east monsoon, from April to October, when cooler waters from south of Seychelles bring a plankton-rich cocktail and a profusion of marine and bird life in their wake. The din is continuous, there are beaks and tails protruding from every rock and hollow and every tree bows under the weight of nests and squabbling avian neighbours.

This is when the elegant but endangered roseate tern forms one of the largest colonies in the world. Once it occurred on many of the smaller satellites of Praslin and Mahé, but roseates are fastidious breeders — they hate disturbance. Away from the protection of Aride, rats and egg collectors have also taken their toll.

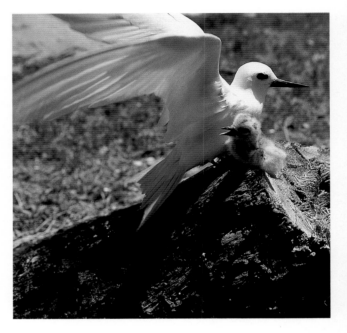

Above: Fairy tern and chick. Seychelles is one of the great avian treasuries of the world, for sheer numbers as well as rarity of species.

Aride also has the world's largest colony of lesser noddies. The population has grown tenfold from 20,000 pairs in 1955 mainly thanks to the protection and management of the Royal Society for Nature Conservation, and to Christopher Cadbury who purchased the island in 1973 as a nature reserve. The original pisonia forest was allowed to regenerate, providing nest sites, while the soft malleable leaves of the trees afford ideal nest material.

The sooty terns arrive around early March and by the end of April, half a million, crying "wideawake", are soaring over the island. Sooty terns are the most common seabird in Seychelles and provide some of the greatest wildlife spectacles in the islands at their breeding colonies.

Other tern species on Aride are fairy terns, bridled terns and the common or brown noddy. Aride also has two species of breeding shearwater — Audubon's and wedge-tailed.

There are white-tailed tropicbirds almost everywhere, adults nesting on both the plateau and the hillside. A single egg is laid and the chick fattens quickly on a rich fish diet until its body weight is actually greater than that of its parents. Eventually the adult birds abandon their offspring, and impending starvation forces it to leave the nest.

The view from Aride's northern cliffs is one of the most breathtaking in Seychelles. The island falls away beneath your feet, plunging to the turquoise sea, which is so clear it is possible to see the coral below and the turtles swimming over the reef. Dolphins sport just offshore while overhead scores of birds wheel and dip, soar and plunge. The lovely red-tailed tropicbird is a local inhabitant, its wire-like red tail almost invisible as it speeds by. This is the only island in the region where they breed, with just five or six pairs nesting in a small cliff-top colony.

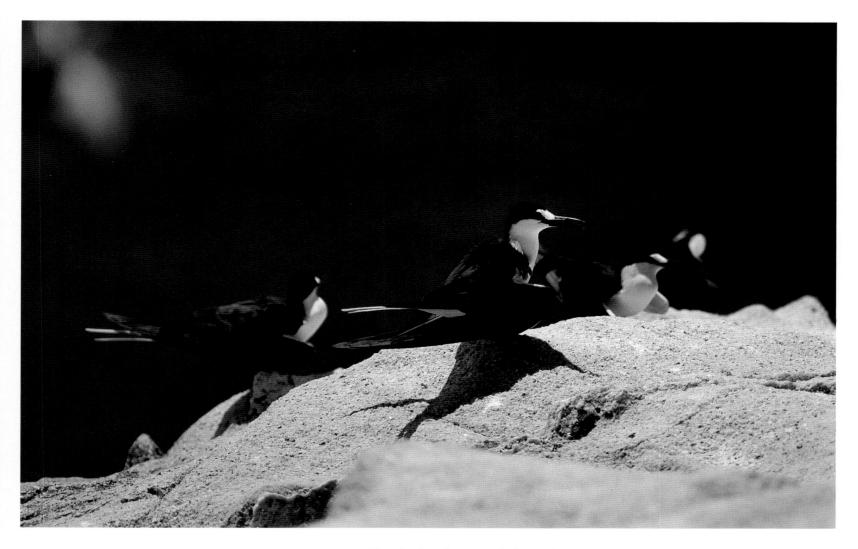

Above: Sooty terns breed in immense colonies on many Seychelles islands, including Aride where half a million birds nest each year.

Hundreds of metres below, the waves lap against the last granite outcrop before the Indian subcontinent, and laid out on the horizon is a panorama of other islands. When you tire of the landscape, you may enjoy the sight of another Aride speciality — hundreds of frigatebirds soaring effortlessly on outstretched two-metre wingspans. Two species, great and lesser, can be seen, though the former outnumber the latter by about ten to one. Aldabra is their nearest breeding site, some 1,000 kilometres away. They mostly gather on Aride outside the breeding season.

Among land birds, the Seychelles warbler takes pride of place. Once almost extinct, and confined to just Cousin Island, twenty-nine were introduced on Aride in 1988 in an endeavour to create a second safe haven. The spectacular success of this programme has led to the reclassification of the species on the Red Data list of birds from "endangered" to "out of danger". The increase in their numbers continues and Aride now has the world's largest population.

Aride also has its botanical specialities. Wright's gardenia, found naturally on

Opposite left: Hermit crab, a species which seeks shelter in the discarded shell of a mollusc, devours a coconut on Aride. Opposite: Geckos abound on idyllic Aride.

151 ◼

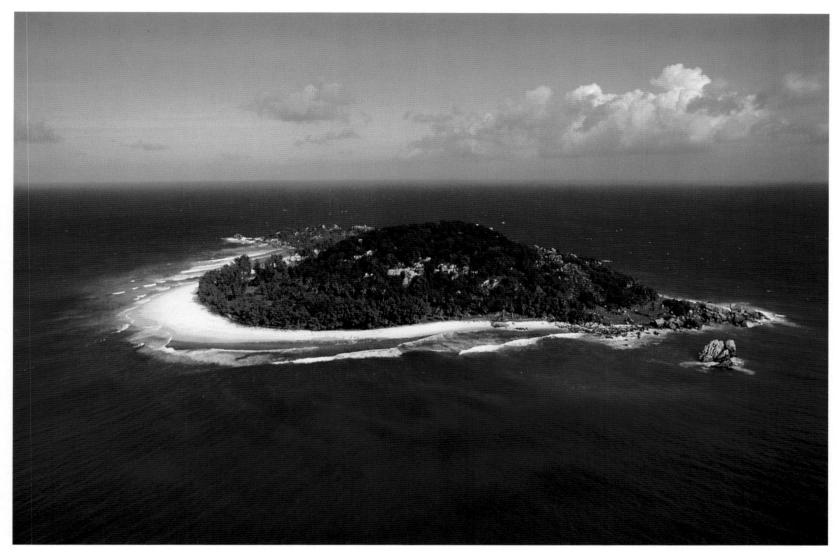

Above: Cousin Island, three kilometres off the south-west shores of Praslin, is a haven for endangered land birds of Seychelles.

Opposite left: Aride boasts one of the greatest concentrations of lizards on earth with one for every seven square yards. One of the commonest is Wright's skink. Opposite: Two species of terrapin can be found in Seychelles. Although protected, they are declining in most areas due to loss of habitat.

Aride and nowhere else, flowers in profusion on the plateau and the hillside. Later, green lemon-like fruits form which earn this tall shrub the local name *bwa sitron*. There is a species of peponium, also unique to the island, which has still to be scientifically described.

Enormous numbers of lizards are another distinctive feature of the seabird islands. One recent study on Aride found the density to be one lizard to every three-and-a-half square metres. Most common are skinks — the slender Seychelles skink, a creature of copper and bronze, and the larger, plump, Wright's skink, unique to Seychelles, though the latter is found commonly only on seabird islands such as Aride. Another endemic, the bronze gecko, hides in woodland by day, but can be seen clinging to tree trunks, guarding its small, round, white eggs.

Offshore from Aride lies another natural wonderland. Sir Peter Scott recorded eighty-eight species of fish in one dive on Aride's reef in 1986. Other

records have increased that total to about 150, and the final figure will be much higher. One speciality is the electric blue and black wedge-tailed tang, more common there than elsewhere. The ocean's greatest fish, the plankton feeding whale shark, is frequently seen, as are hawksbill and, occasionally, green turtles.

Cousin is Aride's sister island. Although much smaller, seven of the ten breeding seabird species found on Aride breed there, and on a world scale, its lesser noddy colony is probably second only to Aride's. Cousin is also owned by the Royal Society for Nature Conservation, although it is managed by BirdLife (formerly International Council for Bird Preservation).

It was bought in 1967 to save a single species, the Seychelles warbler, which had declined to just thirty birds. Christopher Cadbury and the World Wildlife Fund raised money to buy the island and save the warbler. As interest grew so did the price tag and the £5,000 guaranteed by the campaign only met one-third of the asking price. However Christopher Cadbury persuaded shareholders in

Above: The verdant island of Aride is covered with lush tropical vegetation and is partially surrounded by a spectacular coral reef. The view from Gros La Tête, the island's highest point looks down towards Praslin.

Above: White-tailed tropicbird fledgling in nest.

Cadbury's, the chocolate manufacturers, to contribute a further £5,000 and donated an equal sum himself.

Cousin, more accessible than Aride, is usually easier to land on, especially when the south-east monsoon is blowing, and the short distance from Praslin makes it easy for a half-day visit. An Aride visit takes a day.

Cousin's land birds include the Seychelles fody or *tok tok*, which breeds only there, on neighbouring Cousine, and on Frégate. Though not endangered, the absence or extinction of *tok toks* elsewhere is not easily explained. It does not seem to suffer from competition with its introduced relative, the Madagascar fody or *kardinal*. The native bird is mainly insectivorous, whereas *kardinals* are seed eaters. They choose separate nest sites, and the cheeky *tok tok* will fly into houses on Cousin to steal crumbs from the table.

Cousin and Cousine are perhaps the last refuge of the smaller, red-headed subspecies of the Madagascar turtle dove, native to Seychelles, which has disappeared elsewhere due to inter-breeding with the introduced grey-headed form. Privately owned Cousine has the potential to be every bit as good for birds as Cousin, particularly following an intensive campaign to rid the island of feral cats during the 1980s. In mid-1990, following hot on the heels of the highly successful Aride introduction, twenty-nine Seychelles warblers were transferred from Cousin to Cousine. Though the birds have not done so well on Cousine, the warblers there are breeding and, with three separate populations on three different islands, are hopefully out of danger.

Bird Island, ninety-eight kilometres north-west of Mahé, on the edge of the Seychelles Bank, lives up to its name. But there, the enormous majority of birds belong to just one species, the sooty tern, which congregate only during the breeding season when they create one of the most impressive wildlife sights Seychelles can offer. This flat, coral island, is a tourist hideaway where pleasure-seeker and bird co-exist happily. Outside the breeding season, or away from the bird colony, there is a feeling of peace. As guests wander towards the unobtrusive chalets of Bird Island Lodge, many get their first glimpse of the silver beach and the luminous blue sea and know they have found their ideal Seychelles.

Bird Island is protected by coral reef on three sides. In a regular cycle, the sand from the western beaches is swept up to be deposited on the northern tip of the island, forming a massive sandspit. One of the first descriptions of the island, written in 1771, mentions this great swathe of sand, which was ten kilometres wide that year.

Bird Island had little to offer eighteenth-century explorers who found it had poor timber and a single pond full of foul water. There were many tortoises and dugongs, which led to the island being given the unwieldy name of Isle aux Vaches Marines — Isle of Sea Cows.

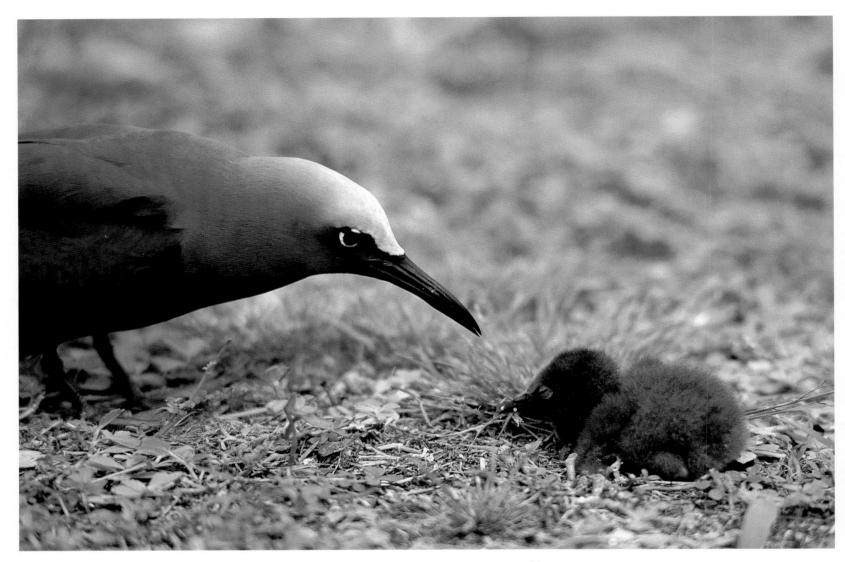

Above: Guardian hen checks safety of her chick. The brown noddy is mainly a ground-nesting species.

A 1771 description explains the more familiar name of Bird Island. The *Eagle* reported "birds innumerable" in a reference to the thousands of breeding sooty terns found there between April and October each year. At one time the island was probably home to large colonies of other birds but now the sooty is supreme.

Even if your interest in birds is only casual, the site of this colony at the peak of the season is one of the wonders of nature. In 1992 an estimated three million birds nested there. During the day, their raucous din guides you to the cleared area where they nest. The sooty terns constantly shuttle back and forth from nest to sea, skimming over the tournefortia bushes.

Given all this avian activity, it is not surprising that from 1895, Bird was mined for its deposits of guano, and 17,000 tonnes had been removed by 1905. The boom was short-lived, however, and by 1906 the deposits were exhausted. Now interest centred on the sooty tern eggs, considered a great delicacy in

Above: Lesser noddies in flight above one of Bird Island's glorious unspoilt beaches.

Seychelles. In 1907, nearly 100,000 eggs were taken, suggesting a colony of over a million pairs. In addition, the island was planted with coconut and paw paw trees, encroaching on the colony's traditional open nesting areas. This exploitation had its effect and by the mid 1930s there were only 65,000 pairs of sooties breeding, and in 1955, just 18,000.

In 1967 the Savy family purchased Bird and laid out a small grass landing strip. They also built a discreet lodge where visitors could find the perfect retreat. Today, one of the best sounds on the island is the bell which announces meal times at the lodge. Fresh produce grown here, including pumpkin, *patol*, paw paw, aubergine, okra, peppers, home reared chicken and pork, is cooked in traditional ways.

There are other birds besides the sootys on Bird. Pure white fairy terns roost unafraid in the eaves of the chalets, and lesser noddies squabble on the lawns for bits of nesting material. In the restaurant, Madagascar fodies and barred

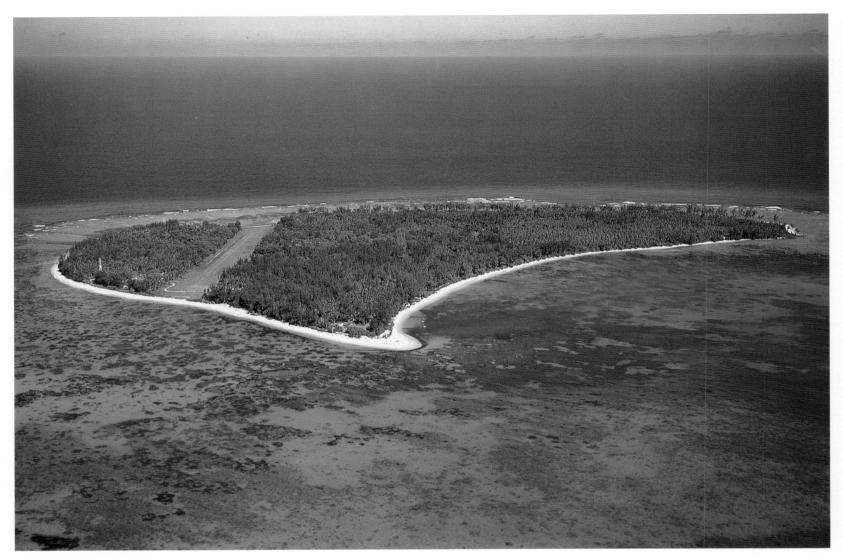

ground doves will steal the crumbs from your plate. Even turnstones, more familiar on the windswept beaches of Europe, are tamer than pigeons there.

The oldest island resident is Esmeralda, one of three giant land tortoises roaming on Bird, which were brought there in 1969. Raphael and Samantha "went bush" on arrival, but Esmeralda hangs around the settlement where the pickings are good. He is now officially the world's heaviest and largest tortoise, weighing in at 304 kilos, and needing ten men to lift him. His reputed age is 150, but this is questionable. All three tortoises are males, despite the two feminine names, given because of confusion over their sex.

Like Aride and Cousin, Bird also has a sister. Denis Island is another slip of coral, but it has no colonies of seabirds. It was once a coconut plantation, and most of the vegetation which has grown up since then is exotic. Its owner, French industrialist Pierre Burckhardt, made his fortune from a multi-national empire of paper mills stretching from Madagascar to the Soviet Union, and wanted to own an island where relaxation and solitude could for once take precedence over speed and profit. His search ended at Denis Island.

Ninety-five kilometres north of Victoria, this is the nearest coral island to Mahé. It is reached in just twenty-five minutes by plane, yet surprisingly you need to adjust your watch when you land. The time of day on Denis is one hour ahead of the rest of Seychelles.

The island was named after Frenchman Denis de Trobriand, who arrived there in 1773. He found an island covered with birds, tortoises, turtles and dugongs. Somewhere on the island he buried a bottle containing the Act of Possession, claiming Denis for the King of France. It has never been unearthed.

Above: Beached catamaran on the shores of Denis Island, where the time is one hour ahead of the rest of Seychelles.

Today, there is a luxury hotel on the island, with bungalows which blend in amid the casuarina pines and palms. No day-trippers are allowed, and guests may stroll along six kilometres of white coral sand, completing a circuit of the island without encountering another soul.

Palm groves and casuarina trees cover the interior except for the grassy airstrip. Flowers are dotted around, such as Madagascar periwinkle, which contains the drug vincristine, which helps combat childhood leukemia, and the tiny witchweed with bright scarlet flowers.

A forty-metre lighthouse, one of the oldest monuments in Seychelles, stands at the northern end of the island. The original light, put up in 1881, had a triple wick kerosene burner mounted on a wooden tower. When the masonry crumbled it was rebuilt by a Mr Ellis of Mauritius. He sent a ship, the *Crooboy* — first officer Mr Daniel Sauvage — with supplies and workmen. Members of the Sauvage family still live in Seychelles. The lighthouse was replaced by a steel version in 1911.

A short distance to the north of Denis, the Seychelles Bank plunges to tremendous depths. There, sperm and pilot whales are frequently encountered, together with game fishing's most treasured species; marlin, wahoo, dorado and tuna. Several records have been broken there, including at one time the world record dogtooth tuna. The best fishing is from December to March.

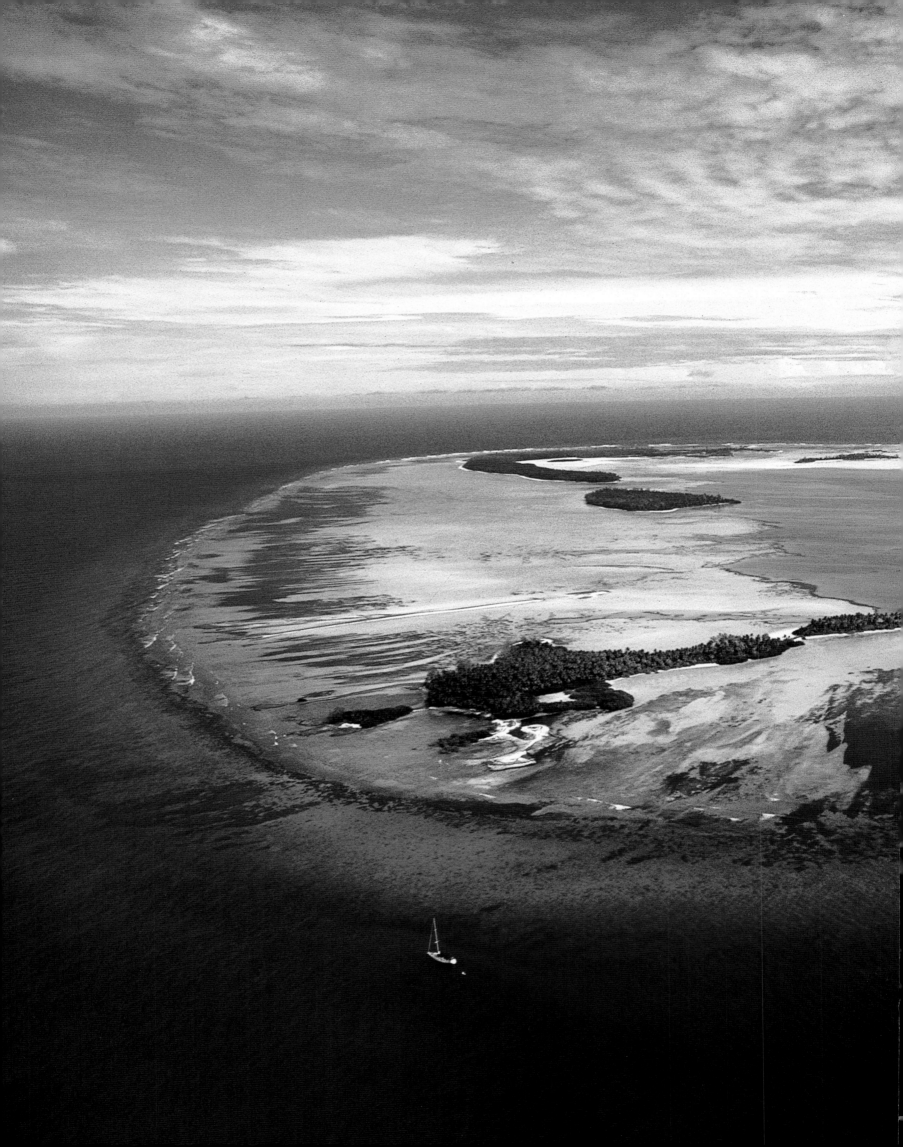

7 · JEWEL OF THE OCEAN

One of Earth's last secret places is the spread of sea between Madagascar and Seychelles, including the islands scattered there. These are the coral gardens of the western Indian Ocean.

The beauty of the coral atoll is legendary, but not until Darwin's voyage aboard the *Beagle* was the mystery of their origins resolved. Until then, the accepted authority, Lyell, believed that coral islands were built upon the ruins of submerged volcanoes. But Darwin decided such gems were the result of the slow submergence of the land, coupled with the upward growth of corals.

Darwin's theory was confirmed more than 100 years later. Similarly it is thought that the Amirantes have a basaltic basement at a depth of perhaps a kilometre though these are still among the least well known reefs of the world. The islands lie on a bank 180 kilometres long and eight to forty kilometres wide. Depths are generally less than forty metres. Beyond Amirantes bank, the ocean plunges to over five kilometres, the Amirantes Trench being one of the deepest areas of the western Indian Ocean.

The first description of these islands was written in 1609, after the *Ascension* passed through. The English ship logged nine uninhabited islands. Ashore they found no fresh water, but many tame "doves" and traces of occupation, including stone walls they thought were 100 years old, perhaps left by Arab sailors.

The French began charting the islands after 1770, but considered them of little interest. The islands were finally accurately charted in 1882 by Captain Moresby in *HMS Menai*.

The closest inhabited island in the Amirantes to Mahé is Desroches, 230 kilometres to the south-west. With its huge shallow lagoon and perfect beaches Desroches has something for everyone, and provides a contrast to the grandeur of the granite islands, being absolutely flat.

The narrow strip of land, just five kilometres long by one kilometre wide, is not only the location of a luxurious hotel, but also the site of a working coconut plantation and prosperous farm. Most of the vegetables and fruit are delivered to Desroches Island Lodge, two kilometres away in the south-west. Opened in 1988, the lodge is equipped with every comfort, including satellite communications.

The sea provides all your entertainment; swimming, diving, snorkeling, windsurfing, canoeing, water-skiing and deep sea fishing. Records have been set in Desroches' relatively unfished waters. A rainbow runner captured in 1989 was just 250 grammes under the world record at fifteen kilos. Other game fish include yellowfin tuna, sharks and sailfish.

There are marked sites for snorkeling, and reef fish teem over the coral heads. More adventurous divers can experience "The Drop" during calm weather. The land falling away steeply into deep water, forms caves which are often home to

Opposite: More than a million pairs of sooty terns cover remote Desnoeufs Island during the nesting season at the time of the south-east monsoon. Sooty terns, also known as wideawake terns because of their distinctive call, also congregate on Aride Island which boasts the world's only hilltop colony of this species.

Overleaf: Lush foliage of coconut plantation on Poivre Island.

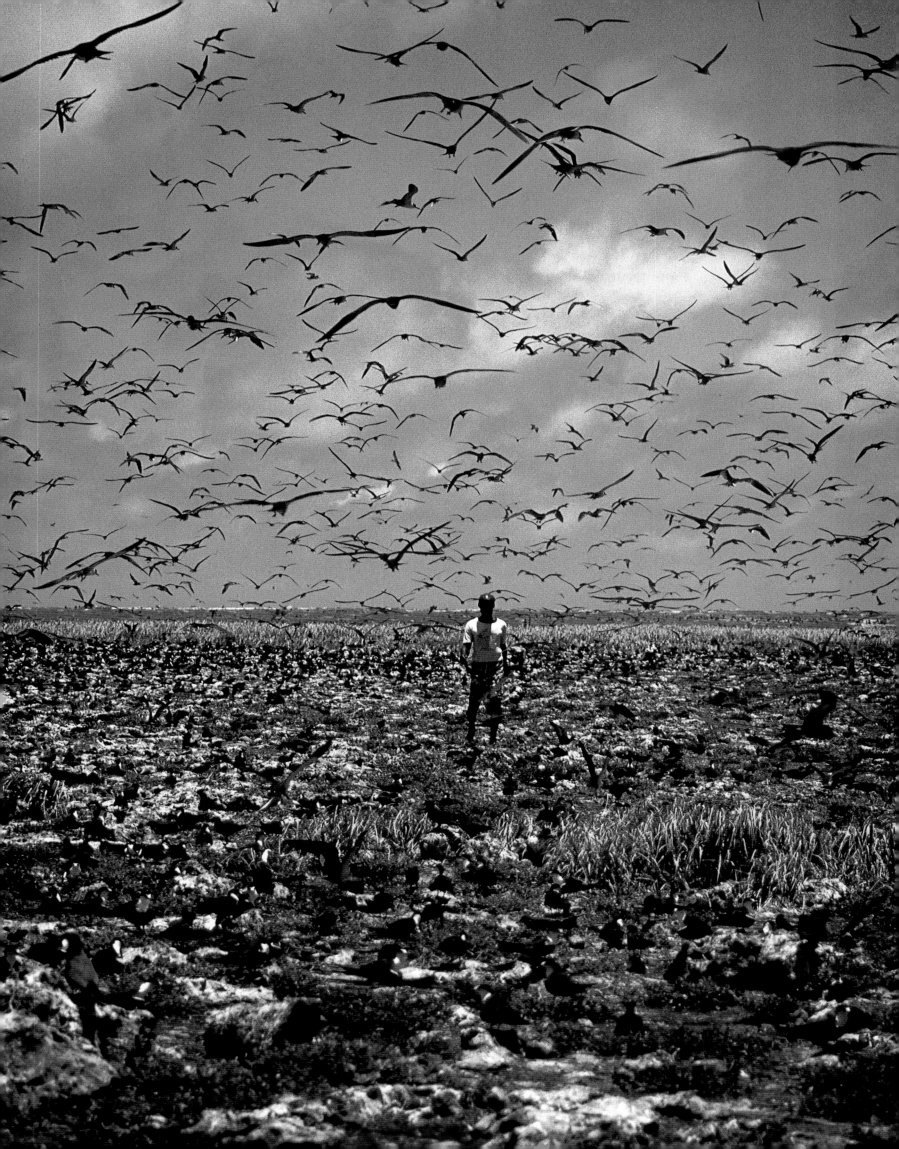

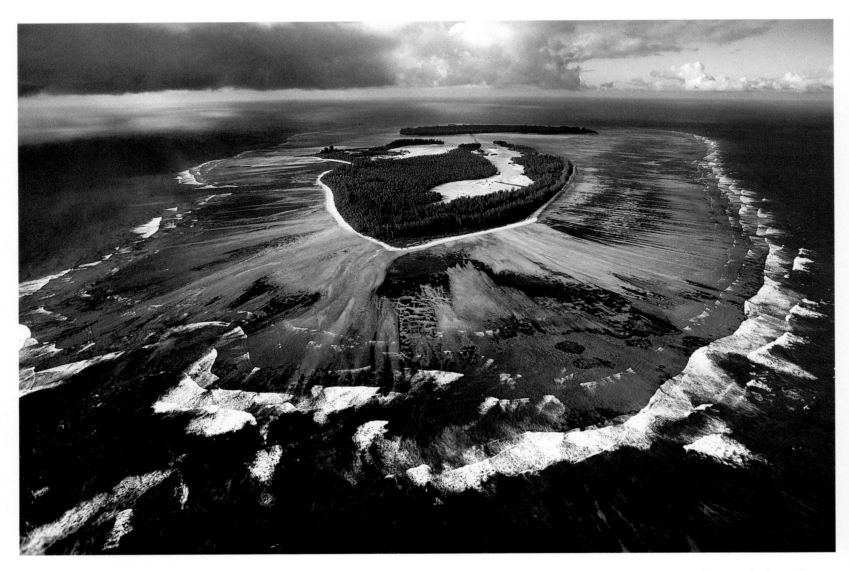

big rays and sleeping sharks. There is always the possibility of seeing a turtle, or huge shoals of Madras snapper weaving among the graceful branches of gorgonian fan corals. On night dives you can get even closer to the fish as they sleep among those underwater sunflowers, the orange cup corals.

Wandering along the sandy tracks visitors can hear the chatter of house sparrows among the palm trees. No one is sure how they arrived, but they have ousted the Madagascar fody from the prime sites around the hotel and houses.

Even more unusual is the presence of two species of game birds. Guinea fowl stalk the settlement, but the secretive grey francolins, probably introduced for sport, are harder to see, lying low in the undergrowth during the day. Occasionally a feeding party of grey plover, sandpipers and turnstones rise up from the airstrip, and whimbrels probe the grassy mounds which are all that remains of the area's disused salt pans.

Desroches produces high quality copra and has always been an important

Above: Aerial view of Poivre Atoll, named after a former French governor of Mauritius, Pierre Poivre, the man who introduced spices to Seychelles. It was offshore that the largest marlin ever boated in Seychelles — more than 400 kilos — was caught.

producer, as the settlement buildings reflect. The wooden copra shed dominates the beach, although it is now dilapidated. It is still a striking building, with its upper balcony reminiscent of a ship's bridge. A large cross throws its shadow into the lagoon, marked only by some initials and a date, 1953. Beyond this is the *kalorifer*, from which drifts the distinctive smell of drying copra that hangs about the settlement. Nearby stands the other essential feature of these islands, an antiquated copra press. In addition to coconuts, the farm once raised chickens, turkeys and ducks. They even produced honey. At one time there were over 400 hives on the island.

The manager's house stands at the end of an avenue of *bwa blan* trees, and the octagonal lock-up, looking spruce after renovation, has lost its barred windows now that it is no longer needed to house unruly workers.

Like most islands, Desroches had a ghost. The day before a ship came, this spirit would announce its imminent arrival with the cry known to all those who lived on the outer islands: "Sail Oh!" The strange call seemed to come from the cemetery. The ghost later appeared in front of the manager's son, and shocked him so badly he left the island.

Poivre Atoll, named after Pierre Poivre, is just a day's sail from Desroches. It is divided into two islands joined at low tide by a causeway. The island was first reported by Duroslan in 1771. He named it the Ile du Berger, after his ship. He found crocodiles, but no fresh water, and even the coconuts tasted bad. The main island of the atoll was given its present name later that year by Labiollière.

The settlement is on the northern island, clustered under an impressive grove of *bwa blan* trees, with their white trunks and bright yellow-green leaves. There used to be many rabbits on the island, but by the beginning of this century they had died out. The once valuable copra plantation is abandoned; three square kilometres of palm trees on the two islands grow tall and slender, stretching towards the sky. Beneath them, the increasing undergrowth is punctuated with the fresh green of sprouting leaves from fallen nuts. Labourers were once paid piece rates for dehusking coconuts, and to see a professional with machete and sharpened stick is a salutary lesson for every tourist who has tried his hand at the job.

Pierre Poiret, the alleged Louis XVII, lived on Poivre for several years, working at a cotton ginning factory. Descendants claim he was smuggled out of prison in 1793, after the execution of his mother, with another boy being substituted for him. The prince was apprenticed to a cobbler, Simon Poiret, and took his name. He was taken from Paris in a box of hay and, in 1804 aged nineteen, was shipped to Poivre. An agent had sailed ahead to deliver secret papers concerning the young man to de Quincy, then commandant of the Seychelles. In 1822, Poiret went to Mahé and was given two land concessions at Cap Ternay and Grand Anse, to set up a cotton plantation.

Above: Sunworshippers on the stunning white sands of D'Arros Island.

There he met Marie Dauphin, by whom he had two daughters. Later he lived with Marie Edesse of Port Glaud, with whom he had seven children. Some of his descendants are said to own pieces of plate with the arms of the French royal family, and a series of letters written by Poiret between 1824 and 1882 to his "uncle", Charles X of France. There is a strange silence in the official records concerning Poiret, which suggests that, whoever he was, he was no ordinary settler.

African Banks marks the northern limit of the Amirantes chain. South Island has submerged in recent years, and North changes in shape and size according to the season, sometimes having sandy beaches, and at other times presenting an exposed rim of honeycombed sandstone to the lagoon. Perhaps it too will sink one day, taking with it the automatic lighthouse erected in 1972 to mark this danger to shipping.

While African Banks survives it is a haven for breeding terns, including crested tern, sooty tern and brown noddy. The rare roseate tern has also bred here, though there are no recent records.

Rémire lies south of African Banks, though on some charts it is called Eagle Island. It is roughly circular with an area one-third of a square kilometre. Once a small population harvested coconuts and guano. In 1935 a sailing ship from Mauritius, the *Diego*, went aground there. All sixty-eight passengers and crew survived, but nearly died from lack of food in the following ten weeks, before they were rescued.

Next island in the string is D'Arros, an oval platform reef, discovered in 1771 by Labiollière. It was named after Baron d'Arros, Commandant de la Marine on the Ile de France. When the Seychelles economy was dependent on copra exports, D'Arros was a very important plantation. In 1906, the trees there, and on neighbouring St. Joseph, yielded 43,000 nuts a month.

St. Joseph lies across a deep, narrow channel from D'Arros and is the epitome of a coral atoll; a circle of thirteen green oases of land, each surrounded by sparkling white sands and dotted around a shallow lagoon of bright blue water. The main island is at the eastern end, with two large islands, Fouquet and Resource, on the northern rim. Some islands have changed considerably during the last century. Chien has shrunk in size, while Bénjamin has splintered into a group of little islets.

Another islet, Pelican, takes its name from the pink-backed pelican, said to have been common there once, breeding at the eastern end of the atoll. There is no other record of pelicans on any island of the south west Indian Ocean.

South of D'Arros are the tiny, bare coral cays of Boudeuse and Etoile, and the larger island of Marie Louise, one of the few permanently occupied islands of the Amirantes group. In 1905 a steamer loading guano there caught fire and sank.

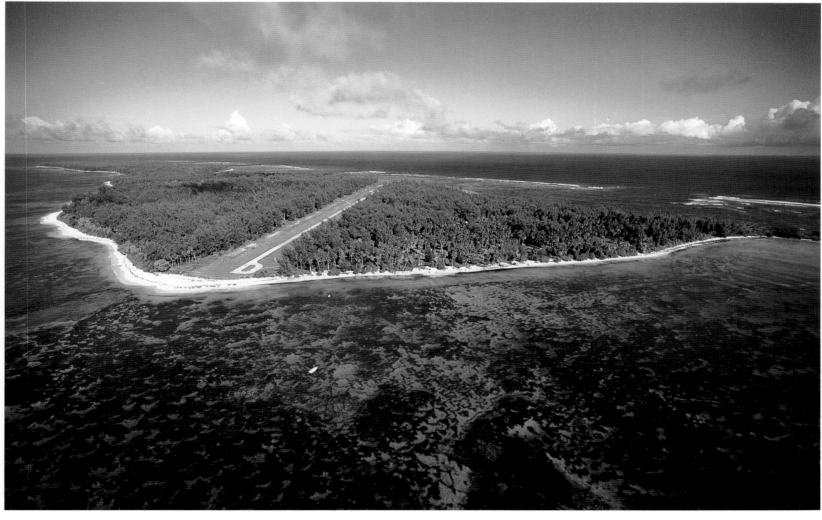

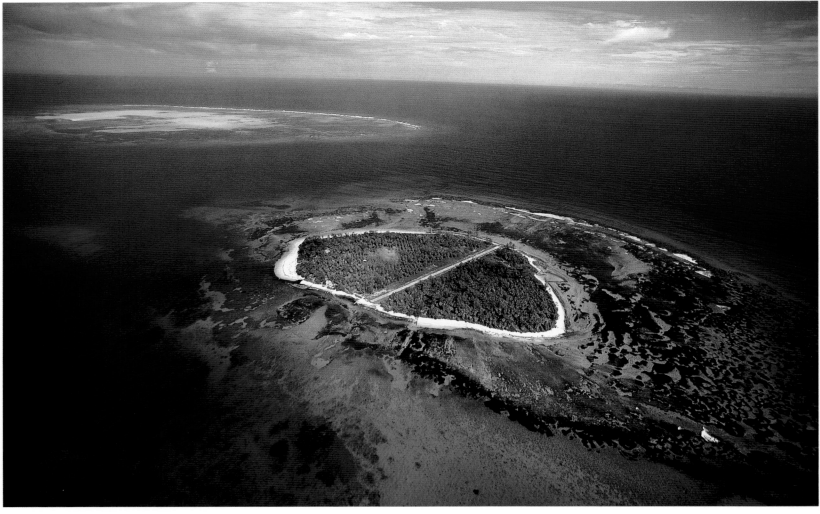

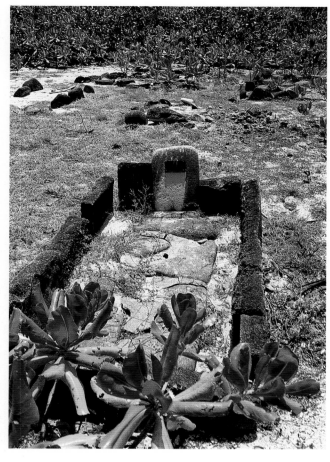

Opposite: Sand Cay, a tiny island which lies between D'Arros and Poivre Atoll in the Amirantes.

Above: Dusting of coral sands covers the forgotten grave of Julia Fagerstrom, 1847-1908, on the remote island of Marie Louise, one of the few settled islands of the Amirantes group.

Opposite: Newly-carved landing strip cuts across the tiny island of Rémire, also known as Eagle Island.

Desnoeufs is a main collecting ground for sooty tern eggs. They were drastically over exploited, but now their collection is controlled. In order to ensure only fresh eggs are taken, the ground is cleared after sundown. The birds will then settle and may lay an egg the next day. In the past, the eggs were simply taken every time until the birds laid no more.

South of Desnoeufs, deeper waters divide the Amirantes from the Alphonse Group, the next set of Seychelles islands, though both groups lie on the same ledge. Before leaving the area, however, visitors should explore two islands which do not fit easily into any group.

Platte Island lies about 140 kilometres south of Mahé. It is about one-and-a-half kilometres long, and so flat, it is only visible from the sea at a distance of about sixteen kilometres. From the air, however, it is spectacular. As the plane circles you see the emerald green island surrounded by a huge submarine platform drying out in patches as the tide ebbs. On the approach, you can spot eagle rays and reef sharks in the crystal waters.

The plane bounces along the landing strip, which is lined with flowers of yellow, pink and white, and comes to a halt opposite the small settlement where a handful of men still farm the land, collect coconuts and raise pigs and chickens. The flight from Mahé takes thirty-five minutes yet the workers talk about the day they will "go back to Seychelles" as though the two islands were worlds apart.

You can walk right around Platte in an hour. The shoreline is edged by salt resistant plants such as half-flower (or scaevola), *bwa blan*, *bwa tabak*, and the ubiquitous coconut palm. Here and there a geiger tree has scattered golden trumpet-shaped flowers on the white sand, or *bwa d'amann*, an indigenous vine, climbs up to display its ten-centimetre-long white flowers which open at night. It is at night that the flowers of the barringtonia or fish poison tree open their four petals to reveal a mass of pink and white stamens. The seeds of this tree, which contain saponins, will stun fish in a rock pool if they are grated and thrown in.

A hundred or more whimbrels probe the drying sandbanks searching for food. They have travelled from as far as the Arctic, as have the turnstones and many other waders. Fairy terns, brown noddies and white-tailed tropicbirds are occasionally glimpsed, but on the land there is just one species of bird, the Madagascar fody. Life on Platte is tough yet, like the birds, man has persevered. In some cases fate has given him no choice. One hundred and eighty people, wrecked on *L'Hirondelle*, a French privateer, survived on Platte for twenty-two days while they built a raft to sail to Mahé. In May 1863, the *Perle* was wrecked on Platte's coral reef. Crew and passengers were saved and rescued a month later.

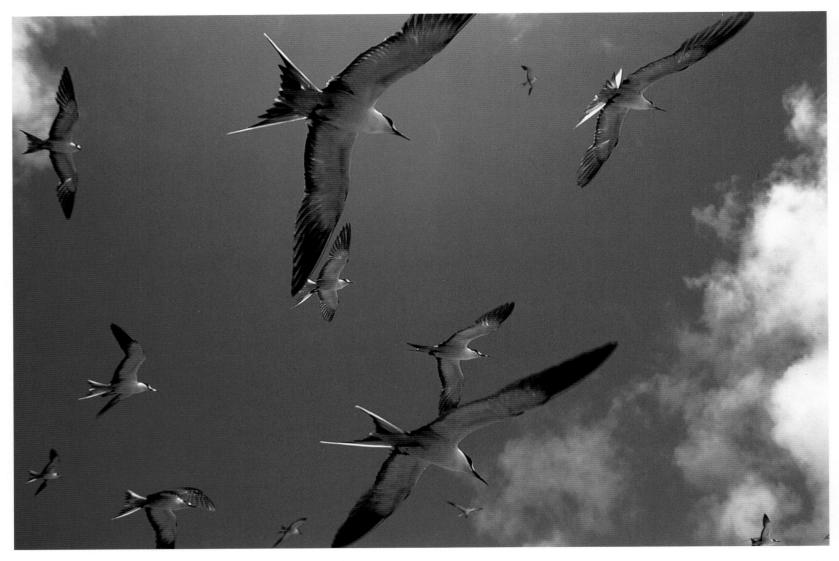

There was an attempt in the years after 1814 to use Platte as a quarantine station. Not surprisingly, most masters balked at the prospect of spending weeks isolated on this island with sick passengers or crew, without any medical facilities. Water was scarce and there was no fresh food, and the authorities abandoned the idea.

Man has left his mark everywhere. Paw paw trees now grow wild and struggle to produce even a single fruit. Pets have gone wild, and feral cats skulk in the undergrowth. Even garden flowers flourish everywhere including the oleander, *koket* and Madagascar periwinkle. There is, however, something tenuous about man's hold on this land. The only creatures truly at home are those living beyond the tide line: the ghost crab burrowing in the sand, the mudskippers skittering over the rocks, and the darting fish. They were there long before the shipwrecks and quarantine stations and will be there long after men "go back to Seychelles".

A further 160 kilometres south-east of Platte is Coëtivy, by far the most easterly island of Seychelles. It is shaped like a whale: ten kilometres long and one kilometre wide. It was discovered in 1771 by the Chevalier de Coëtivy, and until 1908 was a dependency of Mauritius.

In 1929, the British Governor of Seychelles and the Director of Agriculture visited Coëtivy and later produced a booklet of recommendations on how best to use the island. The present government has also considered this question, and has spent money and energy making Coëtivy an important agricultural centre.

Now it has the largest pig farm in Seychelles. Manure is used to grow

Above: Sooty terns quarter the beach of Marie Louise Island in the Amirantes Group.

Above: Rusting remains of a shipwreck mark a Desnoeufs beach. Many islands of Seychelles have become graveyards for shipping.

elephant grass, which is fed to cattle along with a supplement of poonac from the island's coconut mills. Cattle manure is used for the vegetable farm. About two tonnes of fish are caught each month in the waters around the island, mostly for local consumption. Some fish is kept in the twenty-five-ton capacity cold store, which also holds the beef, pork, lamb, chicken and vegetables the island produces.

Coëtivy still exports some copra to Pakistan, but figures are small in comparison with the 200,000 coconuts a month the island used to produce. Now emphasis is on the prawn farm.

Life on Coëtivy is comfortable and most houses have electricity. There is no doctor or nurse, but the manager, as is traditional on the islands, dispenses basic medicines and, in the event of an emergency, the island is little more than an hour by air from Mahé.

No outer island is complete without its ghost, and Coëtivy's is Francesca. She is said to be a lady from Madras who lived there 150 years ago, only to disappear overnight. No body was discovered for several months. Today, if any object mysteriously disappears, the blame is put on Francesca.

The largest sand cay in Seychelles, Coëtivy gave "a valuable return" to its owners in the 1940s, although it was considered there was little to attract a visitor. Recent developments have taken their toll on the environment and perhaps in years to come there may be even less of Coëtivy's original beauty to see.

Continuing through the islands, voyagers reach the Alphonse Group, which lies beyond the Amirantes. Alphonse, which is the largest, is shaped like an

arrow-head, with skeins of white sand trailing away from the tips. It consists of one-and-a-half square kilometres of abandoned plantation, dissected by a concrete airstrip. It was first sighted by the crew of *Le Lys* who, on 27 June 1730, reported an uncharted island while voyaging from Juan de Nova. It was given the name of Alphonse to honour the birthday of the ship's captain. It has changed hands several times and by 1936 belonged to a Seychelles merchant who farmed coconuts on it.

Today the plantation slumbers under the tropical sun, fallen coconuts sprouting far below the spreading tops of their elderly parents. The settlement, once the busy focus of life on a hard working island, is quiet except for the chirping of sparrows and insistent calls of common waxbill flocks. Chickens peck around the empty racks of the copra drier, roosting in the rusty metal pipe which was once stoked with fire to heat the kiln. The avenue of workers' houses, facing each other along the shore, are silent. The little lock-up has no guests and the hospital no patients.

Cloaked from the fiercest midday sun by *bwa blan* and *bwa kasan borlanmer* (guettarda) trees, the manager's grand old house, built from asbestos sheets, tin, and coconut planks, is gutted. Tall narrow doors stand open onto the verandah, letting in slashes of light which pick out the torn mattresses discarded on the floor.

From this house the manager dispensed discipline, rationed the precious supplies of food and drink brought by irregular schooners from Mahé and issued the day's orders. His authority was supreme. He sat in judgment over men isolated on Alphonse for months on end, and could sentence recalcitrants to the lock-up, fine them, or give severe warnings. He was arbiter in disputes, comforter in despair, farmer, diplomat, lawyer, letter-writer, counsellor and doctor — one of a special breed. He needed to be ready for anything. In 1924, for example, there was a serious riot on Alphonse when the men grew angry with the conditions there.

At a discreet distance from the house, the ugly tin of the pit latrine has now warmed to a rich red rust, and is softened by tangled creepers. The outside bathroom, laboriously built out of stone blocks and covered with cement plaster, proudly bears its heart-shaped plaque with the date — 1960. No bath tub and indeed no running water. Just a jug of cold water drawn up from the well.

On the other side of the island, at Cas Hoteau, another plaque records that in August 1947, under the supervision of Mr L G, Administrator, MH and JS built a fine house there. The people left and it made a convenient pig-sty for a time, but now it too is deserted. An age has passed, and Alphonse lies abandoned. Behind the ruined, overgrown settlement, the concrete airstrip cuts ruthlessly across the island to the opposite coast. On either side plants and trees once

Above: Brown noddy proclaims the limit of egg collecting allowed on Desnoeufs Island in the Amirantes Group. Sooty tern eggs are regarded as a delicacy by the Seychellois.

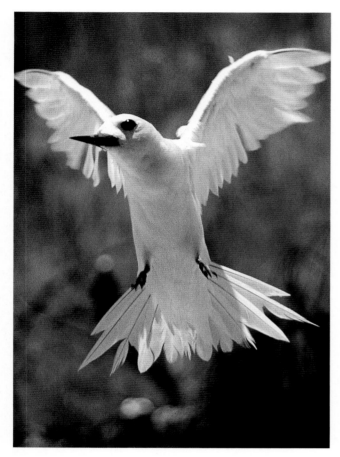

Above: Fairy tern disturbed at its roost flutters into the air on coral Bird Island, most remote of the central islands of Seychelles.

manicured to man's needs have gone wild: pretty pink and white Madagascar periwinkle, and glowing Marvel of Peru grow in great clouds of colour, freed of garden confines. Paw paws stand tall and spindly, producing sour, green fruits and banana trees break their backs under sprays of tiny bananas. Spiky sisals and hemps dot the landscape, the fibre in their leaves once used for fishing line or rough binding twine.

Now the only inhabitants are migrant wading birds — turnstones, whimbrels, plovers and sanderlings. Here and there, the distinctive smell of guano and the whitened foliage beneath the trees betrays a roost for the boobies and frigates which spiral on thermals over the island at mid-day. In 1895, Seychelles magpie robins, now so critically threatened, were introduced and thrived until the 1950s when someone introduced cats. The tame, ground-loving birds were quickly wiped out.

Bright orange dodder, a parasite, scrambles over everything, including the sad remains of the little cemetery hidden in the trees near to the Chemin Madam, which crosses the island to the north. There were many superstitions surrounding death, and a great fear of ghosts and zombies.

The lagoon at Alphonse is immense, some thirteen kilometres in diameter. The water is warm and shallow, dotted with coral heads which make negotiation of the channel to the settlement tricky, but the anchorage is always calm — stark contrast to the thundering ocean as it crashes on the encircling reef. Between Alphonse and the tiny islet of Bijoutier, lie the deep, cold waters of the Canal de la Mort, aptly named for its treacherous nature, and harsh dealings with unwary ships.

The French coal steamer *Dot* went aground on this reef in 1873, and her high funnel, jutting out of the waves, was a salutary warning to shipping for many years afterwards. On the other side of the island, the reef was the final resting place of the *Tamatave*, wrecked in 1903.

Currents surge wildly in the channel, but below the surface, marine life thrives in the plankton-rich, unpolluted water. Great shoals of unicornfish, barracuda, surgeonfish and fusiliers glide among forests of spreading gorgonian corals in amber, russet, white, gold and cream, disappearing into the darkness of incredible depths as the sea bottom drops away into the channel.

Having crossed these deep blue waters another reef jealously girdles and protects its jewel of Bijoutier. This perfect, tiny, round, uninhabited island, with its unruly palms reaching skyward, seems to float serene in the shallow blue-green waters of the great lagoon, like a mirage. Yet around this tranquil heart the waves hurl themselves on the reef in great white sprays, and all about are grim reminders of its power. At least six wrecks are visible, gaunt and forbidding against the skyline, marooned amid the churning white water until they finally rust away. For now, like Cerberus guarding the Underworld, they

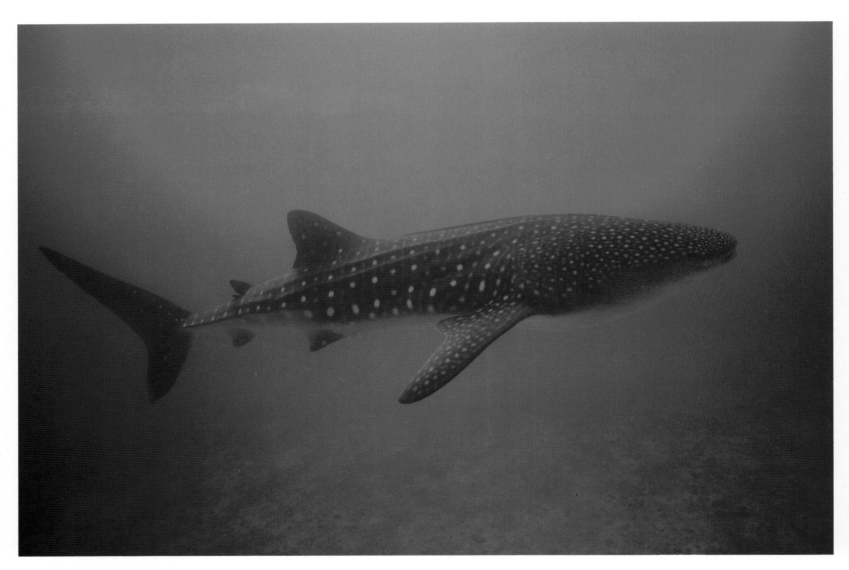

watch over Bijoutier and St. François as if to keep intruders away.

St. François, long and narrow, snakes around the rim of the lagoon, embracing an enormous flat plain of sand which emerges whenever the tide recedes. The only inhabitants, the aristocratic grey herons, whimbrels and other waders, together with myriad crabs, move out into this desert of blinding white sand in search of prey as the tide slips lazily back towards the reefs.

Larger crabs patrol the arched roots of mangroves which ring the lagoon shores, and tiny fiddlers desperately signal to each other across the wide expanses. The occasional cry of the whimbrel, or croaking of the grey herons sends them darting back into their burrows, only to re-emerge seconds later.

St. François is another Seychelles, which few but the most privileged visitor will ever see unless these forgotten islands become more accessible. There are strong ties to the past in this quiet corner of the Indian Ocean. On unspoilt Bijoutier and St. François there is the timeless pattern of life seldom disturbed.

Above: The largest fish in the sea is a plankton-feeding whale shark — it is occasionally seen in the shallow waters around Seychelles.

South of St. François is one of the deepest trenches of the Indian Ocean. With the anchor secure in twenty fathoms off the island, a boat may actually be swinging out over a depth of more than 2,000 fathoms. This near vertical wall, a submarine colossus more than half as high as Everest, has been the doom of many ships.

It is 300 kilometres from the southern tip of the Alphonse Group to Providence Atoll in the Farquhar Group. Providence, a narrow, lonely strip of land was once a coconut plantation, and palm trees still dominate. It was given its name because it proved the salvation of those aboard the French frigate, the *Heureuse*, wrecked on the reef in 1763.

West of Providence lies the raised limestone island of St. Pierre. It is possible for boats to approach very close to the island in the deep waters surrounding it. However, there is just one tiny beach, and landing is difficult. On calm days the resident population of forty guano diggers would be joined by almost the entire population of Farquhar Atoll, swelling their ranks threefold. The men were landed in baskets from boats, and the guano, blasted by dynamite from the limestone rock, loaded for shipment to Mauritius.

The islands of Farquhar Atoll mark the southern limit of Seychelles, placing them dangerously close to the cyclone belt. Shelters were built there with this in mind. Turtle Hill, a huge mound of sand, metres high, towers over the settlement on North Island as a testimony to the power of the wind to shape the land.

Opposite the settlement a jetty juts out to the anchorage. There the boats serving the community timed their arrival and departure with the tides, a current racing at four knots meaning that no engine would be needed. Today, the agricultural output of the island is insignificant, but once there were over 100 head of cattle, together with many chickens, pigs and goats. Maize grew well, but other vegetables and fruits were a problem for the soil is poor and acidic. Small areas were planted by digging pits to the water table, and filling them with red earth imported from Mahé.

Three tiny islands — the Manahas; Nord, Mileu and Sud — separate the main island from South Island, which once had a thriving agricultural community. Further south again is the most southerly of all 115 islands of Seychelles, much closer to Madagascar than Mahé. This is Göellettes, an island of seabirds.

The atoll's western extremity has a shallow passage that lets small boats enter the calm lagoon, taking care to avoid the coral heads and sandbanks which appear as the tide rushes out. From the mouth of this passage, to the next and final island group, is the longest and loneliest stretch of ocean between any of the islands of Seychelles, and Mahé and the granite islands, already a distant memory, are about to become part of another world.

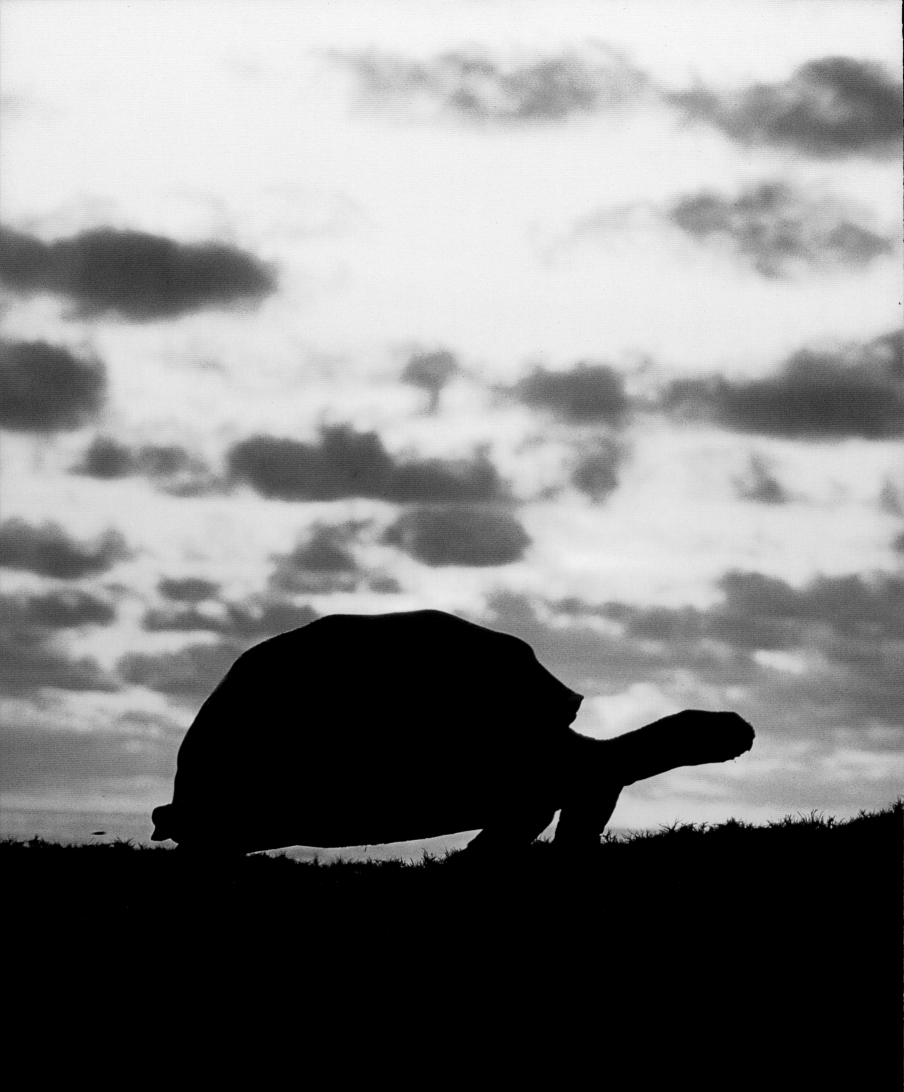

8·ALDABRA THE GREEN

The first indication to a sailor that land is near is the birds. Ocean encompasses every horizon, but you are no longer alone. For hundreds of nautical miles, the only signs of life have been occasional frigatebirds, petrels or a small party of humpback whales. Now there is new company. A red-footed booby sits atop the mast, a brown noddy alights on the prow and a red-tailed tropicbird follows the schooner's wake.

A small island appears on the horizon, then another emerges. Soon the horizon is strung with small, flat islands. As the ship draws nearer, each island reaches towards its neighbour, and gradually they merge into one vast line of land — Aldabra the green, in the midst of miles of blue ocean.

Coming closer a table-like island emerges, a thin crust of coral poised over the ocean, rooted into the sea bed by a thick stem of limestone. The coastal ledge of Grande Terre is sculptured into a mirror image of the curling tongues of the sea that lick hungrily at the land. Here and there, the sea has broken through the coral defences, and a small sandy bay has formed. Such bays gave the island its broken profile from afar.

This is the most remote corner of Seychelles. Politically, it is part of the same country as Victoria, the Vallée de Mai and the mountain mist forest of the high granite islands, but in almost every other respect, Aldabra could be on another planet. Once ashore, a first glance reveals familiar faces — a fody, a sunbird and groups of pandanus trees, but closer examination shows they are as separate from their granitic island cousins as the new land underfoot.

In 1509, exactly 100 years before the first recorded landing in Seychelles, the atoll appeared on a Portuguese chart as *Alhadra*. This is possibly a corruption of the Arabic *Al-Khandra*, meaning "the green", though others suggest the name came from *Al-Dabaron* (or in English, Aldebaran), referring to the brightest of the five stars in the constellation of Taurus. Certainly the atoll was known to Arab navigators who reached the Comoros just a short distance south, and the stars of the night sky were familiar to them.

The first recorded landing on Aldabra was in 1742, but early accounts offer scant details. One writer suggested an abundance of "fresh water and wood for spares", yet it was precisely the lack of timber in significant amounts, and water in particular, which saved Aldabra from uncontrolled exploitation when western interests first moved into the Indian Ocean. The island has a reputation for its unwelcoming nature. In 1879, a band of forty Norwegian idealists set forth from Madagascar to settle on Aldabra. They planned to establish a fishing settlement, but vanished leaving no trace.

Nevertheless, Aldabra did not escape the bounty hunters. Soon turtles, giant land tortoises, and the few trees, were being taken in such quantities as to cause concern. When Charles Darwin learned of the plight of the giant land tortoise in 1874, he and several others wrote to the Governor of Mauritius, pleading for it

Opposite right: A fully grown giant robber crab can measure up to sixty centimetres or more across and has powerful pincers and firm grip to match. Opposite: The china-blue eyes of the Aldabra sacred ibis makes this Seychelles resident a separate sub-species distinct from its African cousin.

Opposite: Giant land tortoise explores the craggy landscape of limestone on Aldabra. Opposite right: One of the most remarkable birds to be found on Aldabra is the flightless white-throated rail.

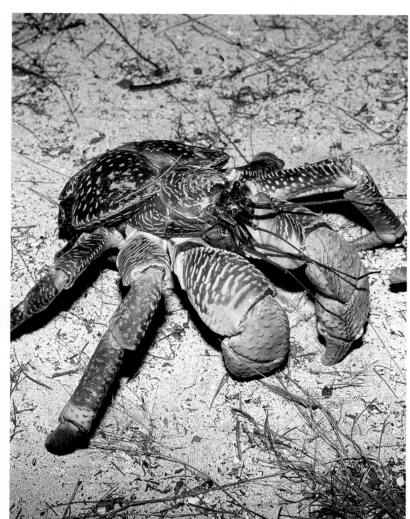
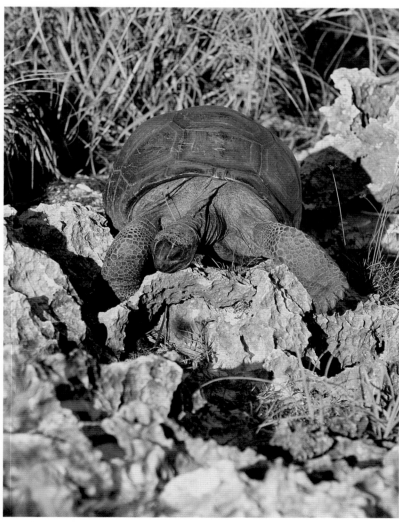
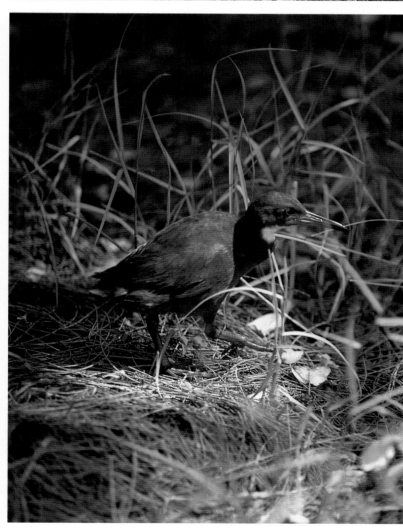

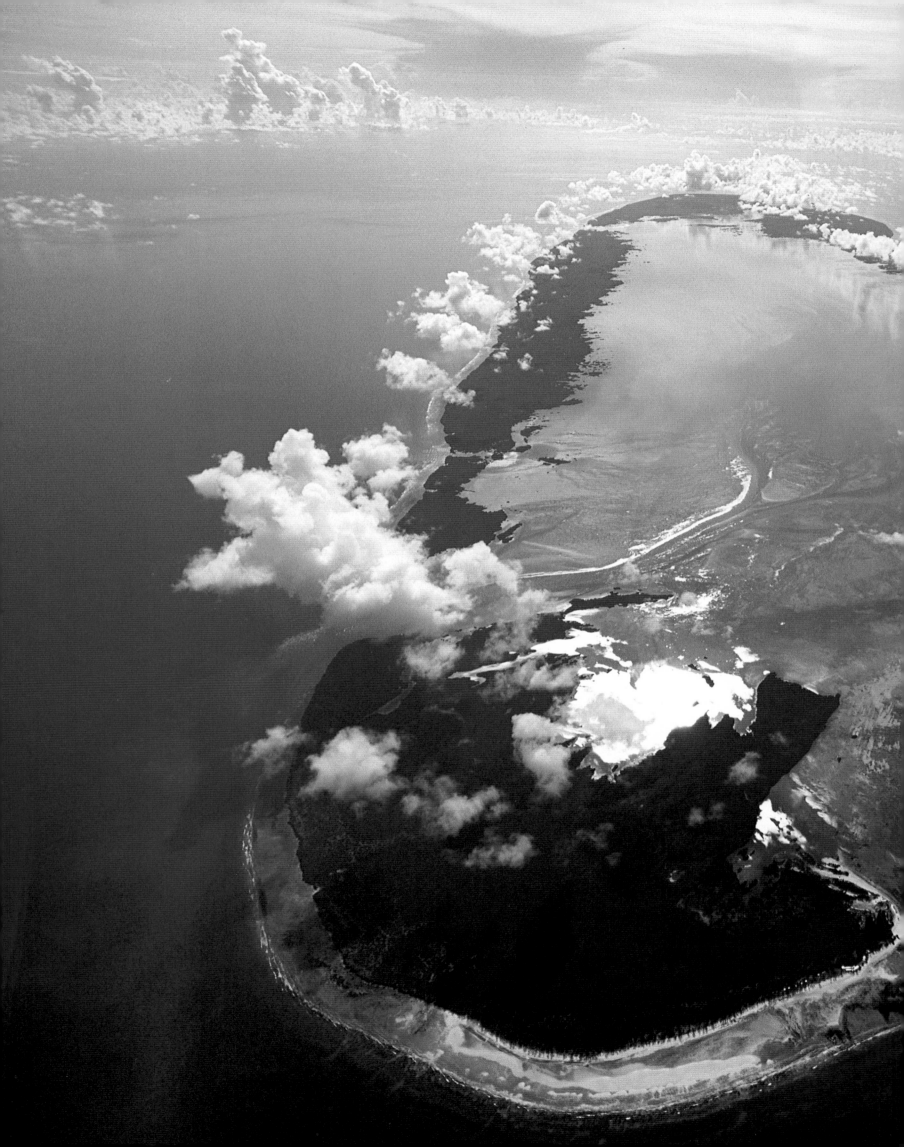

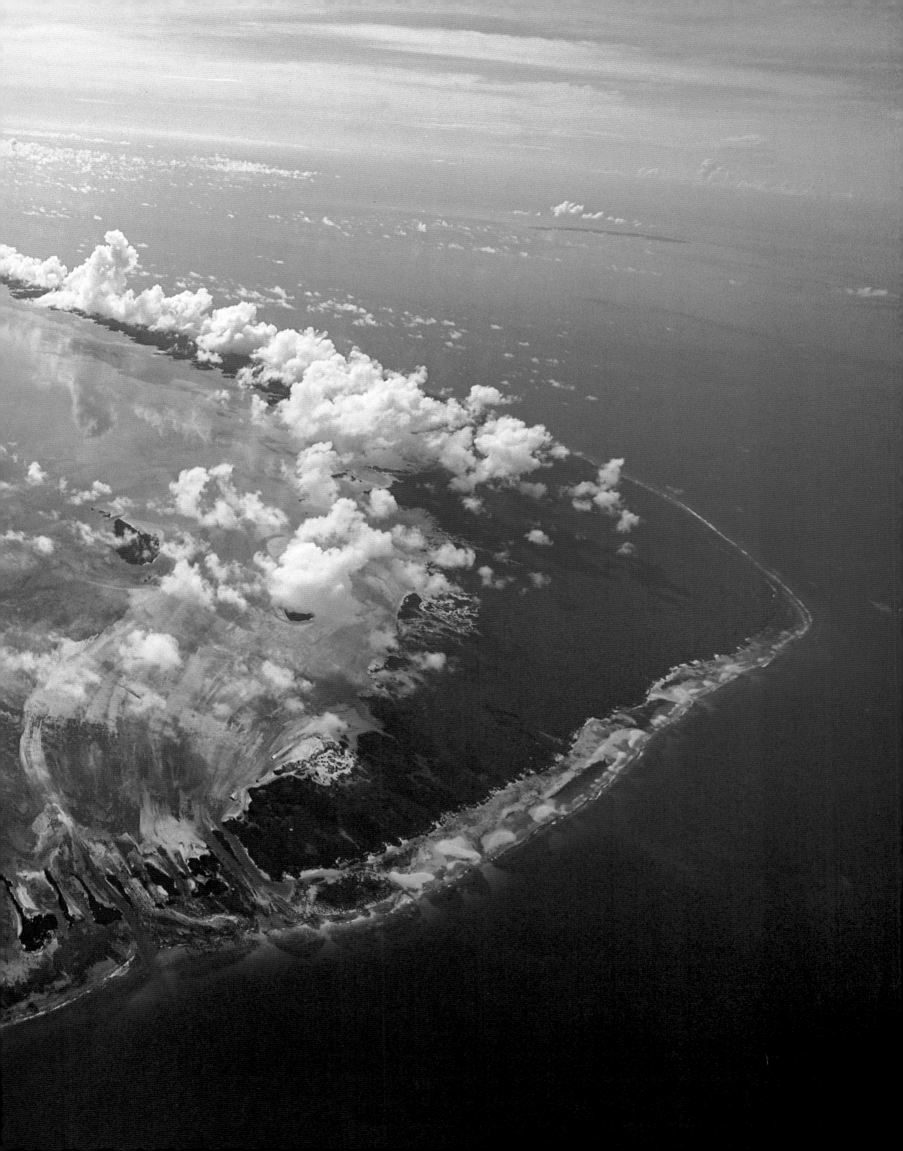

to be saved. The government showed sympathy, though not sufficient to put an end to the trade. In 1888, the atoll was leased to Jules Cauvin of Mahé, who stepped up exploitation of green turtles, tortoises and timber.

In 1891 the lease passed to James Spurs, whom the Mauritian government described as a "lover of nature and an observant man". Observant he may have been, but his intention "to limit" the catch of green turtles to 12,000 a year was a ludicrous proposal for any nature lover. The exploitation of the green turtle continued for many years, and by the 1940s it was beginning to tell. In 1940, one observer reported that "The turtles . . . are slaughtered in huge quantities each year for export, so much so that there is a marked diminution in the numbers which resort to the island for breeding purposes". Some 3,000 green turtles a year were exported to London. The dried fat, or *kalipi,* was in demand for turtle soup. An average turtle would yield almost one-and-a-half kilos of fat, and between 1923 and 1925, 14,000 turtles were slaughtered to provide twenty-one tonnes of *kalipi* for export.

The meat itself was not wasted. A 120-kilo turtle had about thirty-six kilos of edible meat. This was consumed fresh on the island, or dried for later use. From February to May, the breeding season when turtles came ashore to lay their eggs, about 1,500 turtles were shipped, alive, to Victoria, for slaughter and consumption.

Despite the steady reduction of numbers, it was still "a wonderful sight to see the hordes of female turtles often numbering 200 to 300 in one night, coming on shore in the breeding season". Today, numbers are on the increase, and about 2,500 green turtles breed on Aldabra each year. The hawksbill turtle was never common around the island, but with protection more of these may now also be seen.

At least the tortoises were given temporary respite during Spurs' time, which lasted until 1900 when a commercial company involved in fishing, timber production and coconut plantations took over the lease, only to be beaten by the inhospitable terrain and occasional cyclones. Then in 1904 came what Tony Beamish described in *Aldabra Alone* as "probably Aldabra's darkest hour". The next lessee, Monsieur D'Emmerez de Charmoy, with James Spurs as his manager, all but wiped out the green turtle. Then two years later, Aldabra had another close brush with calamity when it was suggested that rabbits, hares and cattle should be introduced to supplement the island's food supply. Fortunately the idea was rejected, for this fragile ecosystem would have been destroyed. Tragically, rabbits have been released on neighbouring Cosmoledo and Assumption atolls as recently as the 1990s. This could rule out any possibility of future attempts to repopulate these islands with giant land tortoises.

After 1945, exploitation of Aldabra on a commercial scale was halted. Then ten years later, scientific interest which had blossomed around the turn of the

Above: Up to 7,000 pairs of the red-footed booby breed on Aldabra, mainly in mangroves on the inner northern perimeter of the atoll.

century, only to be subdued by world war and depression, was reawakened. Jacques Cousteau visited Aldabra in 1954 to study the marine ecology, while university and zoological expeditions from Europe and the United States began to catalogue the wonders of the atoll.

Then just when Britain was shedding its colonies, a new one was formed. Harold Wilson's Labour government announced that Farquhar, Desroches, Chagos and Aldabra were to be lumped together as the British Indian Ocean Territory — BIOT — to form a defensive base against the Soviet Union. The base would be run by America.

The real target of BIOT was Aldabra where they planned to build a five-kilometre runway on South Island, a dam across the main channel, create harbour facilities, and a link road through Polymnie and Middle Islands, crossing Passe Hoareau by a bridge. The airfield would have destroyed the greatest concentration of giant land tortoises on earth. The link road would have wiped out the spectacular frigate and booby colonies, by far the greatest of the southern Indian Ocean, and destroyed the habitat of the Indian Ocean's last remaining flightless bird, the white-throated rail. The dam would have ruined the lagoon and flooded the mudflats where crab plovers and thousands of other migratory birds had their feeding grounds.

In Britain the Royal Society took up the challenge, and drafted proposals for a research station, but defence minister Denis Healey scoffed: "Aldabra is inhabited — like Her Majesty's Opposition Front Bench — by giant turtles, frigatebirds and boobies. Nevertheless, it may well provide useful facilities for aircraft."

International conservation bodies including the Smithsonian Institute, World Wildlife Fund, International Council for Bird Preservation, Royal Society for the Protection of Birds, and the International Union for the Conservation of Nature, all joined the battle.

Tony Beamish filmed a television documentary on Aldabra entitled *Island in Danger,* seen by seven million viewers. Finally, Britain shelved the plan, giving instead its support to the Royal Society's own schemes for Aldabra, which included a permanent research station, laboratories and a library on Picard, from which new data soon began to flood in. Scientists documented an islet with a population of 100 breeding egrets, found the eggs of flamingos, made the first breeding record of Audubon's shearwater . . . and discovered a new species of bird, the Aldabra brush warbler. Formerly an unknown, remote corner of the planet, Aldabra now became a scientific and natural treasure house.

The Royal Society handed over trusteeship of the atoll to Seychelles Islands Foundation in 1980. The following year it was declared a Special Reserve under Seychelles National Parks and Nature Conservancy Act and in 1982 it became a UNESCO World Heritage Site.

Above: The lesser frigatebird breeds only in the Aldabra group during the south-east monsoon on the northern lagoon shore.

Aldabra is home to the world's largest population of giant land tortoise, once widespread throughout the Indo-Pacific. All giant land tortoises in Seychelles, whether captive or wild, as on Curieuse, Frégate, Cousin and Bird, come from Aldabra. There they have no enemies, though young tortoises may be taken by crabs until their shells harden. Aldabran tortoises have a unique ability to drink water through their nostrils, enabling them to quench their thirst from small puddles of rainwater captured by the honeycombed landscape.

They shelter under trees or rocky overhangs when the intense mid-day sun is overhead, and emerge in the cooler late afternoons. They are normally silent, except during the noisy mating process.

The birds of Aldabra have been well researched. Foremost among them must be the white-throated rail. Once, flightless birds were found on many Indian Ocean islands, but this is the only survivor.

Unique to the atoll is the Aldabra drongo, which flits through dense vegetation in search of insects and lizards. The other unique, full species, the Aldabra brush warbler, may now be extinct as it has not been seen since 1983. However, the density of the vegetation on Malabar, the only island of the atoll where it has ever been seen, gives a faint ray of hope that it lives on somewhere in the impenetrable interior.

Aldabra abounds in unique subspecies. Most common are varieties of red-headed forest fody and souimanga sunbird, closely followed by the Malagasy white-eye. The sacred ibis of Aldabra has developed plumage differences which separate it from its African cousins, together with a distinctive china blue colour to the eye. Comoro blue pigeons, Malagasy turtle doves, Malagasy bulbul, Malagasy nightjar and Malagasy coucals have all developed into unique Aldabran varieties. As their names suggest, the islands south of Aldabra have been the main source of avian invasion and the avifauna has nothing in common with the granite islands.

Another land bird, the Malagasy kestrel, came from this same direction. It remains to be seen whether it will become established on Aldabra. Not all species make it. Barn owls, once common, have died out.

Among the most fascinating of all Aldabra's birds are the two species of frigates. These giant, primaeval birds nest in the mangroves along the inner northern rim of the lagoon. In the breeding season the males inflate their red throat patches like balloons to impress the females.

Alongside them nest the red-footed boobies. Each pair rears a single chick which learns to vibrate its gular skin, around the throat, to reduce heat by producing evaporation. To stay cool while sleeping it has developed the bizarre habit of leaning forward using its bill as a prop, thrusting its rear skyward, exposing a bare bottom which reflects heat.

Aldabra's vast lagoon is about twenty-six kilometres long by eight kilometres

Opposite: The name of Astove is synonymous with stories of lost treasure. It is the subject of many legends, being linked with castaways, shipwrecks and treasure troves.

Opposite: Lying 1,045 kilometres from Mahé, Cosmoledo Atoll is a ring of twelve islands, many of which are unsurveyed.

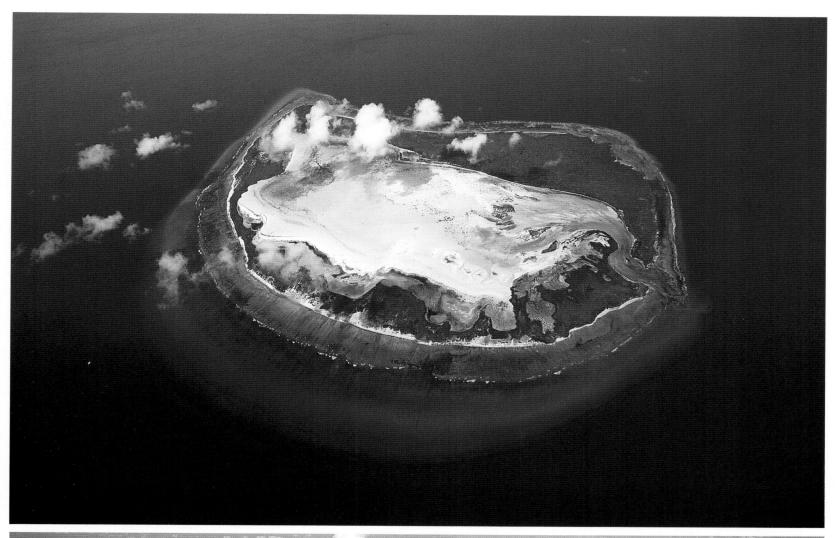

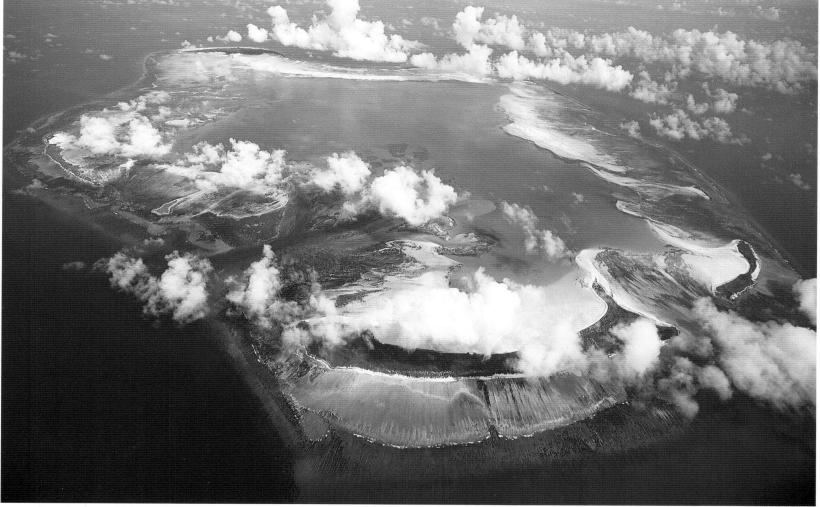

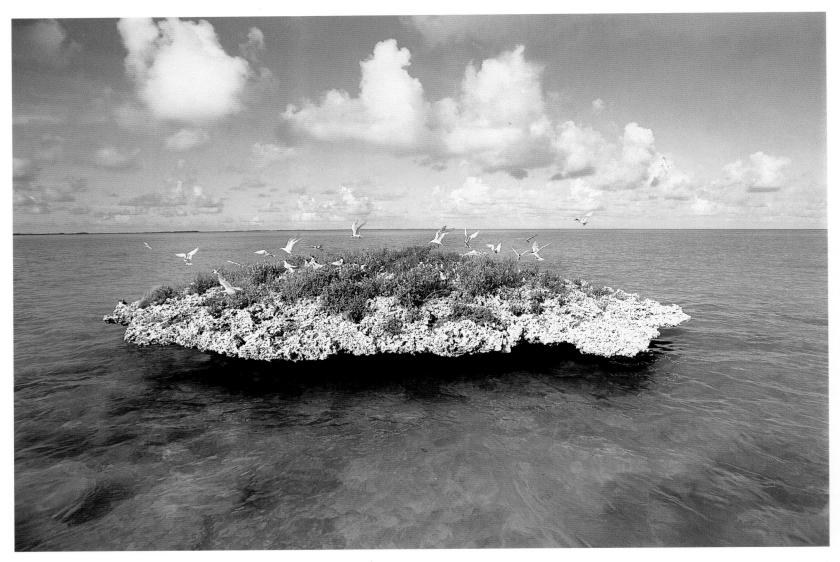

Above: Constant tidal erosion has created strange shaped mushroom islets and in places an almost impenetrable shoreline.

wide. You could fit the island of Mahé into it. As the tide turns, the water surges in and out through the channels at a tremendous rate, but the lagoon is calm. Sometimes your *pirog* seems to skim over glass, which perfectly reflects the table-like islets rising out of the water on their single stems, crowned with tufts of scrubby vegetation. There are long winding channels through the mangroves, whose bark was once dried on Picard Island and sent for export. It yields a red dye.

Travelling from islet to islet, the low-lying land is no more than a faint smudge on the horizon, and it becomes possible to believe the story of the *Königsberg*, a German battleship reputed to have hidden in the lagoon during the First World War. The ship had been raiding in the Indian Ocean, then vanished. English, French and Japanese ships searched for it.

Some Seychellois on a fishing expedition are said to have found it anchored inside the main channel to the lagoon. They raced to Mahé to raise the alarm, and soon the news was being broadcast all over the region. But the signal was intercepted by the Germans and when a British man-of-war arrived on the scene, the *Königsberg* had gone. Those who know Aldabra's currents say it was impossible for any ship to anchor there safely. Others think it might just have been possible.

Stepping ashore — where there is a shore and not just a jagged overhang of rock — there is a great sense of anticipation, for this is one of the last wildernesses on earth, and there is still the feeling that something new and undiscovered could be just around the corner. But Aldabra's reputation for inhospitability is no myth. In addition to lack of water and dense scrub, there is

Above: The beautiful greater flamingo can be seen regularly on Aldabra.

the *sanpignon*, a word that evokes painful memories for any Aldabra veteran.

It looks like the result of a volcanic eruption, it sounds like porcelain ringing, and it cuts like razors. Formed by rainwater eating away at the coral, there is no regular pattern to the erosion, leaving pinnacles and sudden holes scattered at random. You either tiptoe delicately, trying to avoid slashing your ankles on the pinnacles, or leap lightly from point to point.

The *sanpignon* is occasionally interspersed with flat areas, or *platen*, which are always a great relief. The ground underfoot feels hollow, and you are reminded that the sea finds its ways through crevices and tunnels right beneath the atoll. Sometimes you can glimpse it through a small hole, or else whole ponds open up, with treacherous, overhanging sides. They teem with creatures which have somehow made their way through the labyrinths of coral beneath and into these sheltered pools.

Apart from Aldabra atoll there are three other islands in the group sharing a similar origin with raised limestone and the same rough, pitted surfaces. Each illustrates a different stage in Darwin's theory of atoll formation. Assumption, the smallest and youngest, is simply a flat island of coral rock and sand dunes. At Astove, the peak has disappeared, though it is otherwise a similar, single flat mass. The small shallow lagoon dries out at low tide. Aldabra is a perfect atoll with an enormous lagoon. The ring of land is broken into four main islands by channels through which the ocean tides breathe in and out. Cosmoledo represents the final stage; the submarine peak has completely submerged and a ring of eight islands surround the place where it drowned.

Nevertheless, on closer inspection it appears these islands, far from sinking,

have been uplifted, or the sea level has fallen due to a change in ocean currents. Aldabra has two distinct terraces at four metres and eight metres, considerably higher than the coral islands of the Amirantes, or Bird and Denis, which barely rise two metres above sea level. The island limestone probably dates from about 125,000 years, or about the time of the last interglacial period.

Unlike Aldabra, the other islands of the group have been seriously affected by human interference. Assumption, in particular, has been devastated. It was home to the rare Abbott's booby until the 1930s or 1940s. Today they survive on Christmas Island. Unlike most boobies, it roosts only in trees over forty-five metres tall, which suggests the woodland on Assumption was once spectacular. In the quest for fertilizers, man destroyed the birds which created the guano which once covered the island. The company which mined the guano went bankrupt and the island was deserted, but too late. No longer do the Abbott's boobies' strange cries, likened by one writer to an "arboreal cattle fair", boom across the island. Flightless rails, once common, have vanished. In their place are alien species, introduced illegally — the red-whiskered bulbul and Mozambique serin, which pose a potential threat to nearby Aldabra.

Recently, an airstrip opened on Assumption, which it is hoped will bring limited tourism to Aldabra. People will fly to Assumption and transfer to Aldabra by schooner. This could be the ultimate package tour for those who want to get away from it all. It will certainly complete the contrast with conditions there in the 1940s. The population of Assumption then was about 160. There was little fish or turtle, and no vegetables. The only fresh greenery in their diet was *koupye*, the wild portulaca. When supplies ran out, they were reduced to *riz rousi*, or fried rice . . . until the oil ran out. A pier nearly ninety-two metres long was built for the steamers which came to load guano, and their arrival sent the lonely community wild with joy.

Cosmoledo, 110 kilometres east of Assumption, is a huge ring of a dozen islands. As on Aldabra, red-footed boobies, red-tailed tropicbirds and various terns breed. Both Cosmoledo and Assumption have different varieties of souimanga sunbird, while Cosmoledo is also home to Malagasy grass warblers.

In the past Cosmoledo was used as a base for fishing and turtle collection. They also sent out egg yolk. In one year alone the island produced six tonnes of it. The settlement is on Menai, named after Moresby's ship, where, like most of the outer islands, water is scarce. Workers store rain water in tanks to see them through the dry season.

Astove covers almost seven square kilometres of which much is fertile. For this reason the island has had an almost permanent population. They grew cotton, sisal, maize, castor oil plants, and a small amount of copra, which was sent the 1,045 kilometres to Mahé for sale. They also fished, took an average of 400 turtles a year, and dug large quantities of guano. Today, all activities, except

Above: The Aldabra fruit-bat has evolved a unique island form and has a white face unlike its cousins on the granite islands.

Above: Aldabra boasts unique flora such as the remarkable Aldabra lily, which has fleshy thorny leaves and a spike of orange-red flowers.

fishing and the occasional taking of green turtle illegally, have ceased.

The southern edge of the Aldabra group, rising from the depths that separate Seychelles from the Comoros and Madagascar, is journey's end. Astove's sudden appearance has also spelled journey's end for many a ship, carried too speedily along by wind and current, and dashed against the reef.

One of the earliest victims was the Portuguese slave ship *Dom Royal* which struck the island in 1760. A large anchor and a cannon on the reef off the north point are said to be from this wreck. The captain and crew set out for Africa by longboat, and were never heard of again. The slaves established what was arguably the world's first black island republic.

However, their freedom was far from assured. News of their republic reached the Ile de France and two vessels were despatched, only to be wrecked in mysterious circumstances. Twenty years on, another ship reported that, on their approach to Astove, the inhabitants "set up wild shouts of defiance and placed themselves in an attitude of defence".

The incident was reported to the authorities in Bourbon, and another vessel set out, again to be lost in unknown circumstances. In 1786, a British ship attempted to take the slaves by force. Many were killed in the clash, which proved inconclusive. Another ship set sail and successfully embarked 100 slaves only to be wrecked while attempting to find a passage out. All aboard were lost to the sea and sharks. The surviving castaways were picked up a short time later, except for one man who chose to remain. He too vanished for reasons unknown, for a visiting ship in 1799 reported the island deserted.

These would not be the last people forced to survive on Astove. In May 1836 the beautiful new ship *Tiger* left Liverpool. At the Cape of Good Hope, a Captain William Stirling joined the vessel en route to Bombay. Later he wrote a dramatic narrative of this fateful journey which was dogged by bad weather. The *Tiger's* captain, who had received medical treatment at the Cape, was seized with delirium and confined to his cabin. But near Madagascar, "with the cunning of a maniac, and the speed of lightning, he darted through a port which had unfortunately been left open".

Captain Stirling wrote: "I then looked over the side, and there I beheld a sight which I shall never forget: the Captain with a vigour and energy which appeared supernatural lay on his back in the water with his head and knees quite out of it, his wild stare of insanity glaring at the ship as it passed him, and his whole bearing being that of a man who had achieved a triumph rather than that of one who felt himself on the brink of eternity."

Shortly afterwards, a sail and boom crashed from the maintop. That night the crew's fitful sleep was broken by a horrendous shriek from the helmsman who thought an apparition had appeared on deck. But it was the second mate, who had taken him by surprise. The following night, the helmsman again alarmed

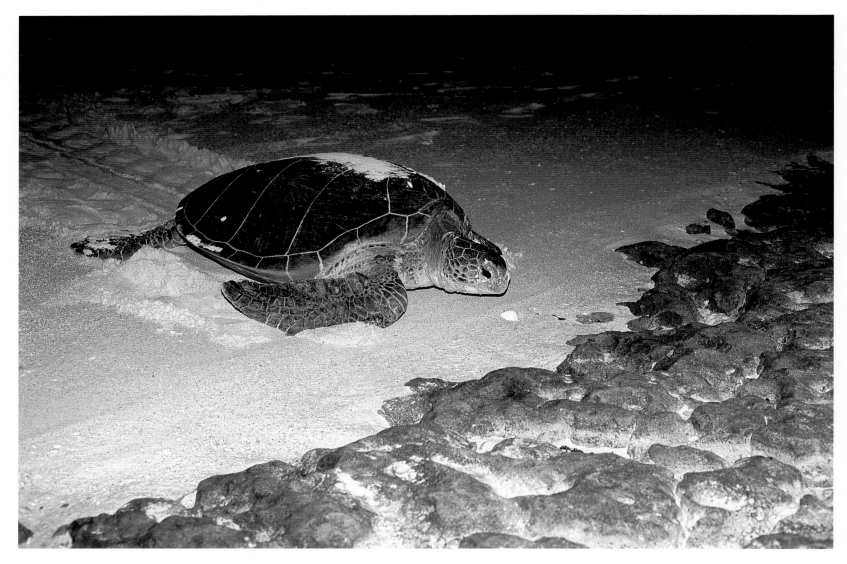

Above: The green turtle, although still endangered, is now a protected species and around 2,500 nest each year on Aldabra.

the other sailors with his screams, claiming he had seen a ghost as high as the mast, without a head, stalking towards him, wearing white trousers and blue jacket.

Finally in the early hours of 12 August, the ship "descended with an awful and terrible crash, with its whole weight on the rocks." The pounding continued all night. Next morning, the crew beheld the island of Astove.

Making land they found fish and turtle in plenty, together with flightless rails and red-tailed tropicbirds. Eleven men set out in a longboat, hoping to reach Mahé and organize a rescue party. However, mistakenly believing they were on Juan de Nova, (now Farquhar), not Astove, they set a false course. Unable to reach Mahé, they turned towards East Africa, eventually reaching Zanzibar.

Captain Stirling, his wife, and the remaining crew, were meanwhile rescued by the *Emma*, a South Sea whaler from London, which gave them passage to Mahé. Before leaving their tents, Captain Stirling wrote a message in large

Overleaf: A catamaran lies at anchor in the waters around
Aldabra Atoll.

191 ∎

*Above: Golden sunset silhouettes lesser frigatebirds on the
island of Aldabra.*

painted letters on the ship's hatch and left it in a prominent location. It read:
"The passengers and crew of the *Tiger* were providentially taken from this
island by the *Emma* of London, Captain Goodman, to Seychelles 16 October
1836."

The sign has gone. So have the rails and the tropicbirds. However, sunbirds
and white-eyes still flit through the bushes. Turtles, given new hope following
the recent abandonment of the settlement on Astove, haul themselves up the
beach to lay their eggs. The coral reefs swarm with fish — one expert declaring
Astove to be among the top ten dive sites on earth. Nature is once again
triumphant. This is the way it used to be in Seychelles, and the way it will
continue, so long as all who journey through this remarkable archipelago treat it
with the respect and wonder it deserves.

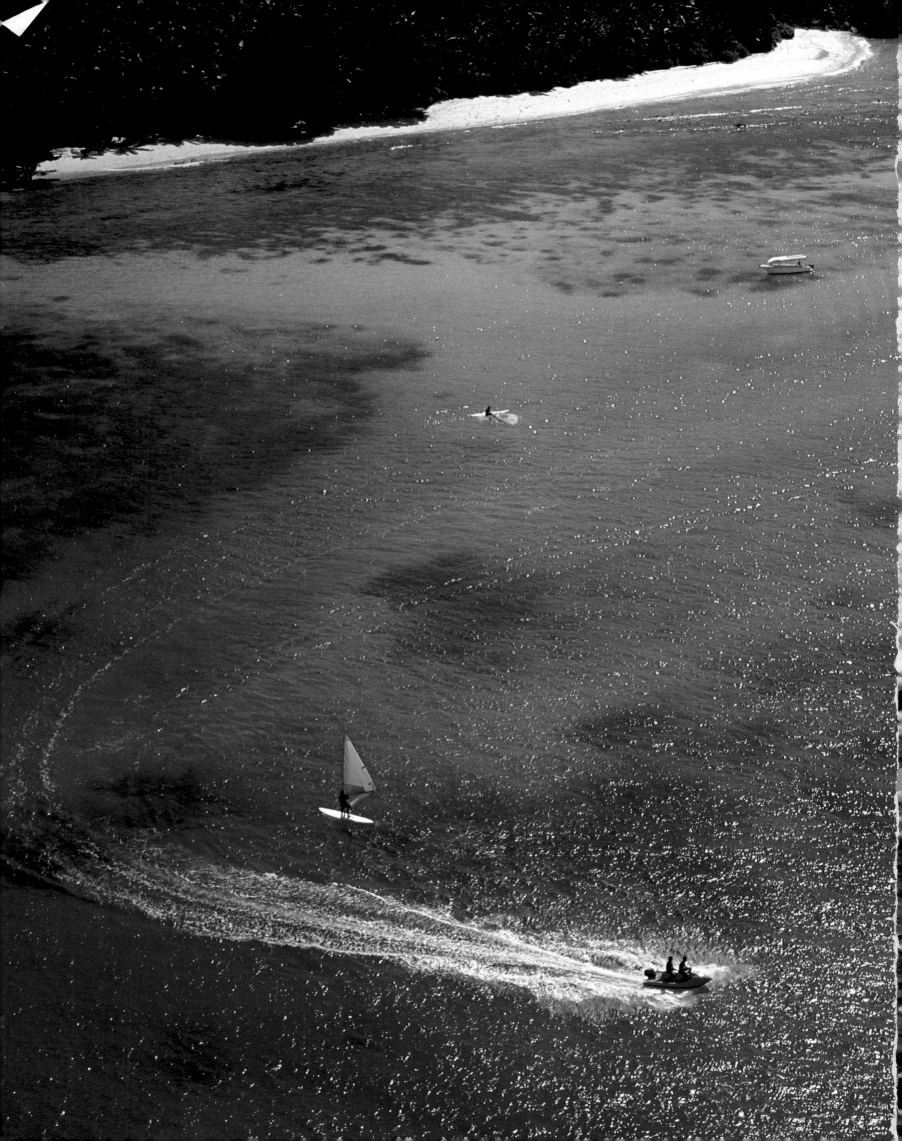